10/31/00

To Andrew —

Happy Birthday!
May this remind you
of all the wonderful,
simple joy that
exists!

Love, Lea

Philip B. Kunhardt Jr.

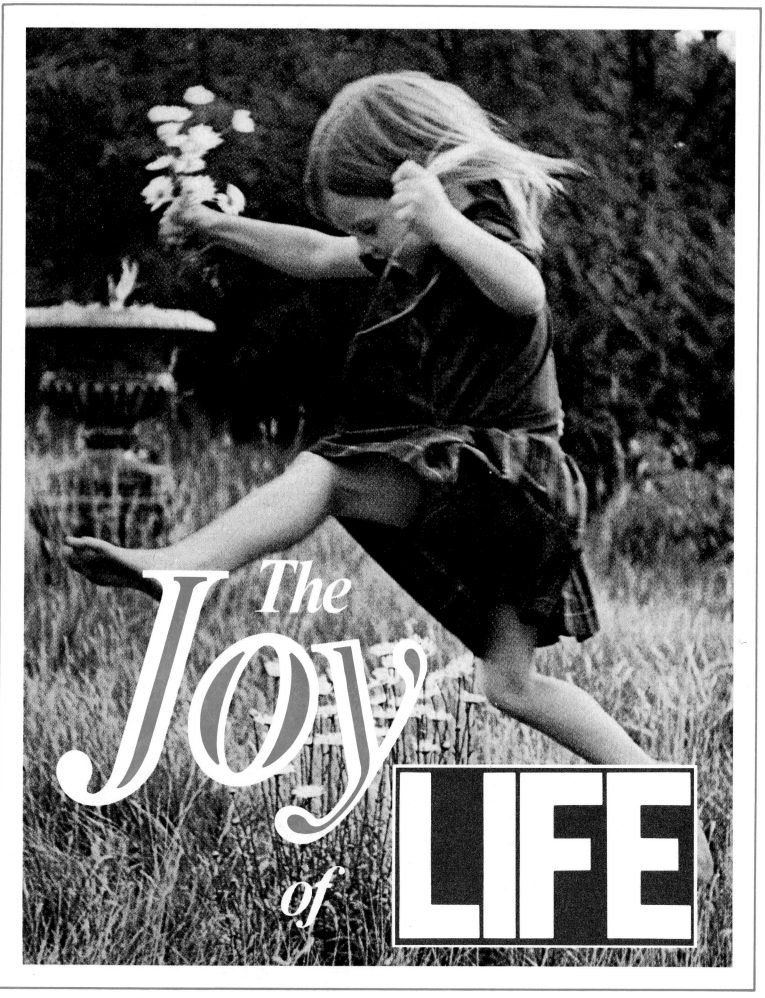

The Joy *of* **LIFE**

For Katharine

Edited and written by **Philip B. Kunhardt Jr.**
Design and Production: **Gene Light**
Editorial Coordinator: **Gedeon de Margitay**
Copy Editor: **Ricki Tarlow**
Picture Research: **Gretchen Wessels**

FIRST EDITION
Library of Congress Catalog Card No. 89-12293

Published simultaneously in Canada by Little, Brown and Company (Canada) Limited

Acknowledgments to photographers and illustrators, including permission
to reprint previously copyrighted material, appear on page 224.

PRINTED IN THE UNITED STATES OF AMERICA

Contents

*T*o illustrate the theme of joy I had at my disposal the pictorial treasures of more than 2,000 issues of LIFE. I had magazine upon magazine, more than 50 years' worth, the most extraordinary array of photographic scenes ever put together— scenes of events and politics and war, of sports and adventure, of the lively arts, of science and nature, scenes of art and beauty, of architecture, food and fashion, of history and civilization and, finally, scenes of just plain ordinary human experience. From this final group, scattered through hundreds of thousands of magazine pages, I drew the majority of the pictures used here to illuminate the subject of joy.

*I*n making my selections and figuring out how they could be fused into a book, I shied away from recognizable people, from public events, from posed situations, from phony occasions and from all professional aspects of the lively arts. Everything shown on the following pages is real. Real people doing real things. As LIFE has always done, I pretty much stuck to America. For the 10 chapters into which the book is divided I formulated the kingdoms of joy that interested me and left out those principalities that seemed less absorbing. Or less visual.

*F*or the sake of freshness I steered clear of LIFE's well-known pictures, even though many of the magazine's most famous photographs would often have filled the bill to perfection. For cohesion I focused on the great cycles of life and its milestones—from birth on. Always I was guided and inspired by the moving qualities of LIFE's superb photographs; for me joy defined itself through them.

*O*ut of that intense involvement, the joy of life (or LIFE) revealed itself in many forms; for, as I searched the pictures, it was clear that the human emotion I was pursuing had many faces, myriad moods. At its most basic, joy is that special pang of pleasure that springs from happiness. It is

The Many Faces

that excitement from unrestrained abandon as well, from being free. It is that thrill that comes with love. It is that peace that can descend when the spirit is moved. It is that extraordinary feeling that is triggered by the expectation of good. It is that jubilation that wells up when miraculous things occur. It is that awe when the size and scope and beauty of the world are felt. It is that arrow of delight that hits its mark when fulfillment is achieved.

*J*oy is contagious. It can spread like a forest fire, whipped by a high, hot wind. Joy can be shared in a crowd. Or it can be savored all alone. Joy can bellow. Or it can fall soft as a kitten's tread. Joy can excite. Or it can comfort. Joy can be sensuous. Or it can spring from the intellect. Joy can bewitch. Joy can be sweet. Or it can be zesty, euphoric, giddy. It can teach. It can heal. It can lay to rest old pain. In a world so darkened by suffering and uncertainty, joy can brighten our heavens and make life worth living all over again.*

P. B. K.

of **Joy**

Beginnings

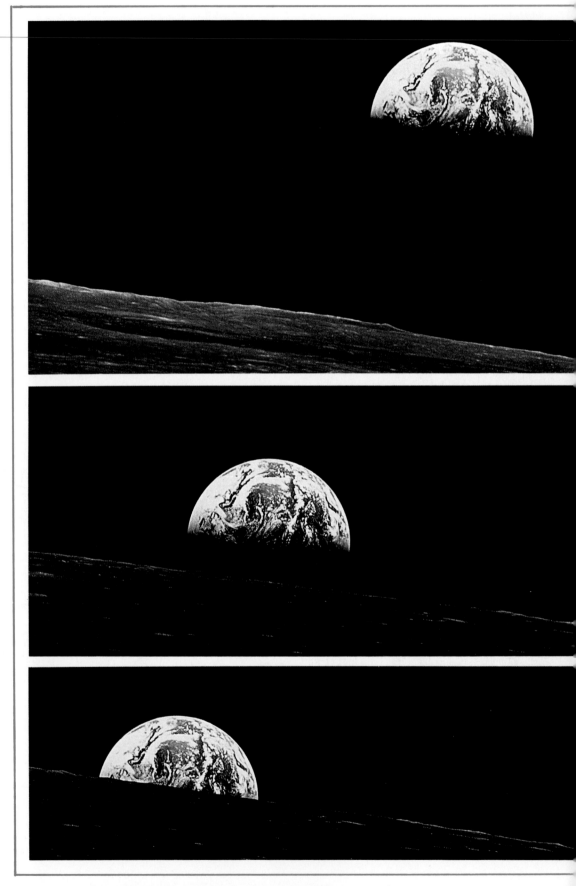

A quarter of a million miles from the moon, in a Pennsylvania hospital,
Tom Roberts becomes a father as he helps his wife with the birth of their baby.

In the beginning there is darkness. Then, rising over the bleak lip of the moon comes Earth, aswirl with the water and the air that make life possible on our great blue planet. Rising too, out of the darkness of the womb, comes a new life. And with it comes new joy, new pain, new hopes and dreams, new mystery.

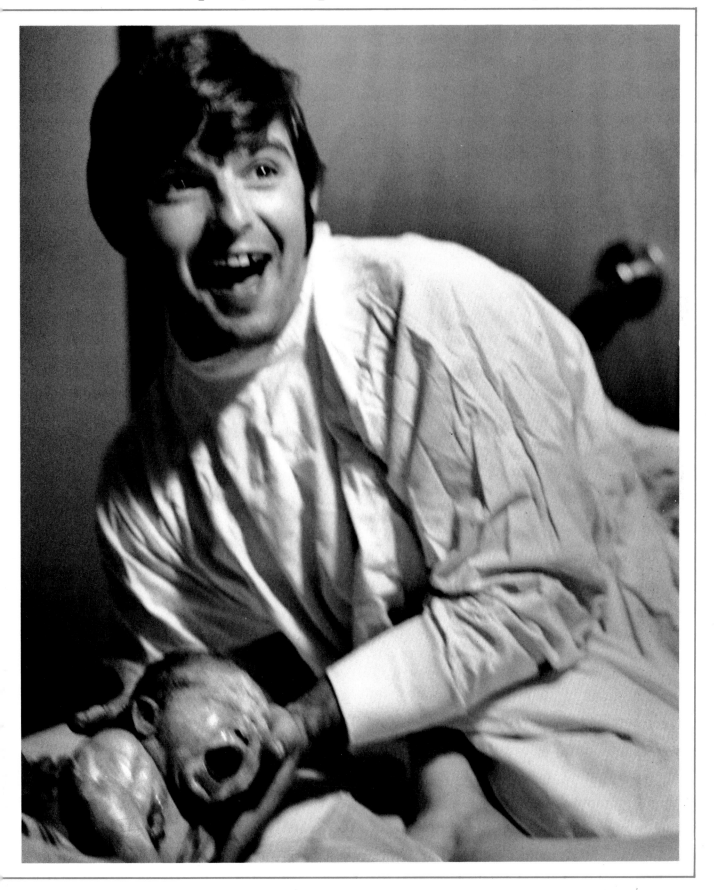

*An awestruck audience in Kentucky's
remote Cumberland mountains*

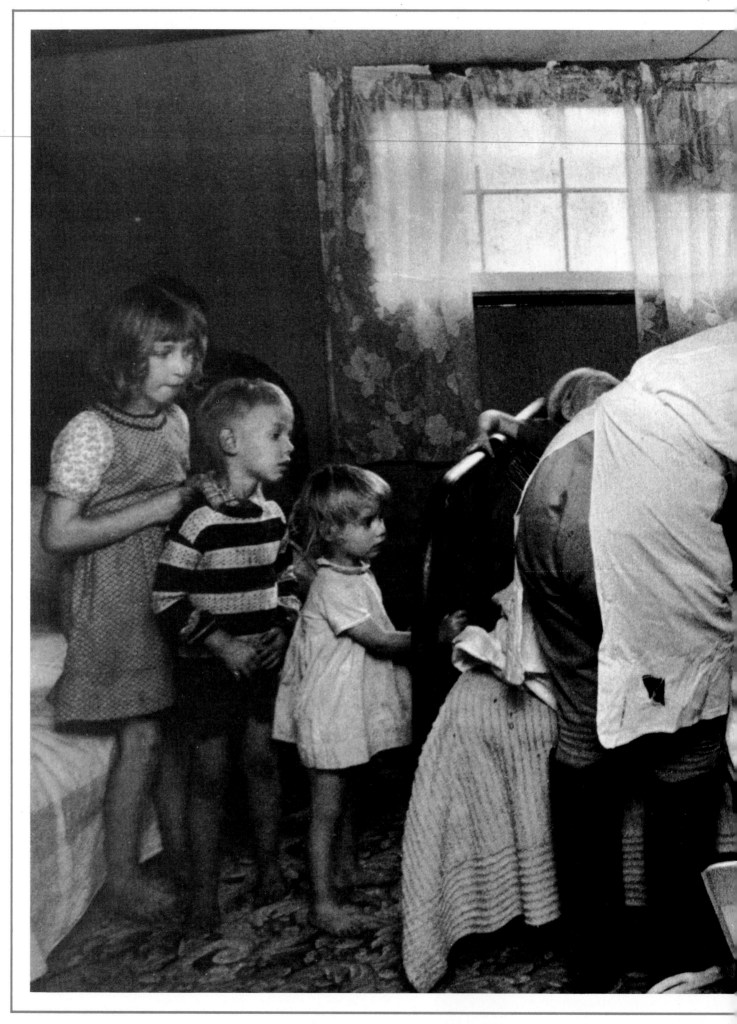

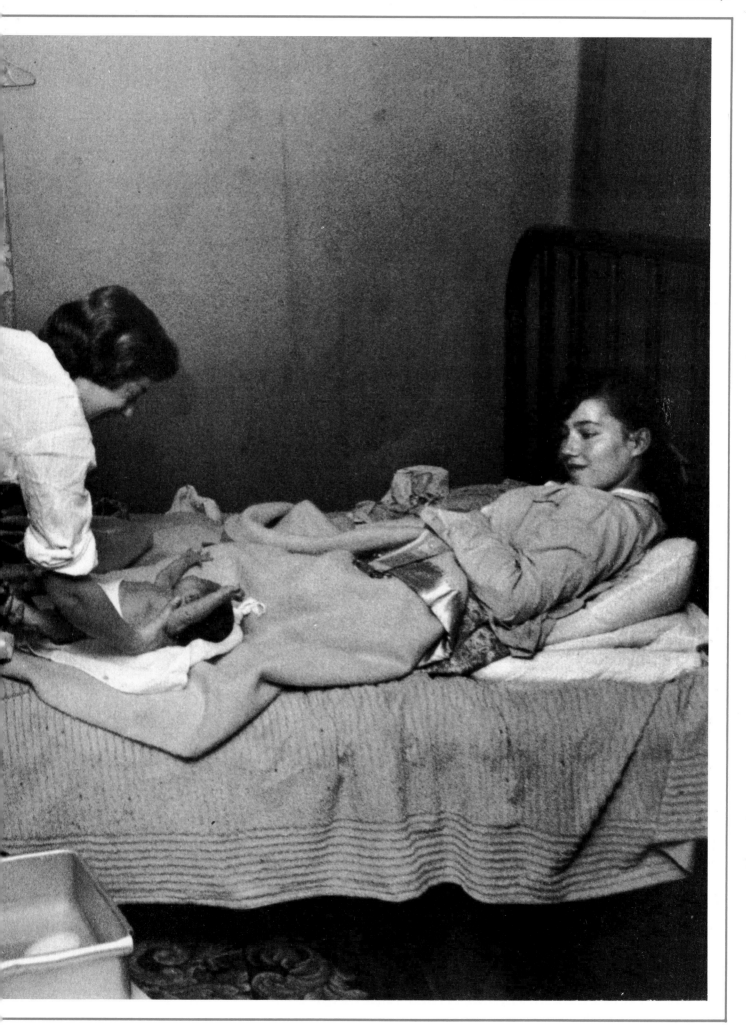

Nurse-midwife Jo Ann White checks out a new addition to the Colette family.

What marvelous kaleidoscope of dreams beneath that fuzzy, much-kissed head?

A man-child sleeps right where the last stretch took him.

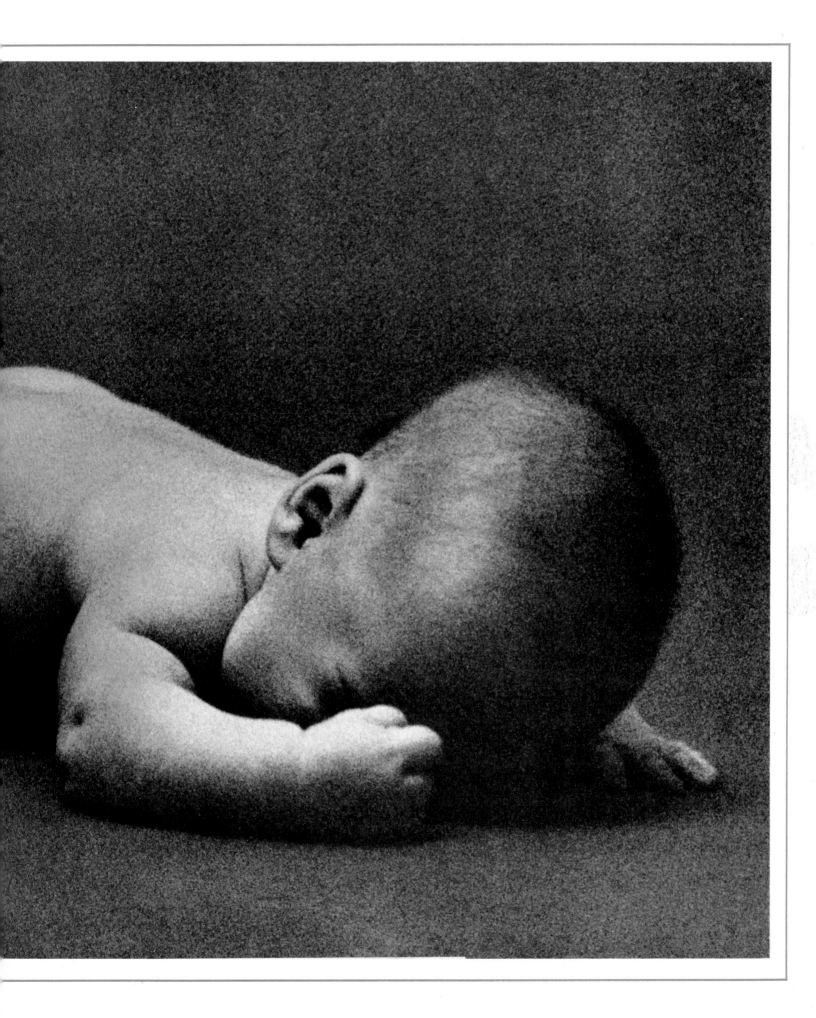

Early messages conveyed by the gentle touch of loving hands

Joanne Barton stretches for her three-month-old son Trace. ● Palmer and Sonia Beasley admire their three-month-old son Fletcher. ● A Japanese father shows his adoration. ● In 1907 a mother nurses her child.

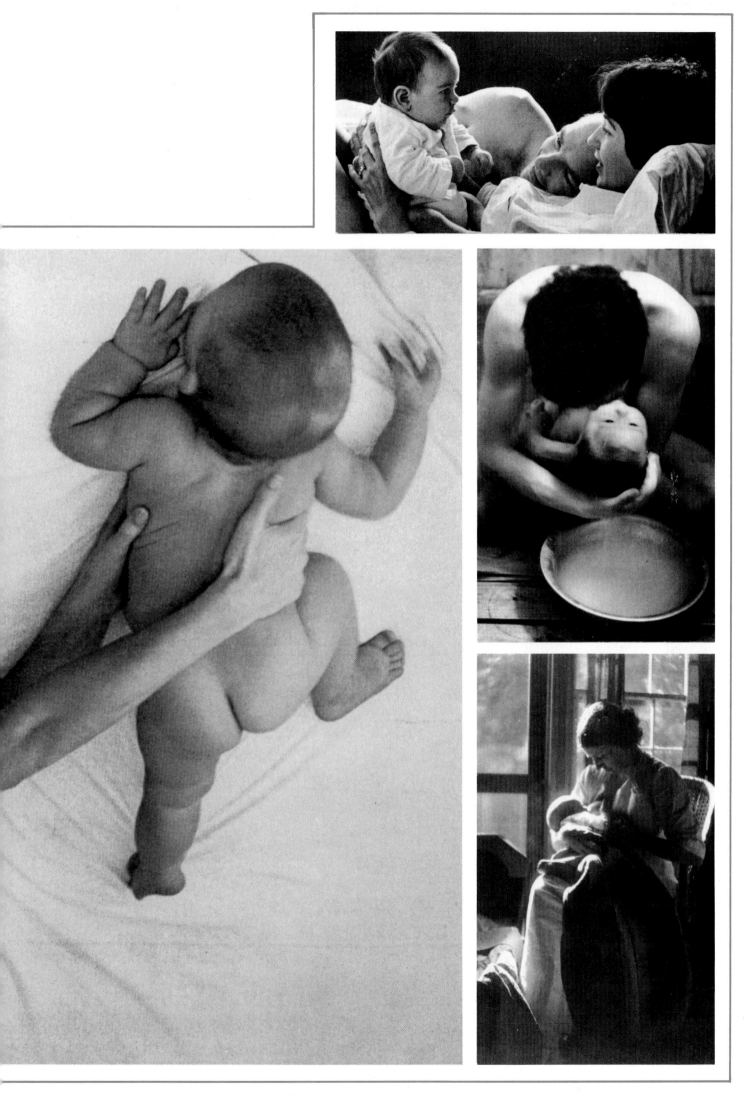

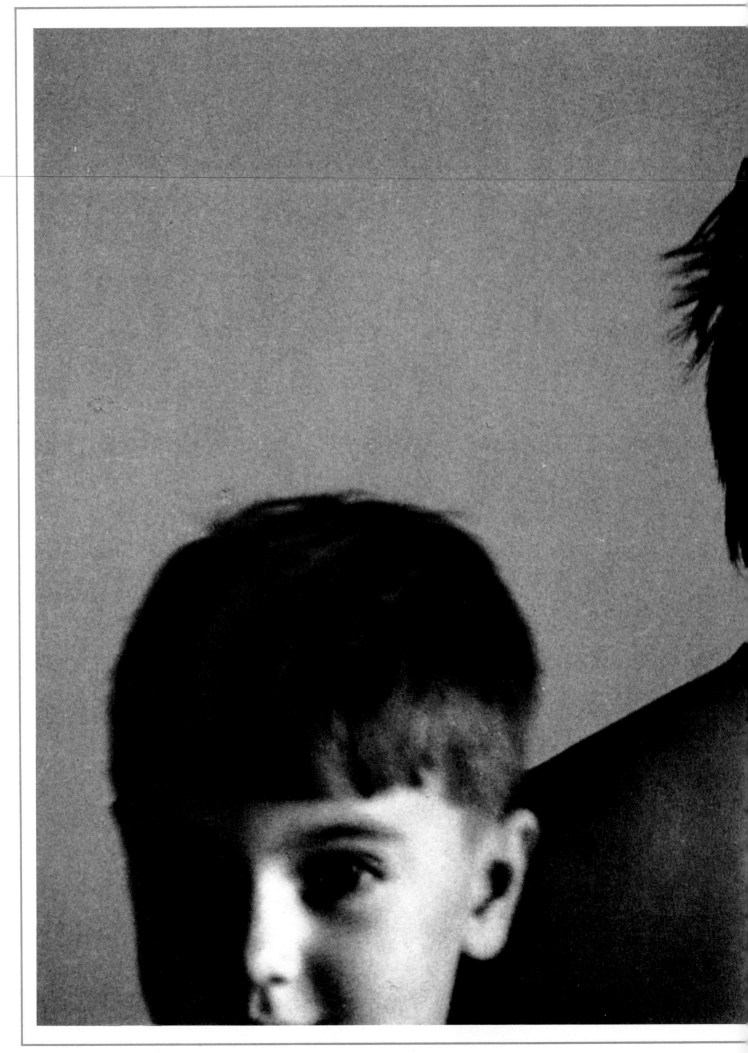

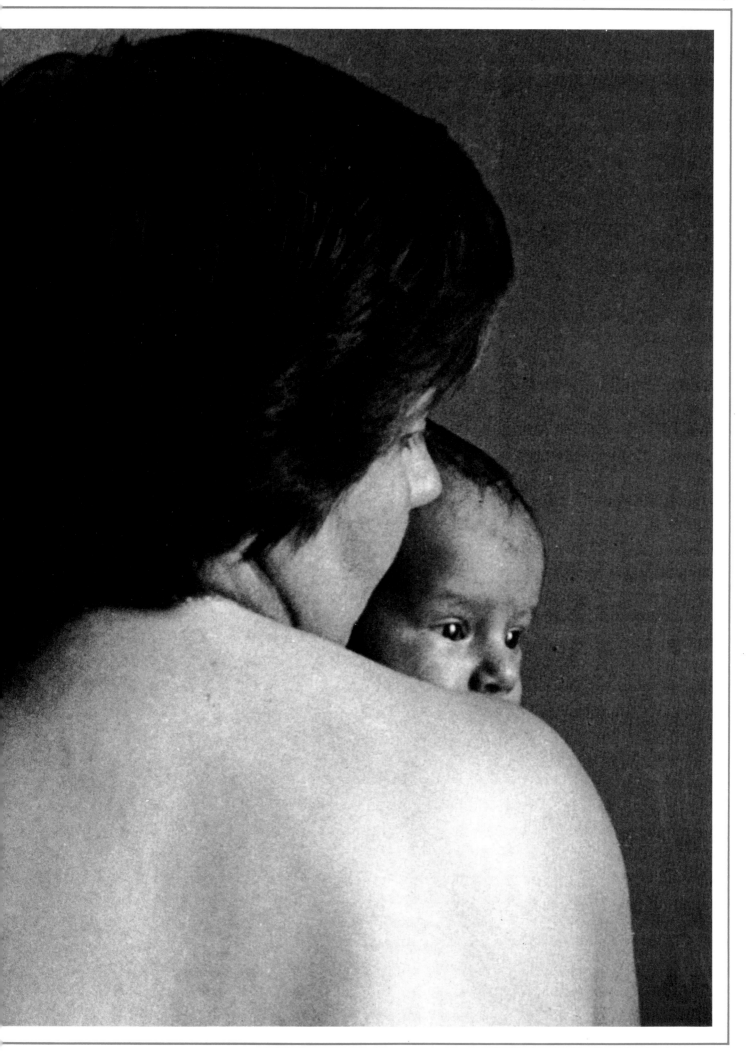

*Which the grown-up,
which the child?*

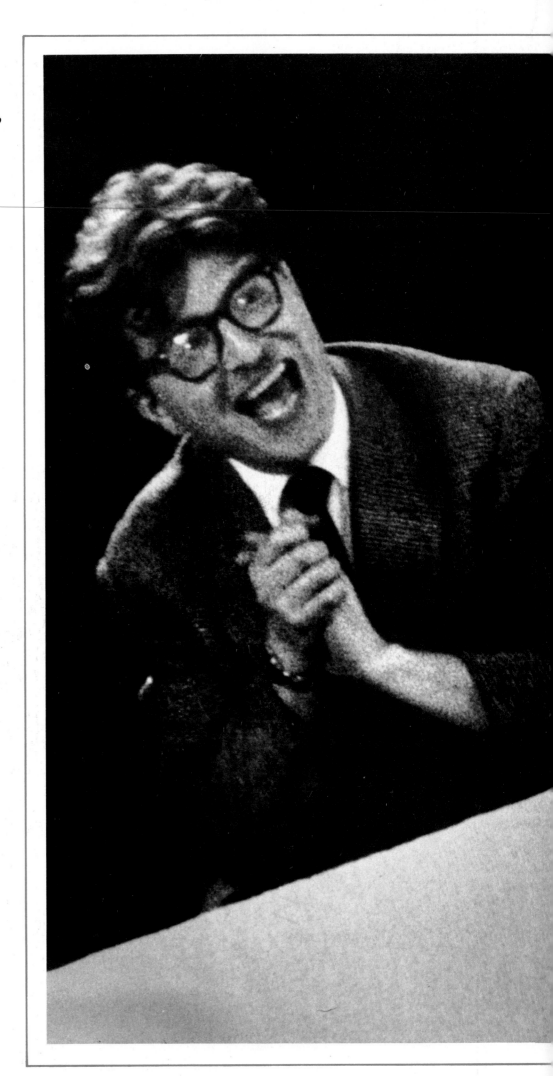

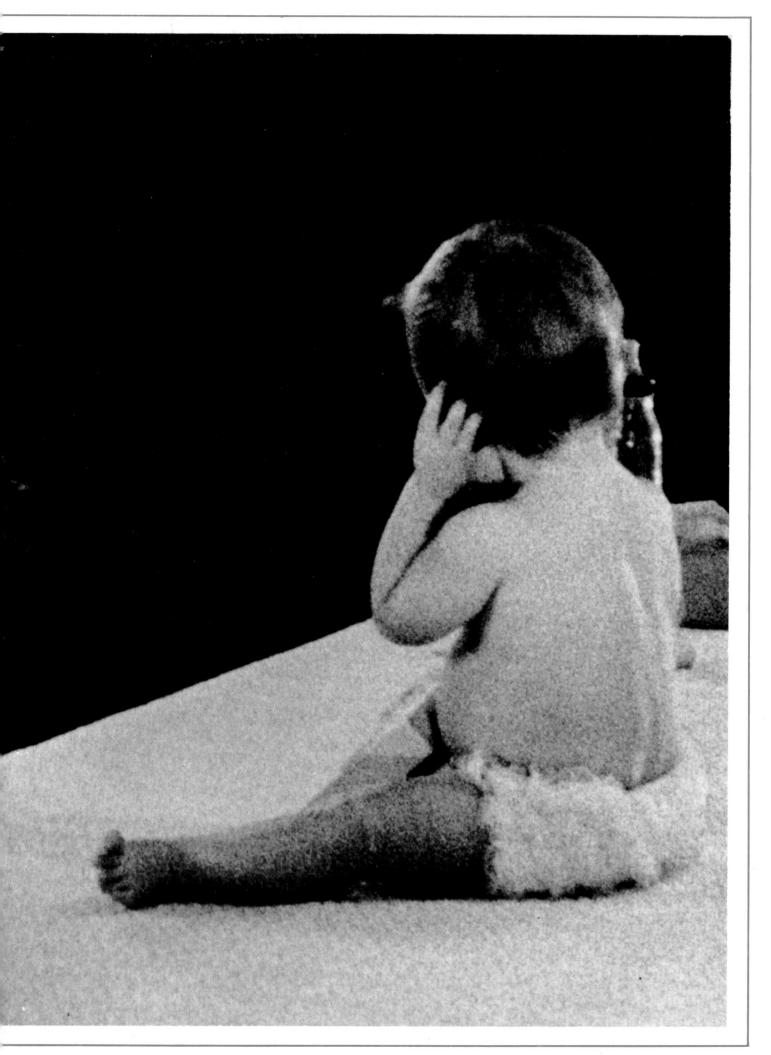

*Posing for a diaper commercial 10-month-old Robin Portello makes
professional smile-cajoler Josef Schneider work for his money.*

17

Bearing the pain for her baby

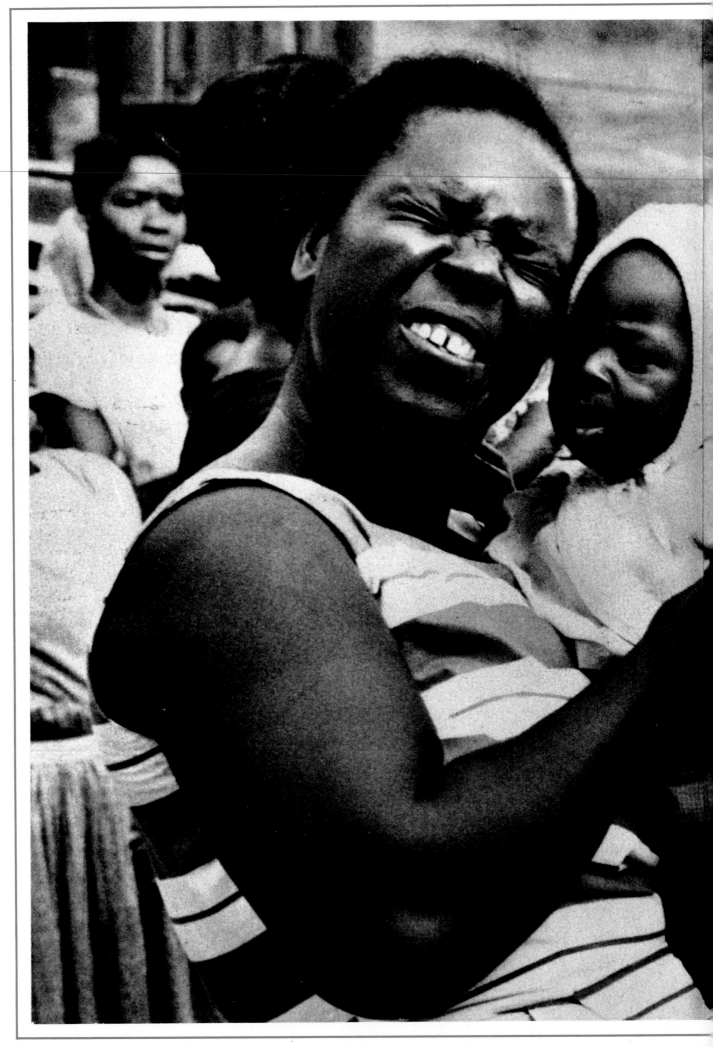

In the wake of Hurricane Flora in 1963, a mother winces in empathy as her child gets inoculated against typhoid on the island of Tobago.

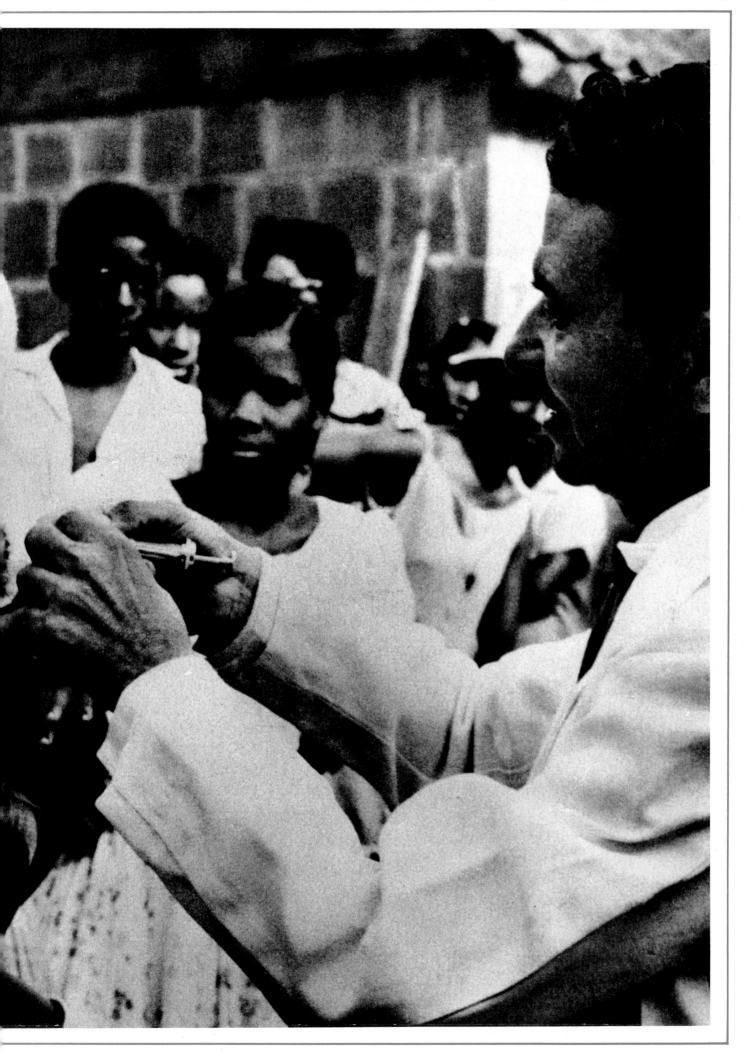

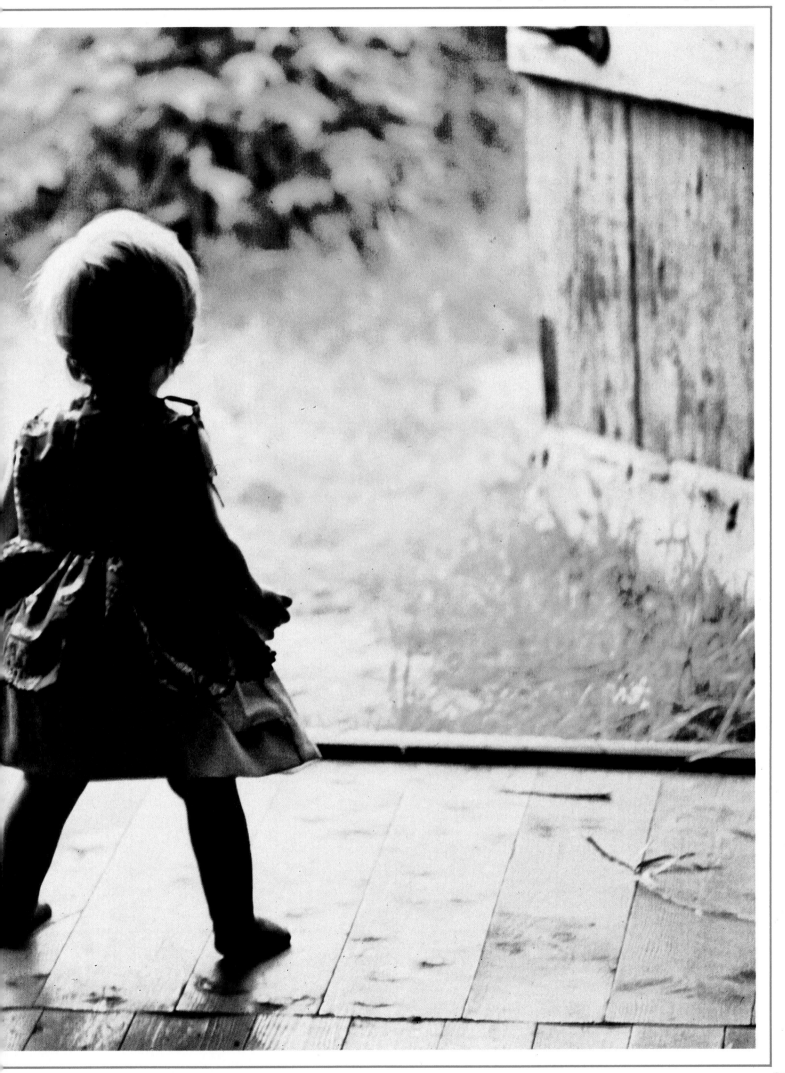

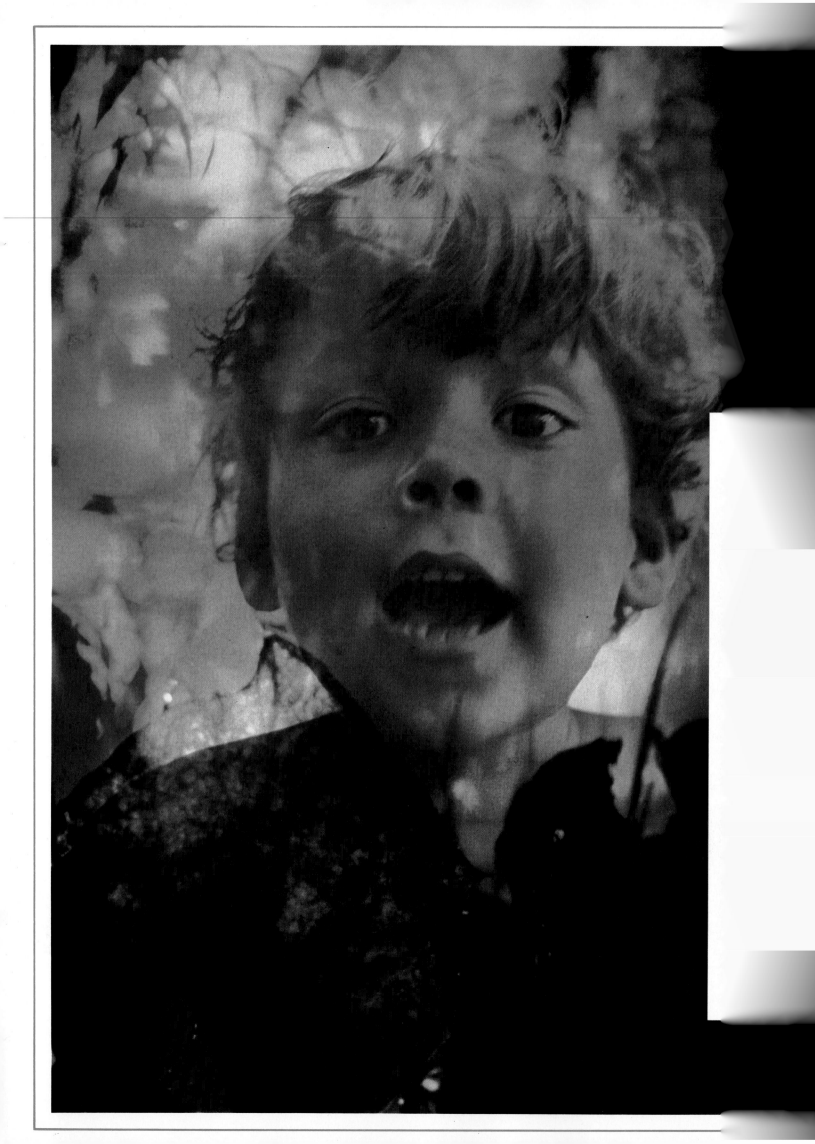

A Child's World

*For a moment we can enter the child's secret world of feeling,
know its wonder,
and try to understand
the pain and pleasure of our own lost, longed-for childhood.*

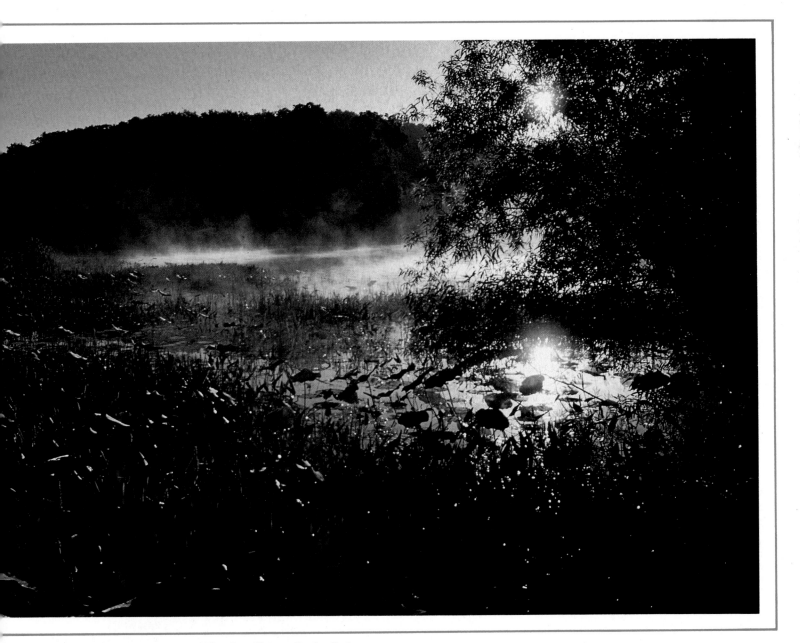

*"There's me. Shining in the water-sun! There's me!" wrote Gordon Parks
in a poem to his grandson Alain, to accompany this picture.
In his photographic essay on an enchanting, watery world,
Alfred Eisenstaedt tried to show a pond from a child's viewpoint.*

The ancient rite of cooling off in summertime

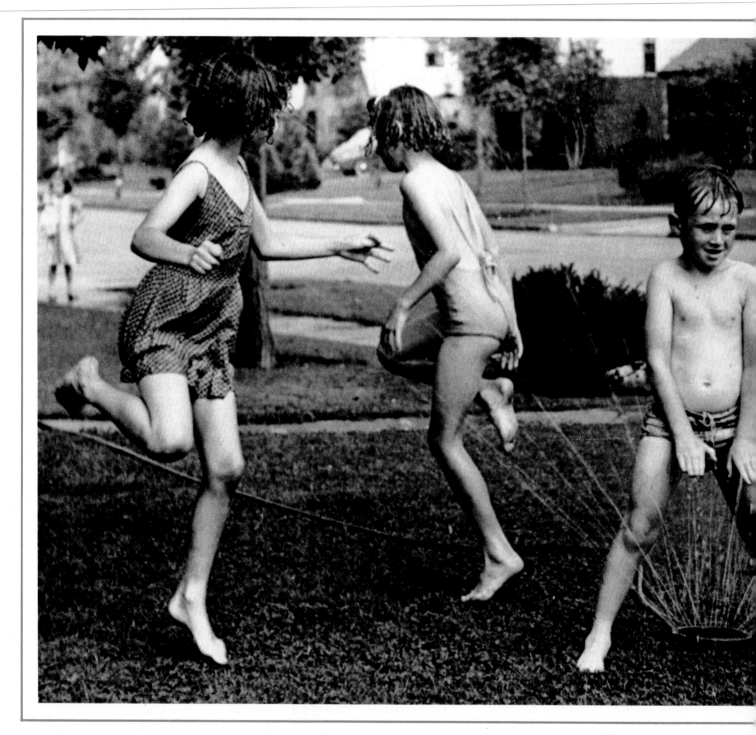

Taking a sprinkle back in 1942 and dealing with a water sheet in the '60s.

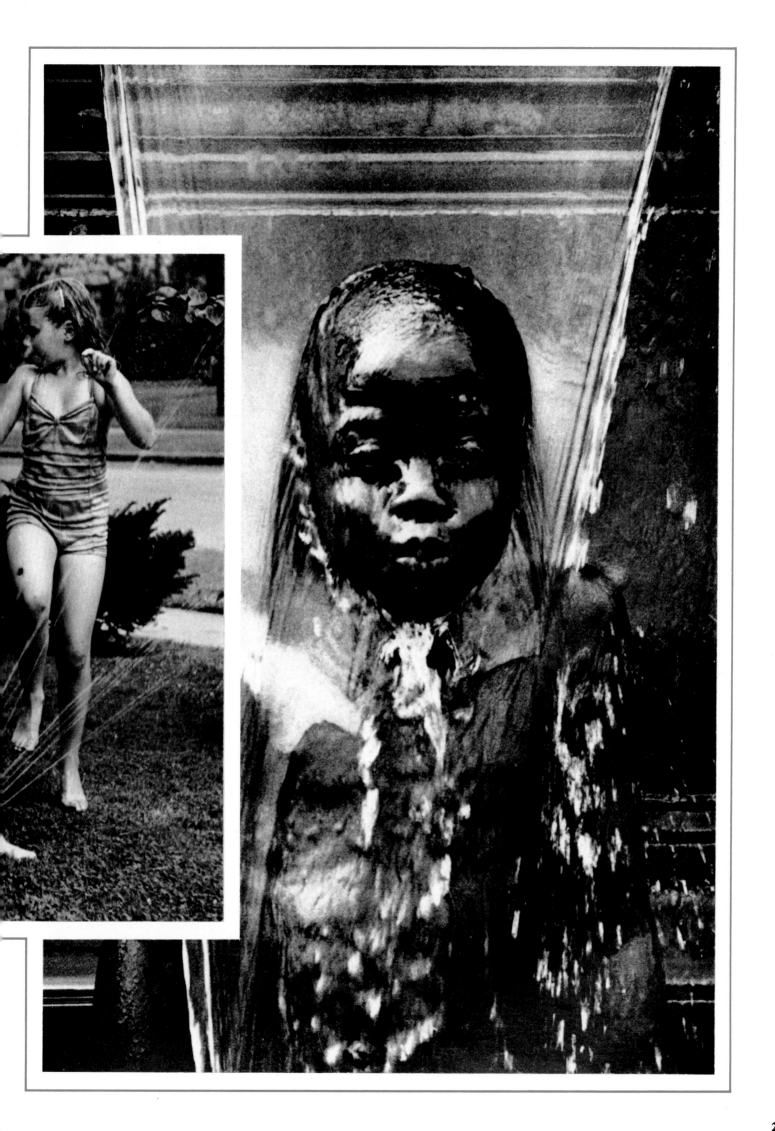

Everywhere lurks wonder in a child's garden of surprises

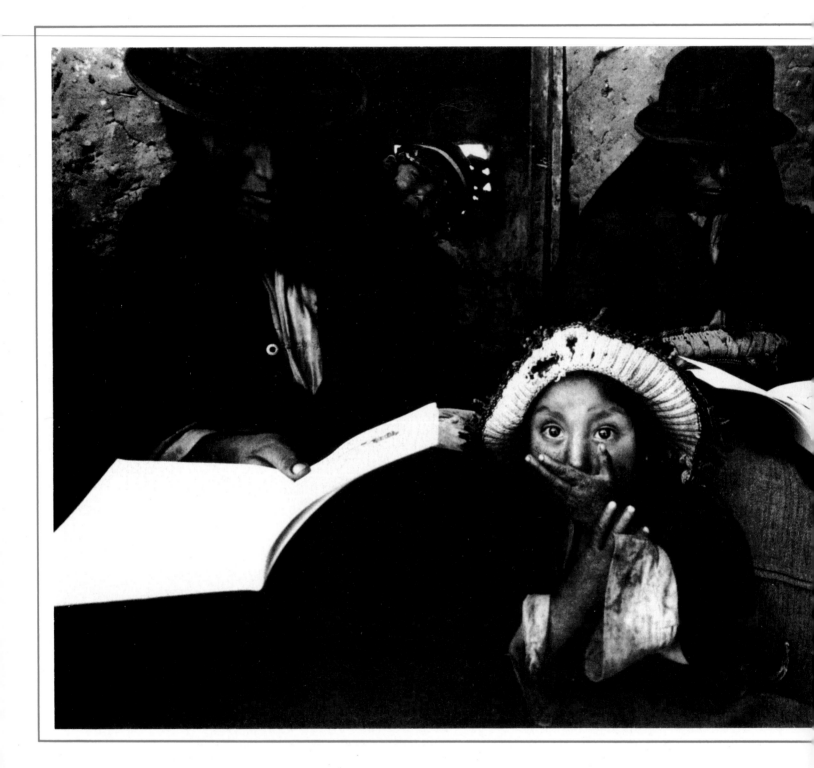

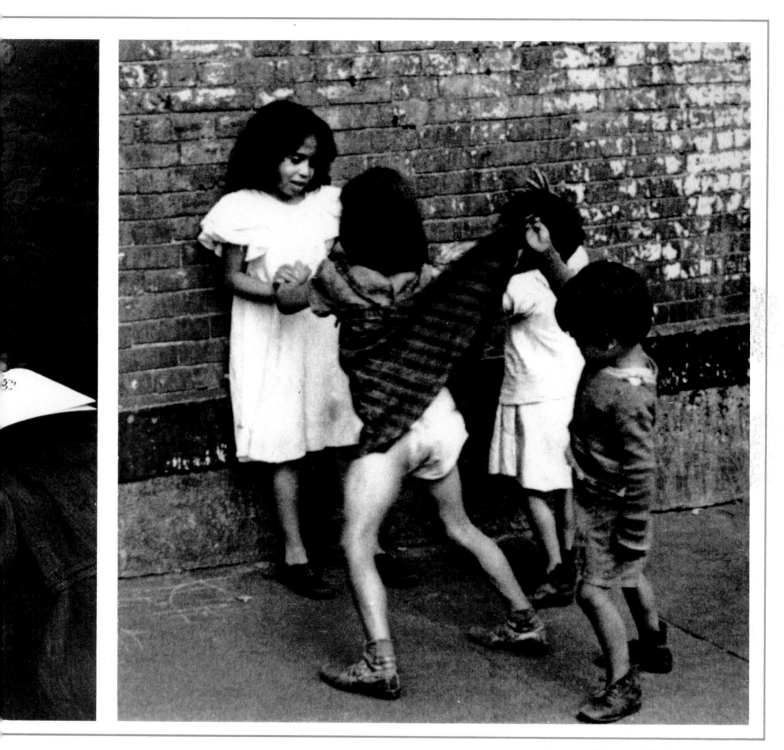

A surprised Peruvian girl and an investigator.

Faces made to fit the moment

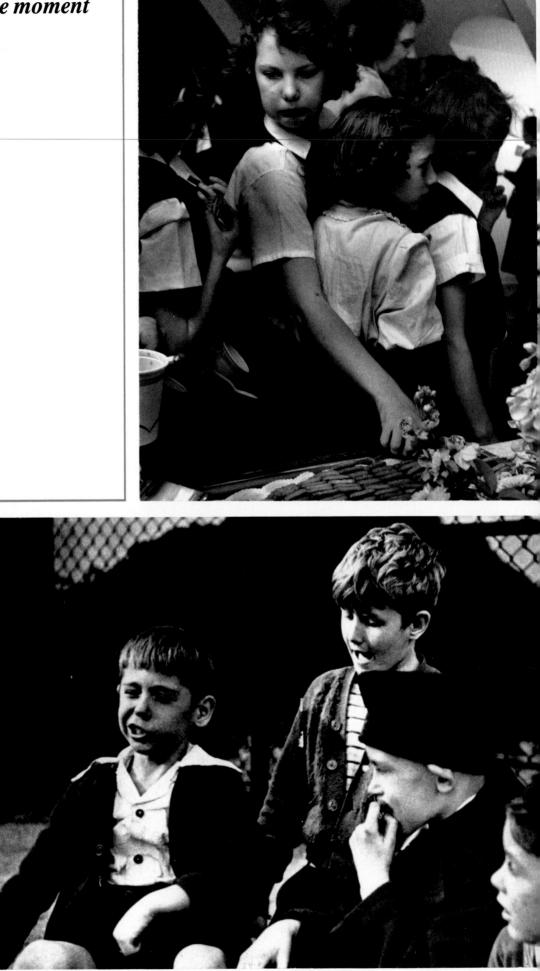

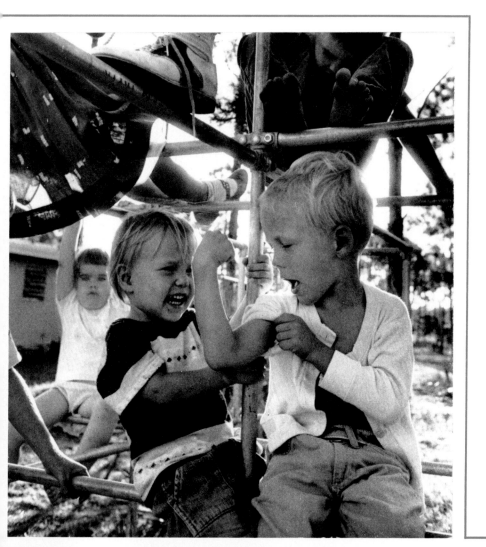

Her mouth already full, a girl guiltily sneaks a second cookie. ● A boy shows his muscle to his kid sister using his strong-man look. ● A quartet of glowering boys act out what a gnome looks like when he's angry. ● With animation Jimmy Hendon tells the plot of a movie to his friends.

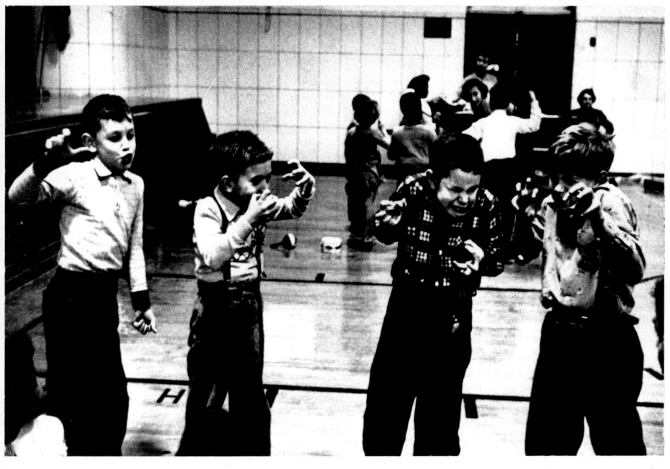

Fast travel in the small-fry kingdom

In Australia's outback, five-year-old Jim Mahood is in hot pursuit of an imaginary creature he calls Otskeek. ● In Massachusetts a Gloucester filly easily clears a daisy jump.

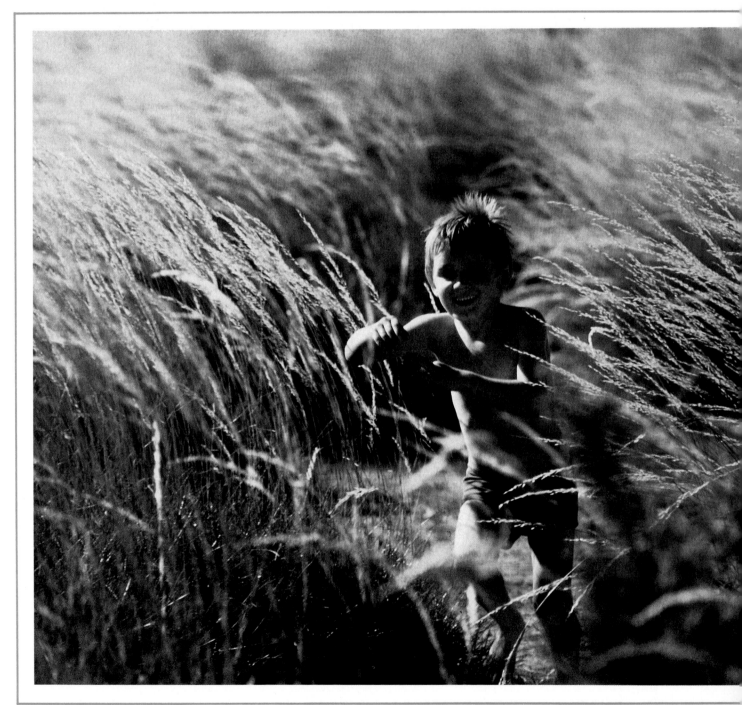

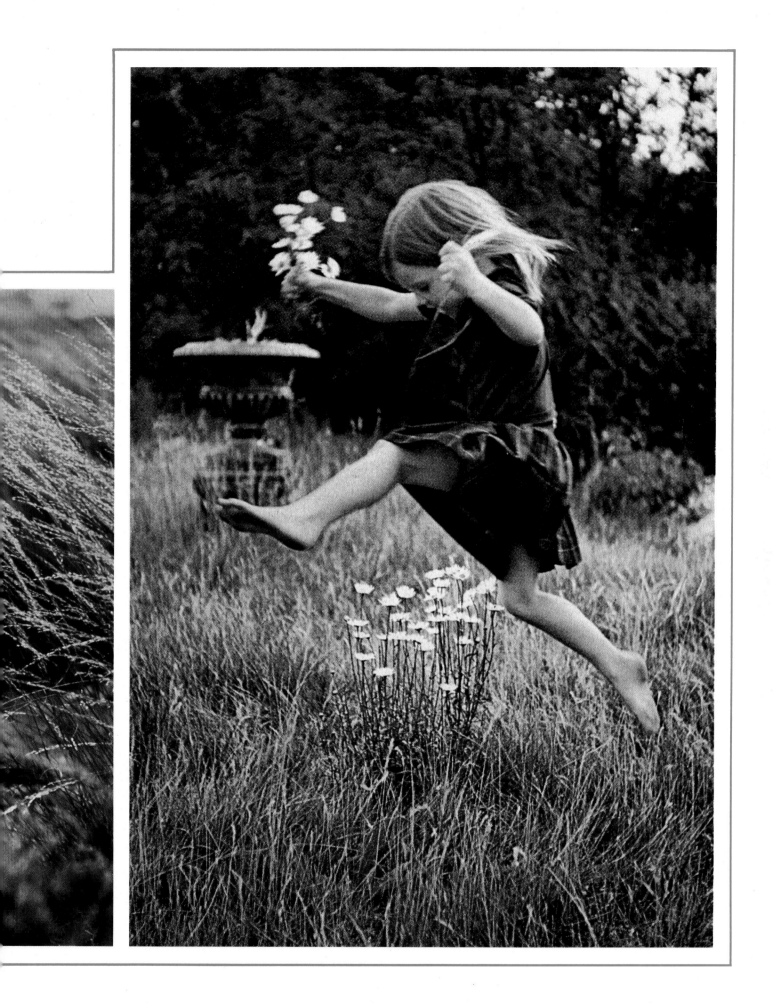

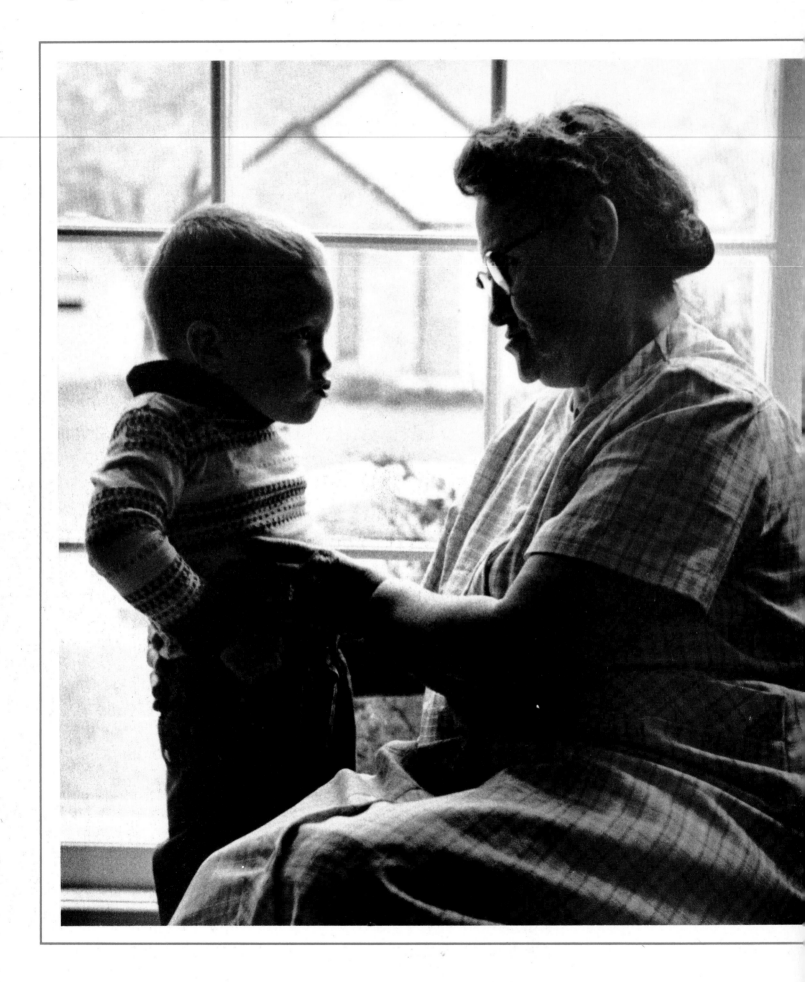

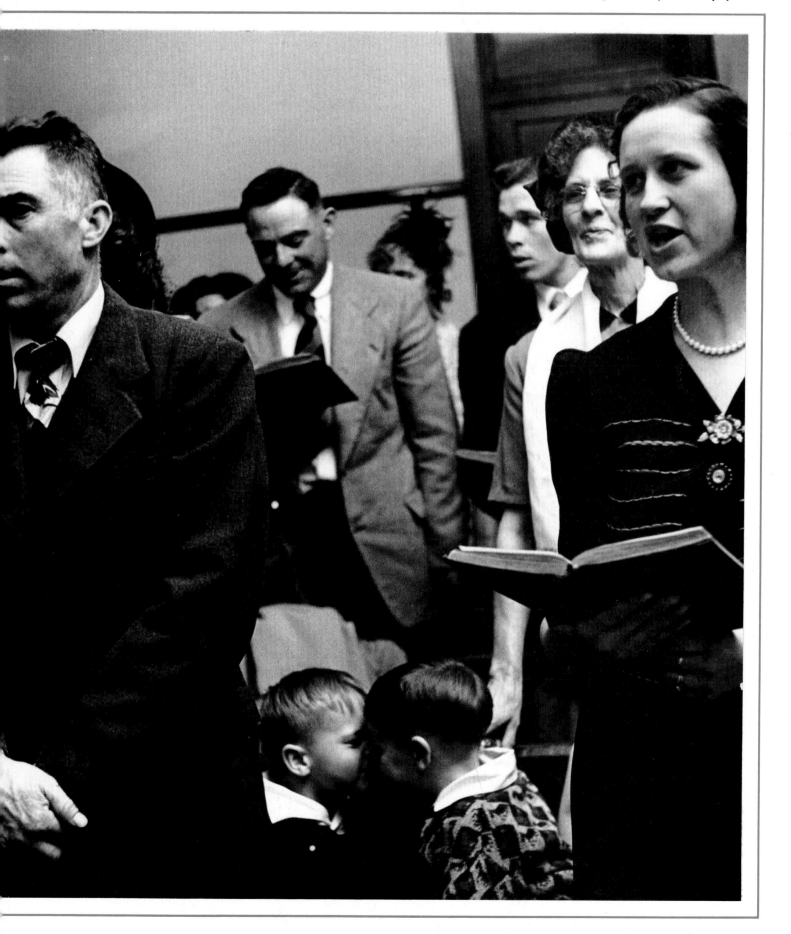

Chan Gibson, 3½, mimics his sitter in a showdown over permission to play outdoors. ● *During a Missouri Baptist church service, Jimmy and Tommy Rosenthal play nuzzle.*

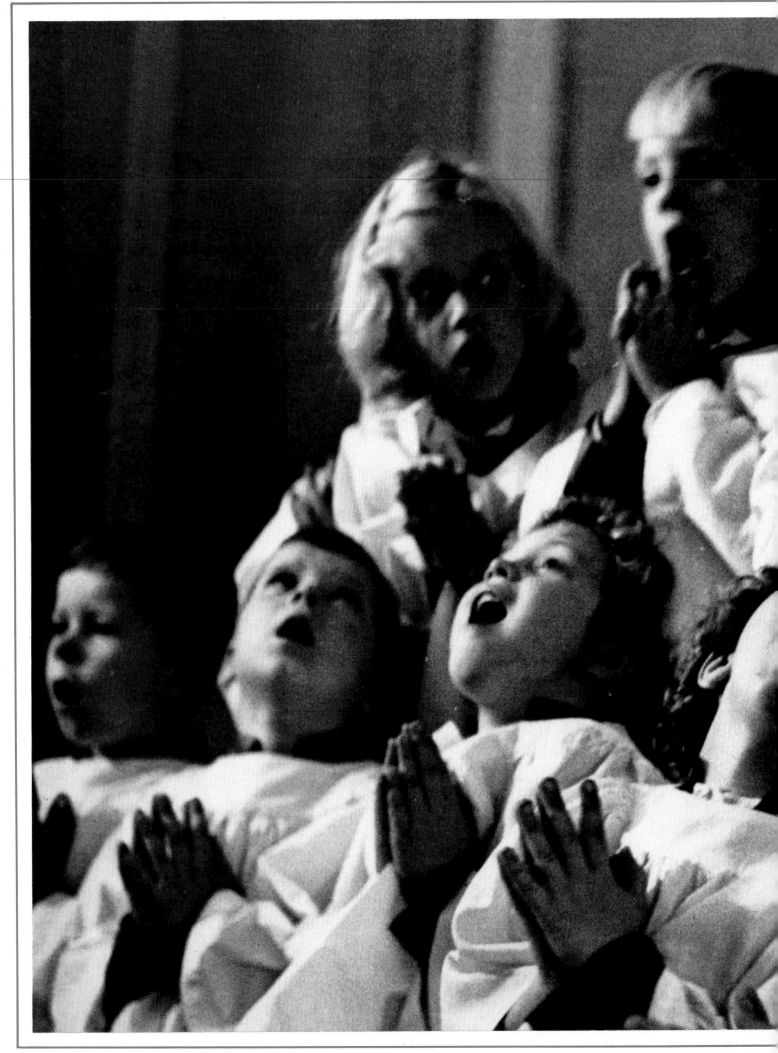

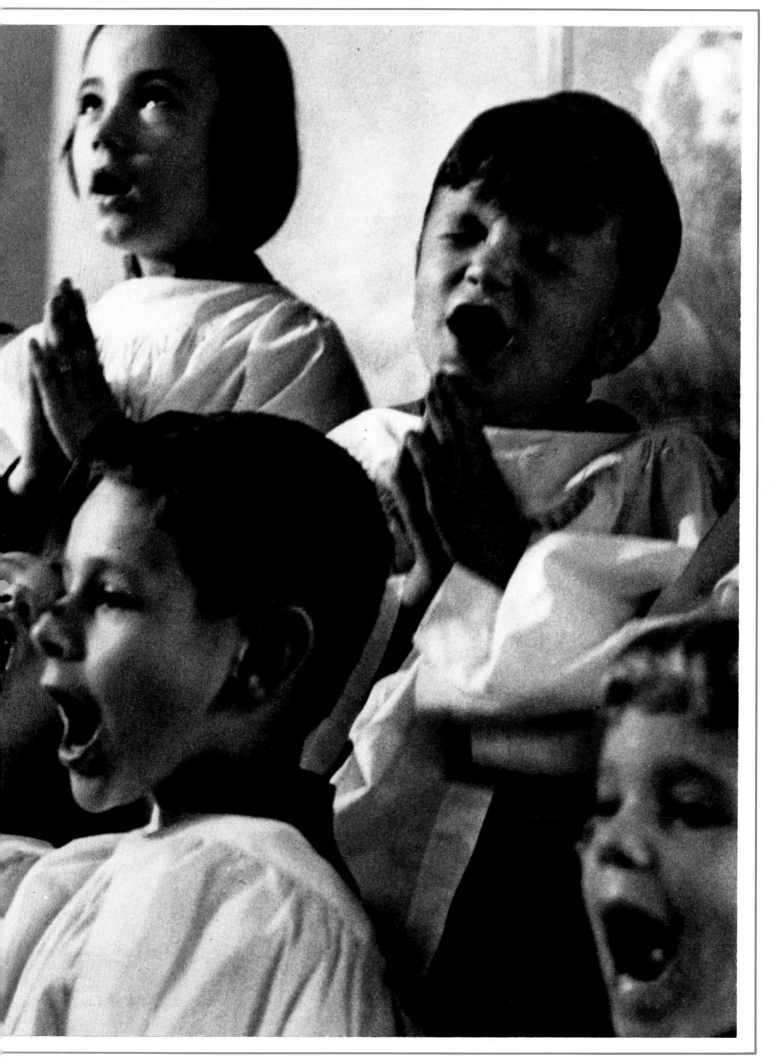

At St. Mark's Methodist Church in Brooklyn, New York, a choir of two- to five-year-olds is lost in song. The choir director insists that the singers' hands be locked in an attitude of prayer to hold pinching and poking to a minimum.

Showing no respect for their elders—or their elders' vices

After a short experiment, six-year-old Billy Connor is disenchanted. ● *Across the Atlantic, British politician Aneurin Bevan speaks bravely on, while five-year-old Eddie Mooney does some wicked mimicry.*

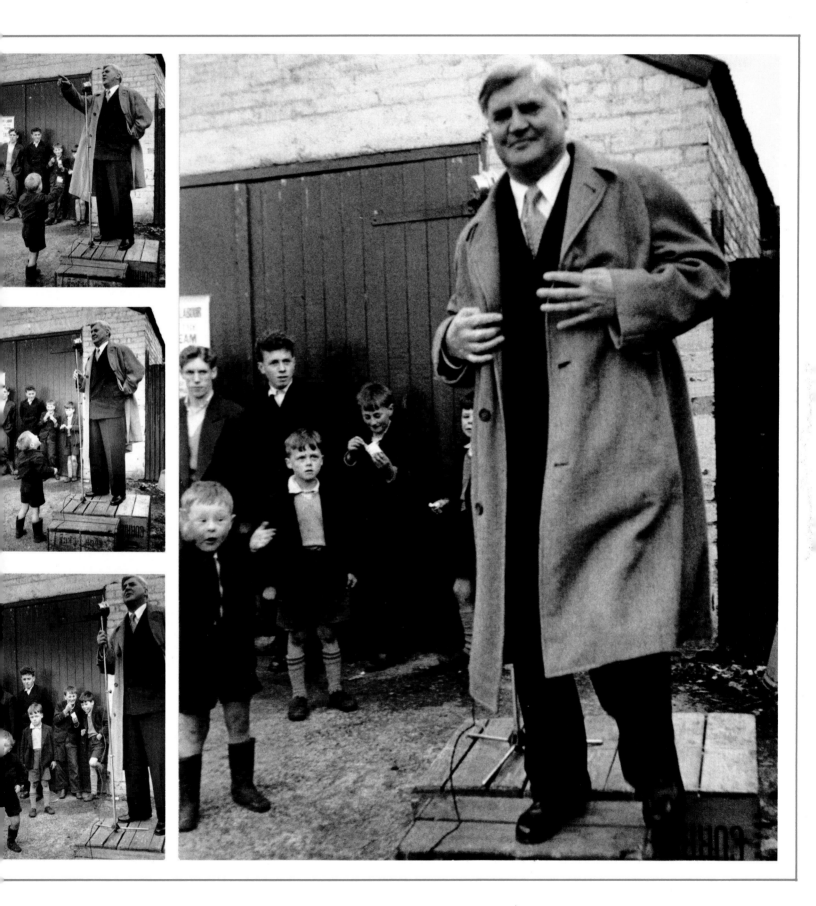

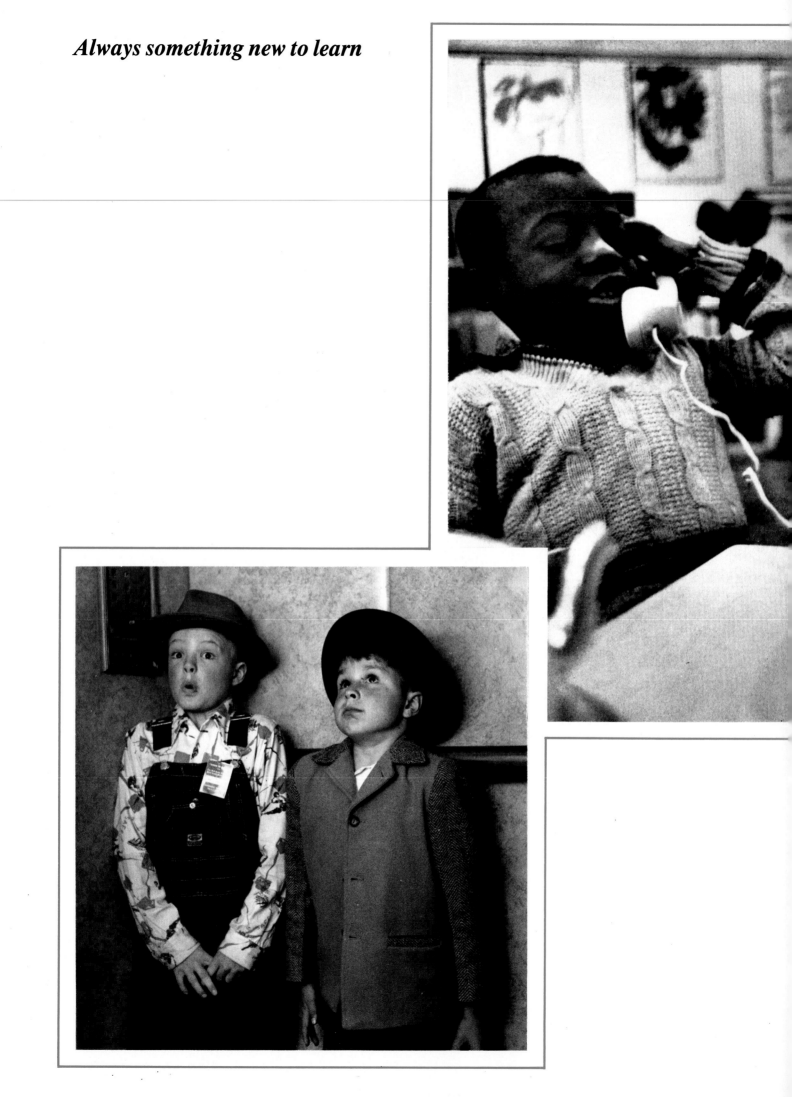

Always something new to learn

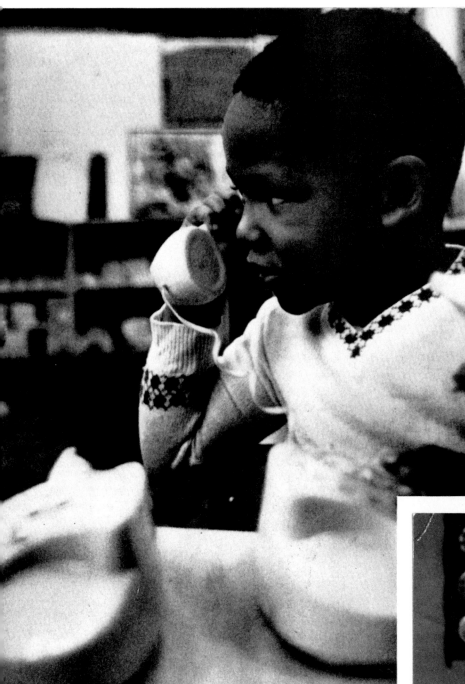

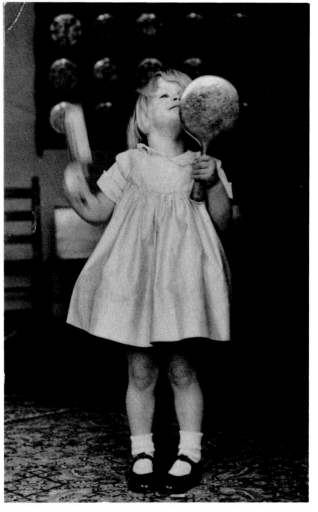

Utah country boys Kemp Savage and his cousin Bruce absorb the giddy feelings of their first elevator ride. ● By making use of classroom phones, Vincent Shuler and Darrell Turner are learning the magic in spoken sentences. ● Decked out in a party dress, she's discovering she's pretty.

Children's games that echo grown-up scenes almost too precisely

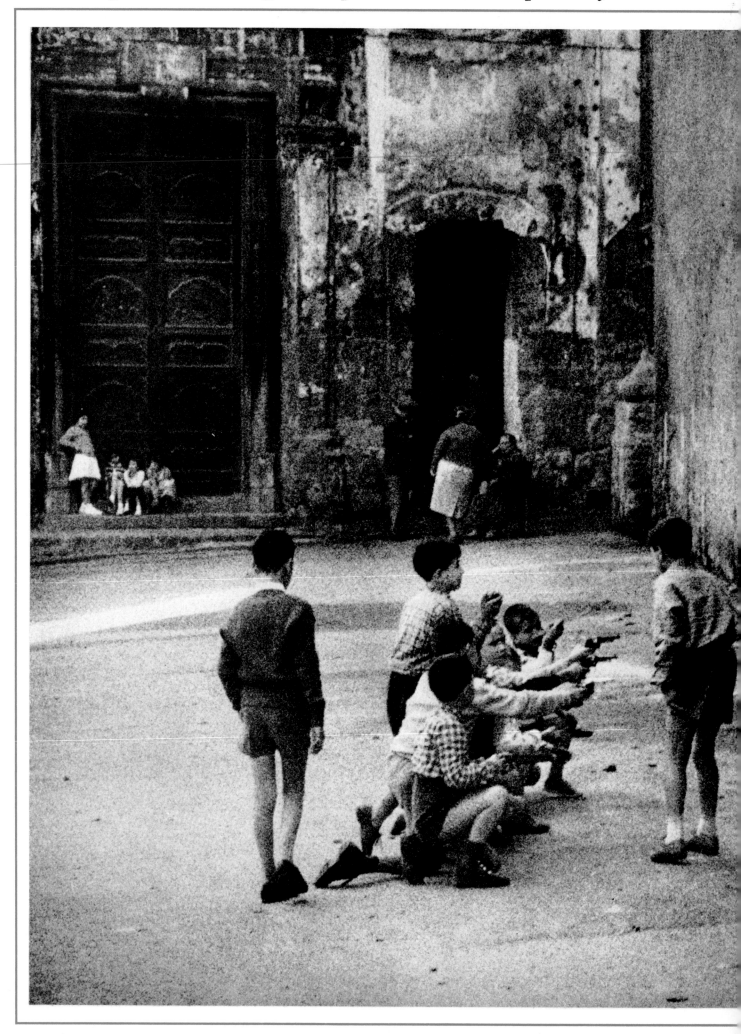

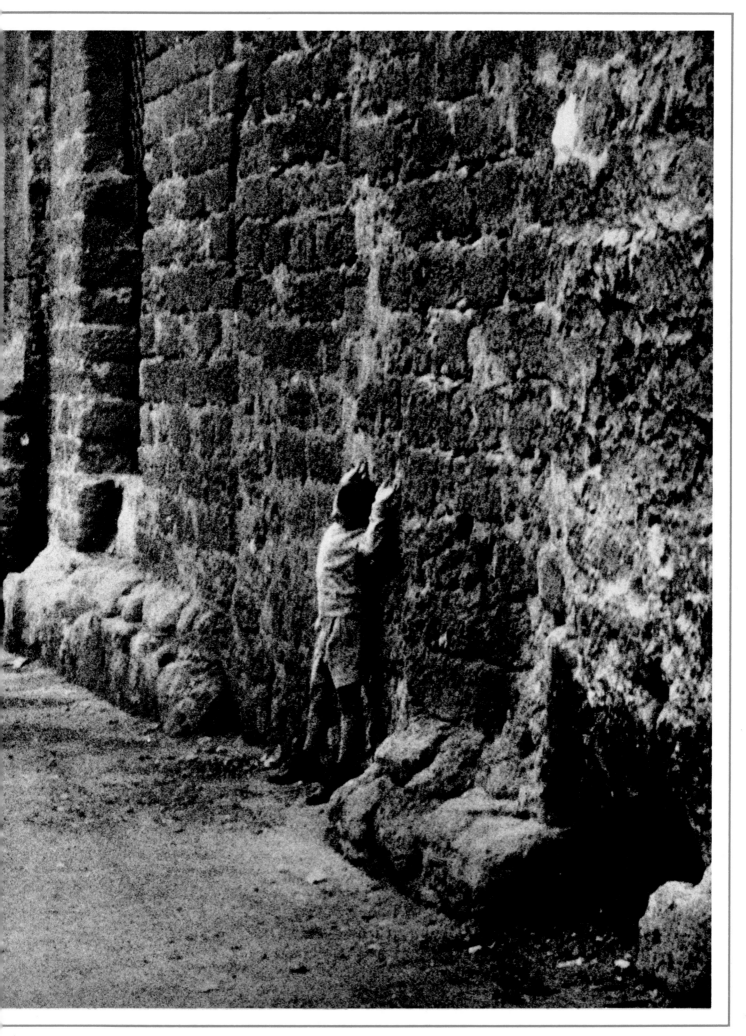

Kids in Sicily try out their new toy pistols in a spontaneous firing squad.

Fear and pain bloom early and stay with us forever

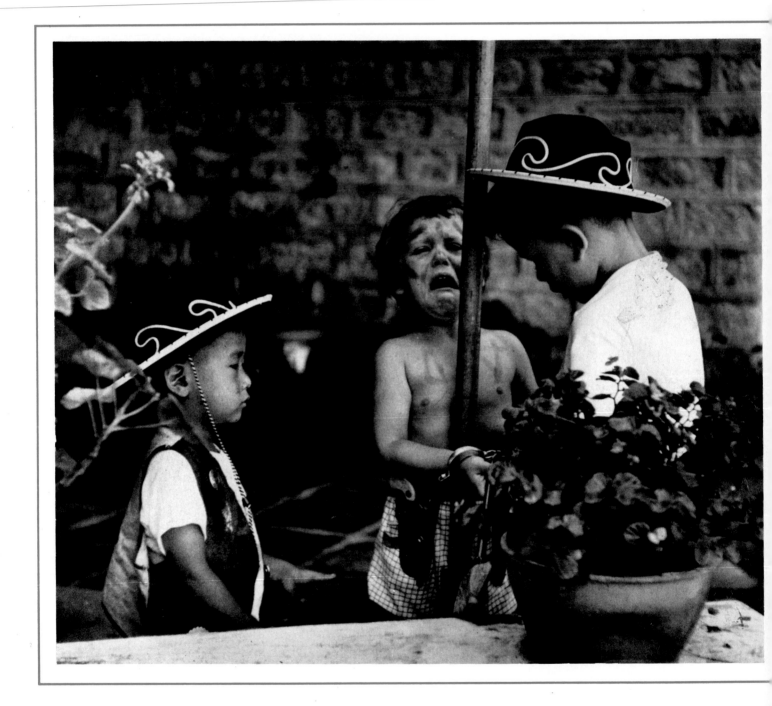

Four-year-old Dori Dominis protests at being handcuffed to a pole.
● Clutching at the sting of a punch, a little girl heads off in pain.

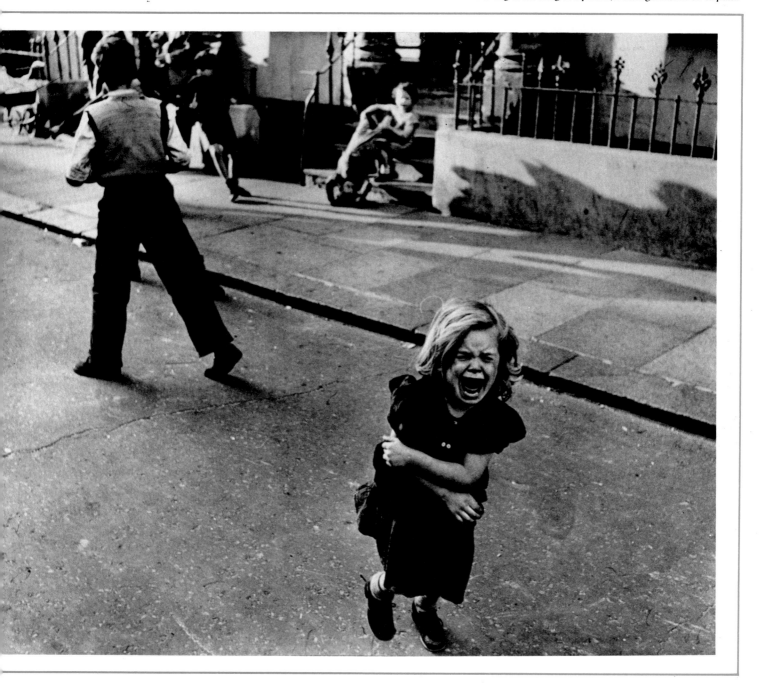

First day at school—a smiling heaven or a screaming hell

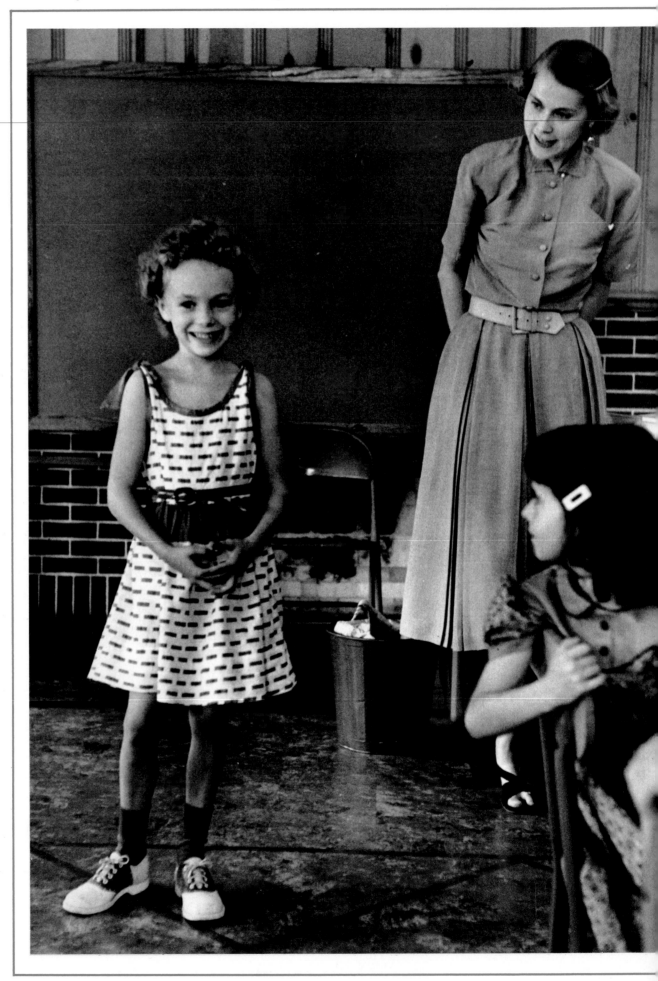

At Mt. Vernon, Illinois, Marsha Brush starts off her first day of first grade with a report on her pony-riding summer. ● As school opens in Detroit, first-grade teacher Mary Anne Wickersham restrains a new pupil who is being deserted by his mother and little brother.

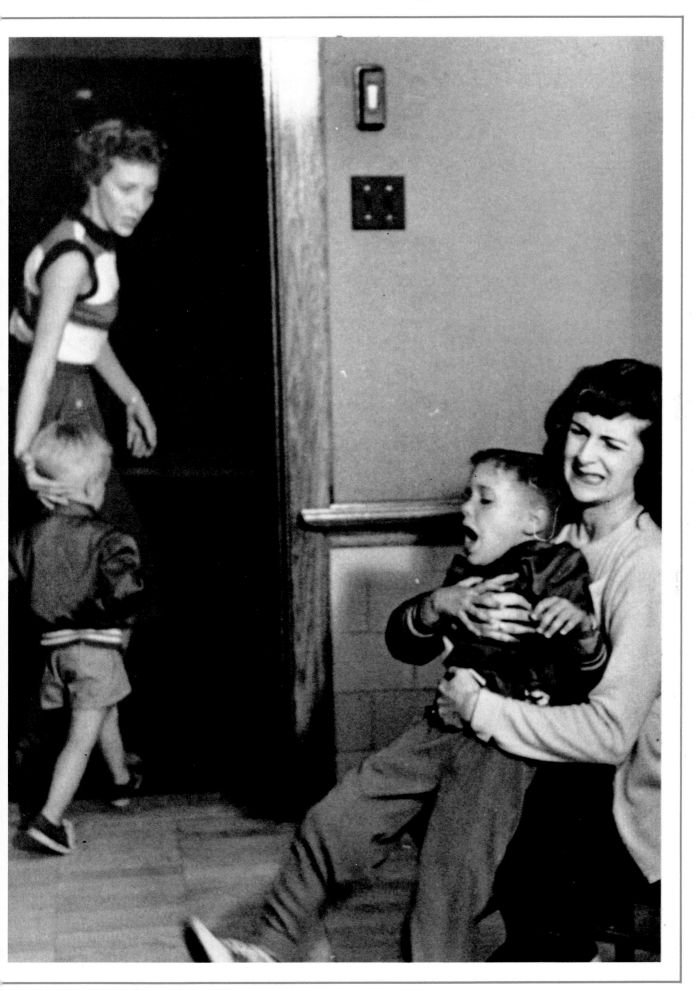

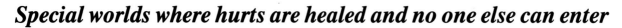

Special worlds where hurts are healed and no one else can enter

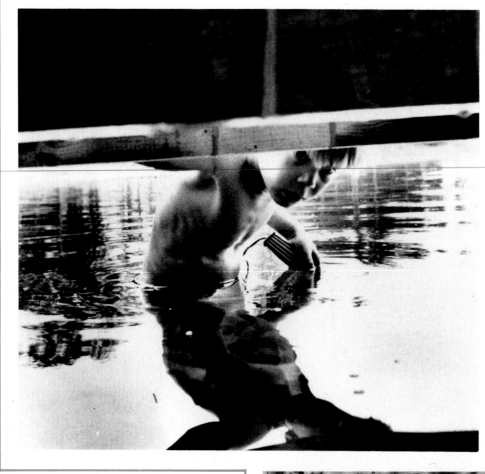

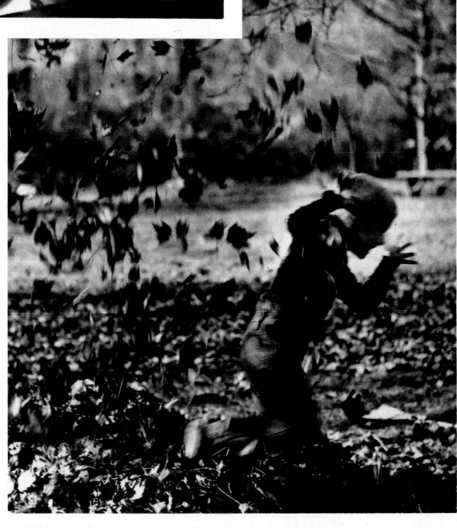

Five-year-old Sandy Smith searches for magic fish beneath a dock. ● Stewart Blickman revels in a kingdom of leaves. ● In a New York forest, Princess Sandra runs her royal dogs.

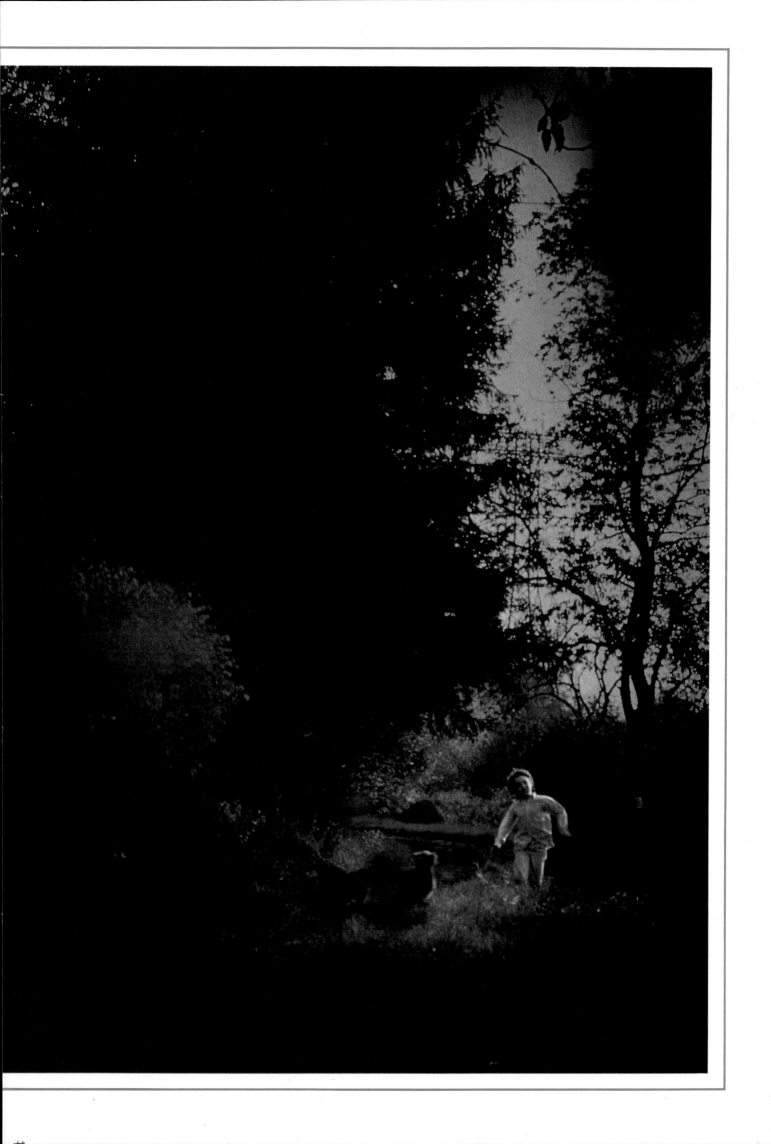

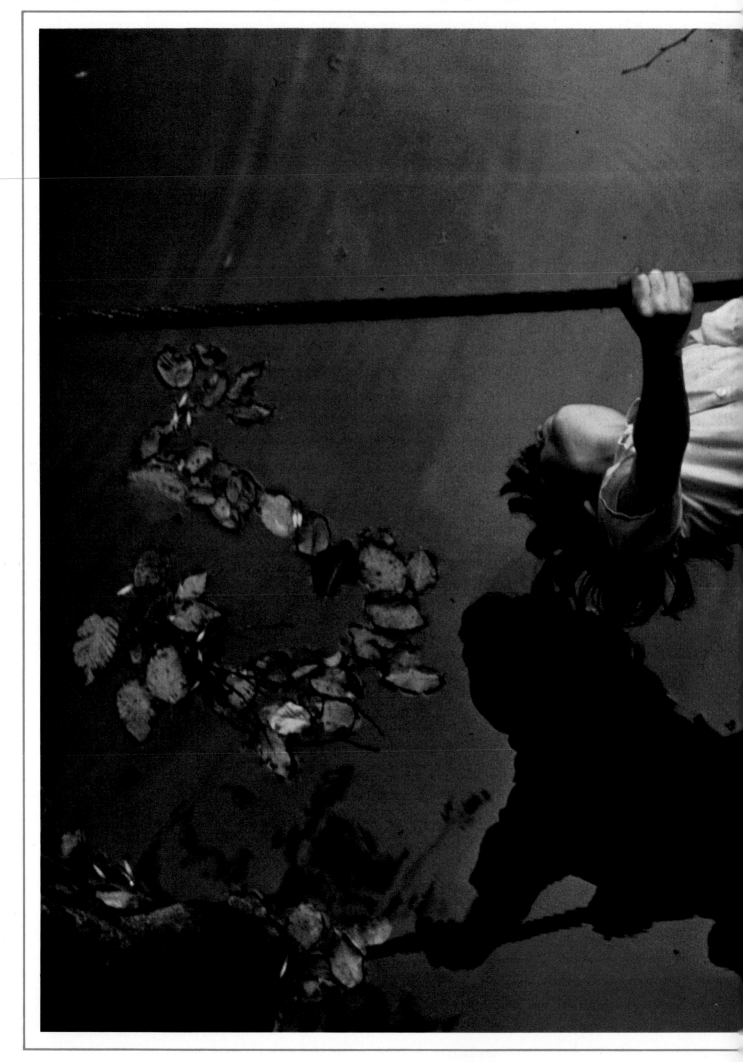

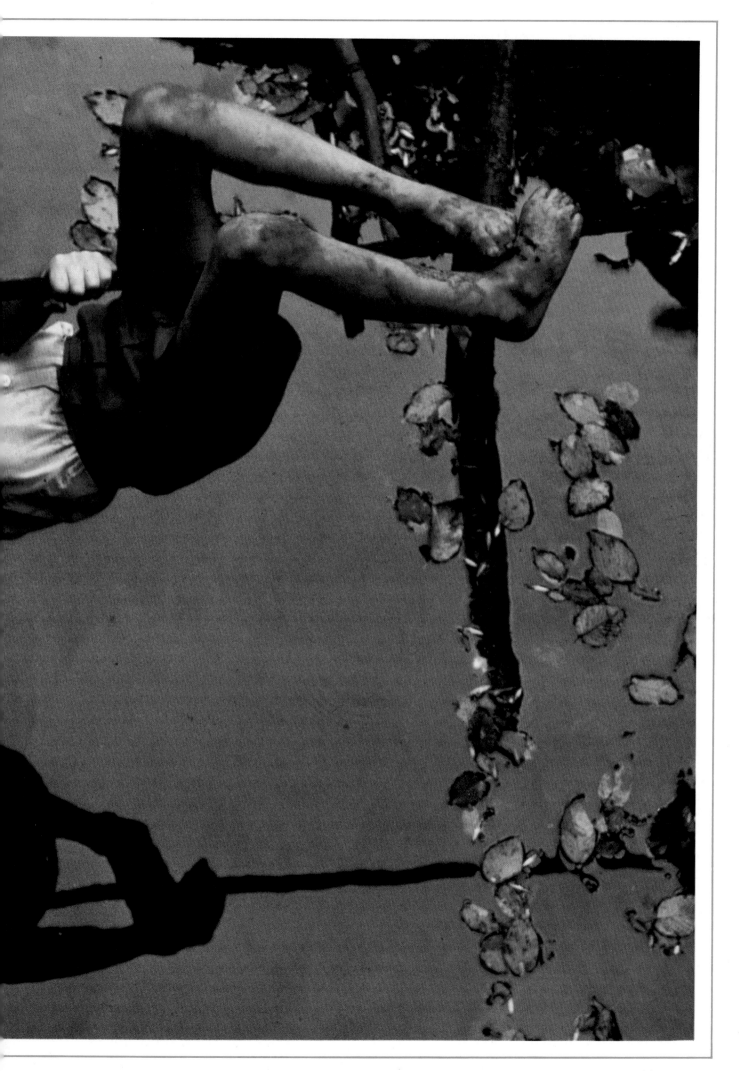

A boy on a rope.

Growing Up

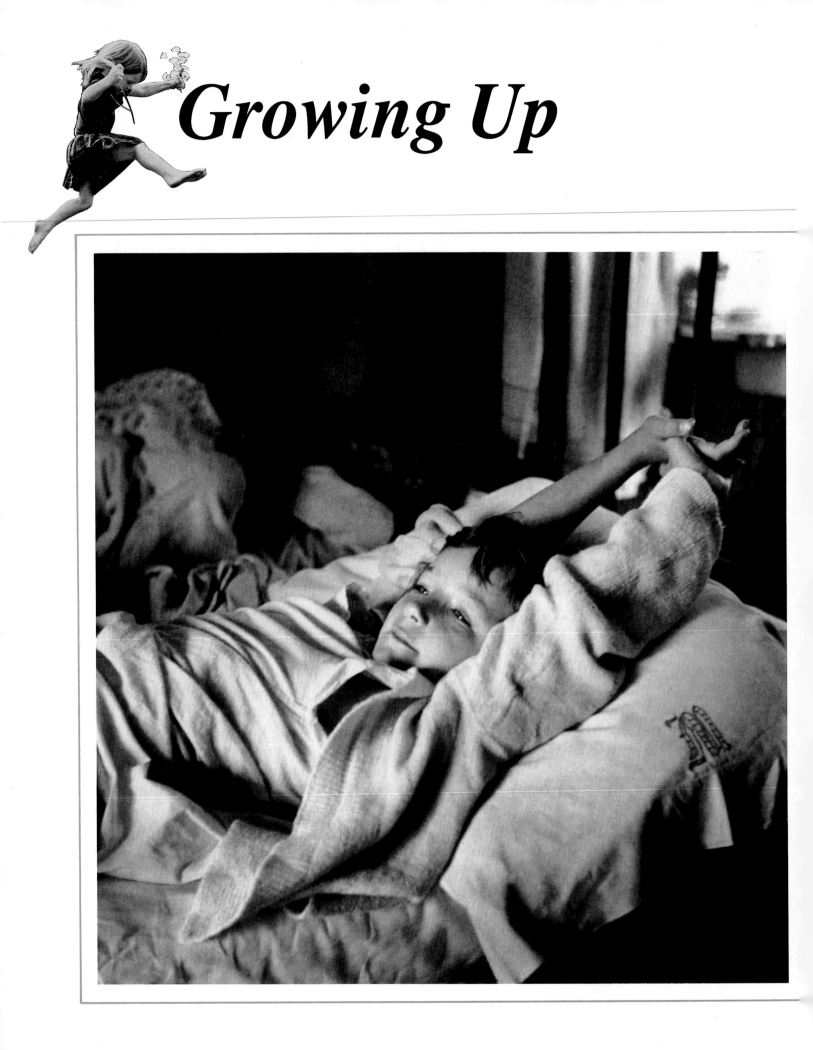

Those awakening years when the world is young, those brief and bittersweet days, so full of sorrows and delights, when the simplicity of childhood begins to vanish.

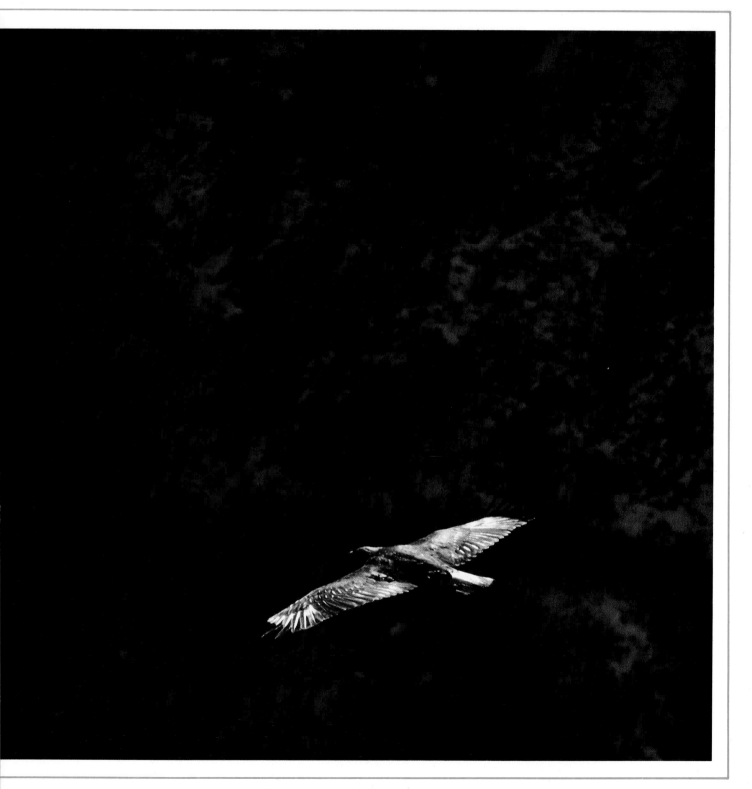

Jeanette Miller wakes to greet the world on the morning of her ninth birthday. ● Over an Idaho ravine a golden eagle stretches out its 7½-foot wingspan.

With legs afire, bodies that never seem to tire

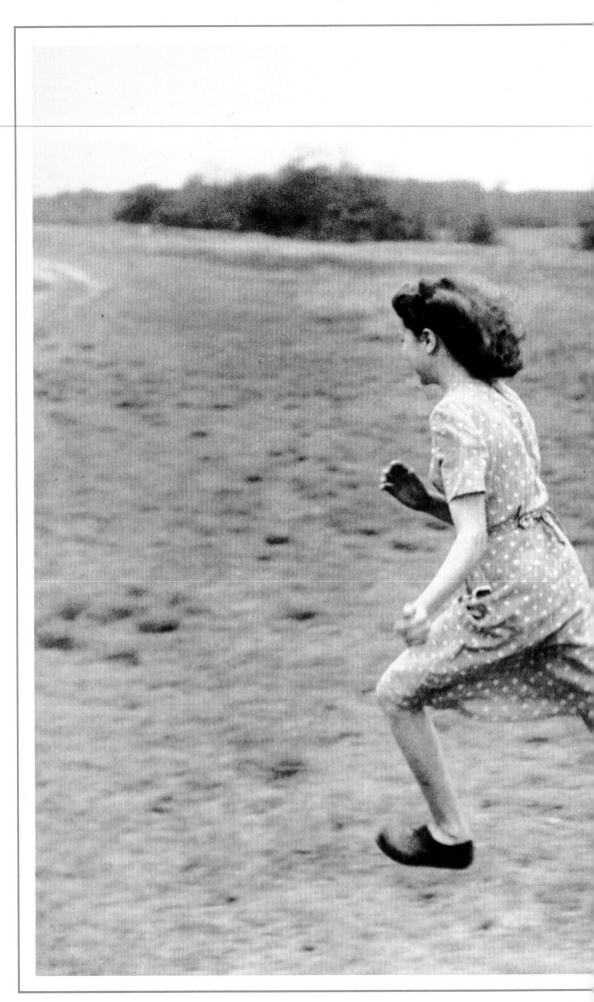

Just for the heck of it, a couple of teenagers race madly around the Louisiana bayou country where they live.

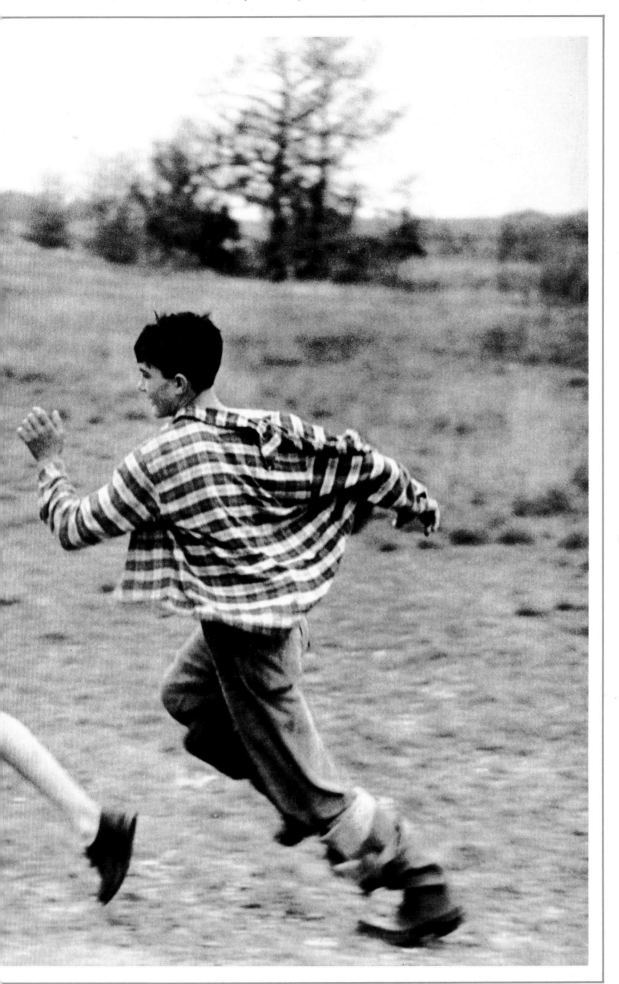

Their busy days are rich and varied and sometimes a bit nutty

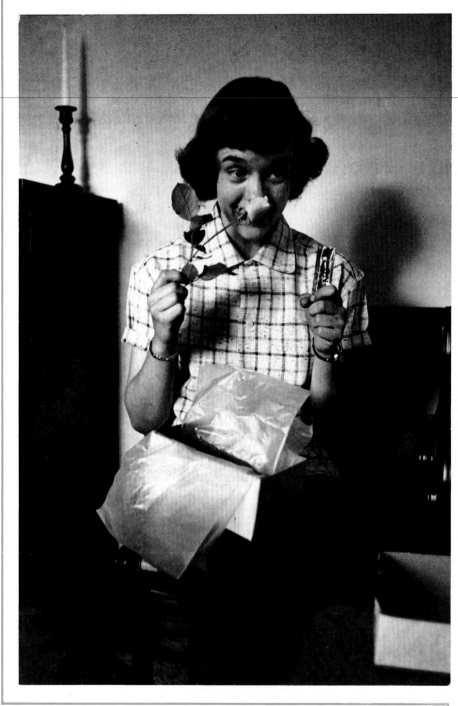

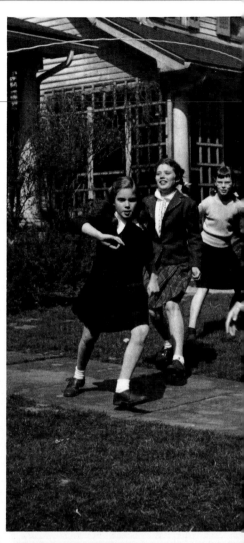

Hovering somewhere between childhood and womanhood, Barbara King holds two unexpected yet symbolic presents from her boyfriend—a rose and a candy bar. ● The pigtail set works off excess after-school energy doing the jump-rope favorite "Skim the Milk." ● For 13-year-old John Creech having a kid sister entails dancing practice, something he could do without. ● These Wellesley, Massachusetts, teenagers out for a stroll appear to be slightly screwy. ● Definitely no screws loose in Jonathan Katz who is filming Tom Sawyer in his backyard. Here he shows Gretchen Walther (who plays Becky Thatcher) what a loving gaze at Tom is supposed to look like.

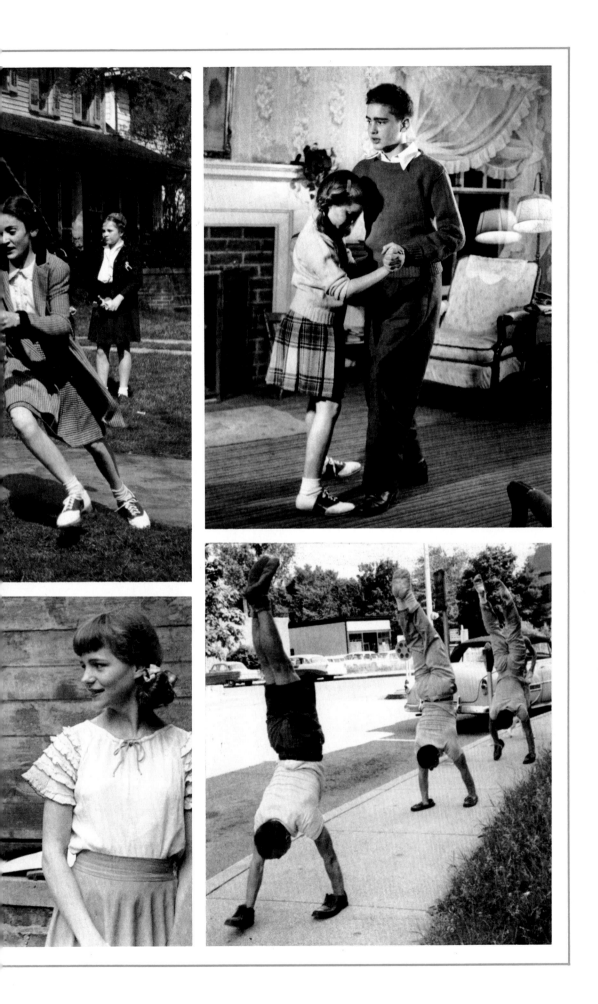

Special pleasures of the oversize family

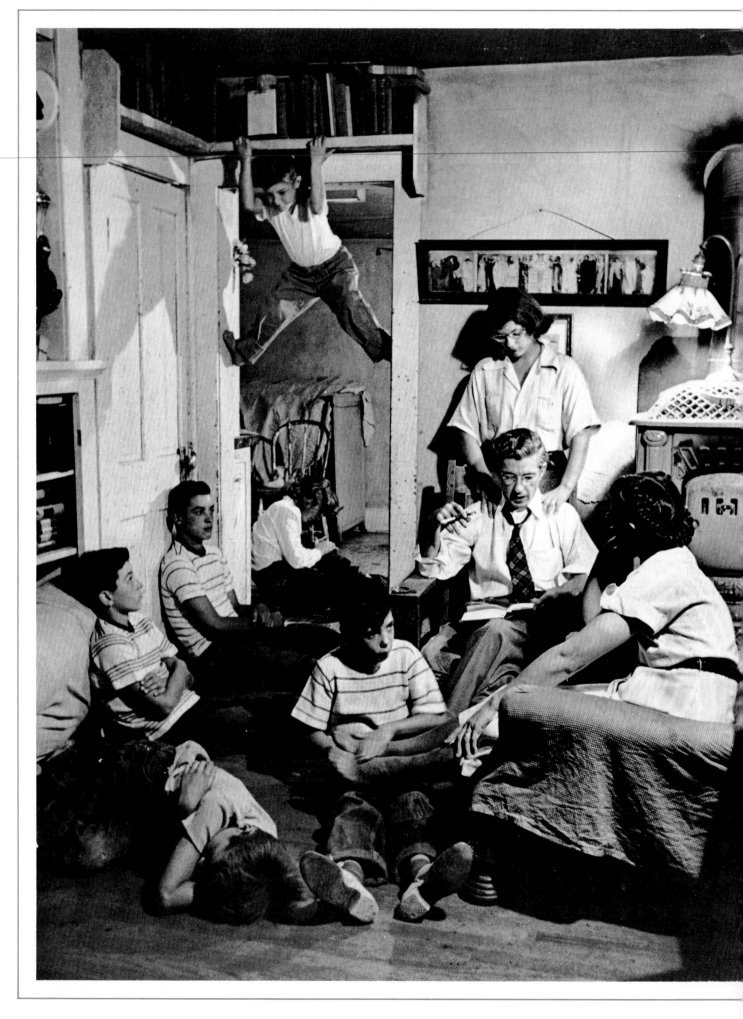

After-dinner ritual in the 1950 Colorado home of Bill and Avis Walsh always includes a reading session with Dad doing the honors and many of the 12 Walsh children in attendance. Mom sometimes gets a foot massage. • Another large '50s family belongs to Joe and Carol Powers of Port Washington, New York. Here some of their 12 children help make light work of the family station wagon's weekly scrubdown.

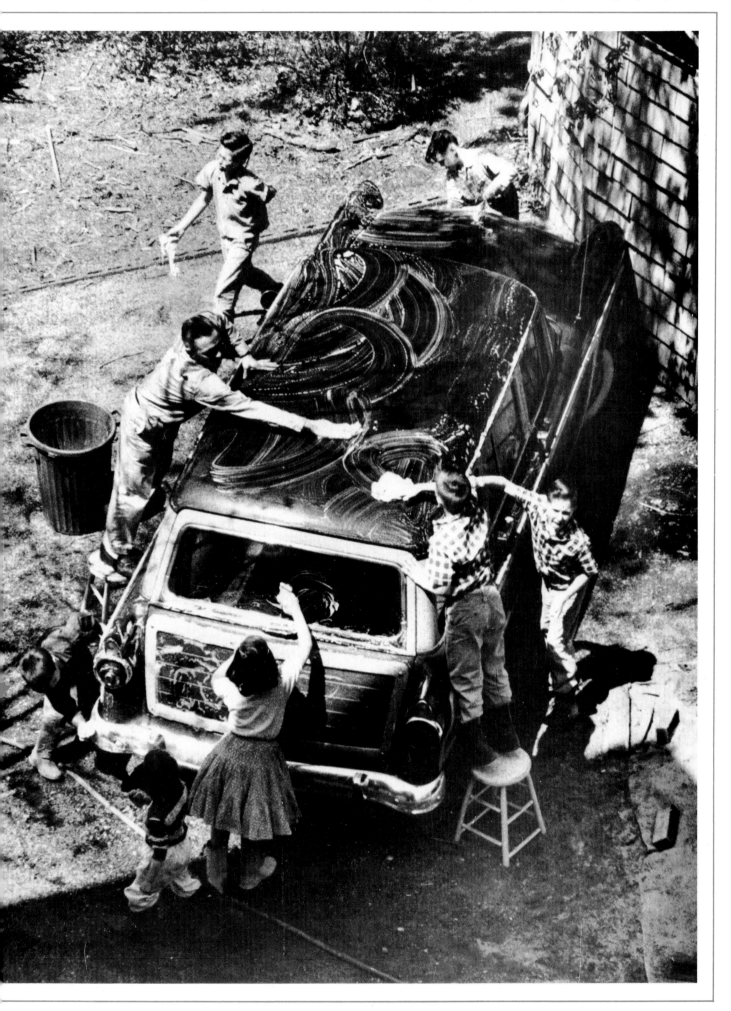

Homework, marks and pleasing the parents

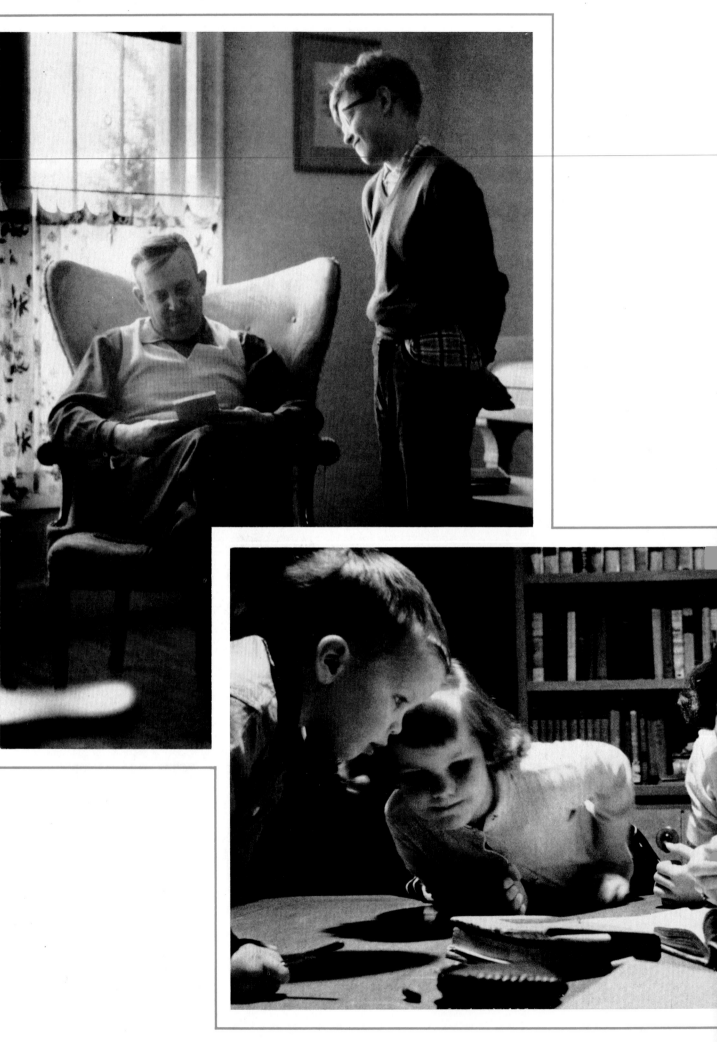

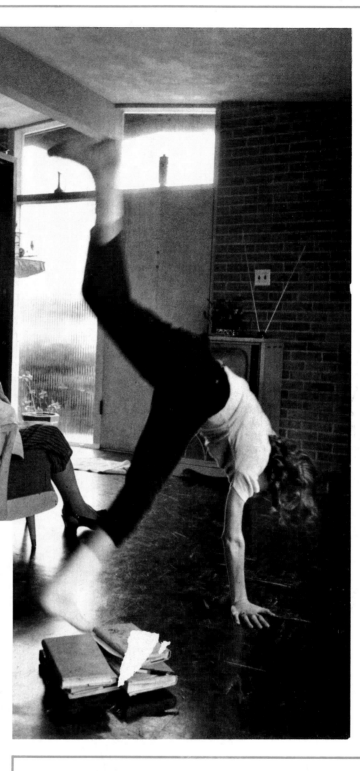

Awaiting approval of a new book Barry grins nervously down at his father. ● *Eleven-year-old Suzie Riesenmy of St. Louis labors over her homework with a transistor radio at one ear and the bedlam of her younger siblings at the other.* ● *For once, Suzie's homework is done before dinner, an event celebrated with a triumphant cartwheel in front of her baby-sitting grandmother.*

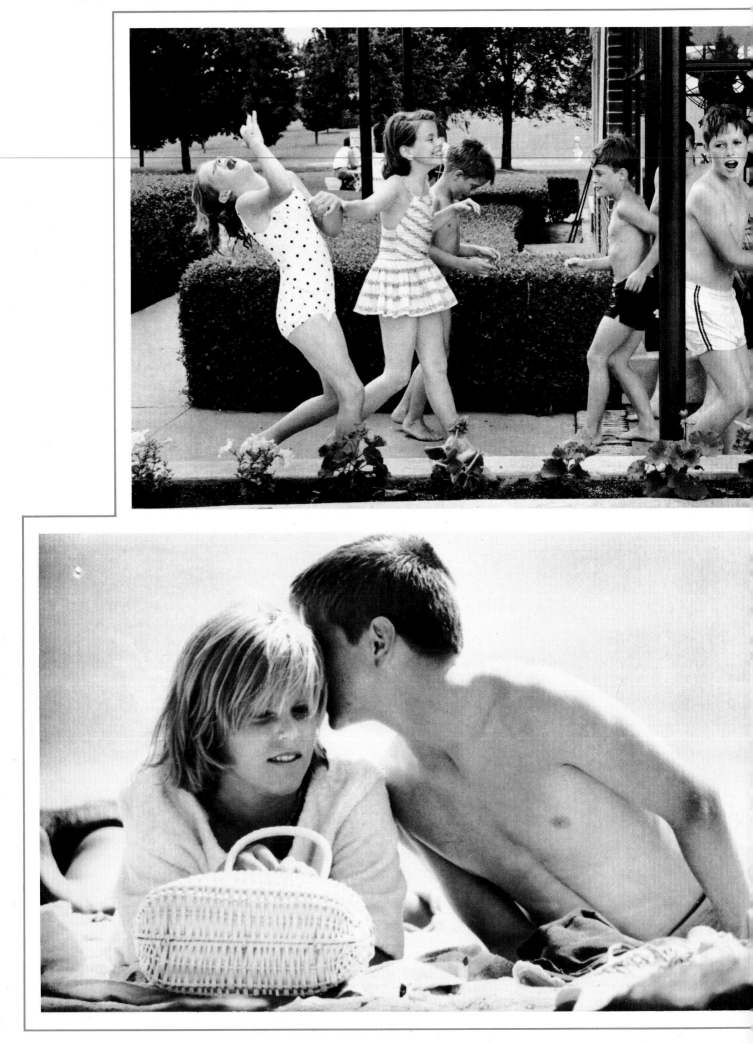

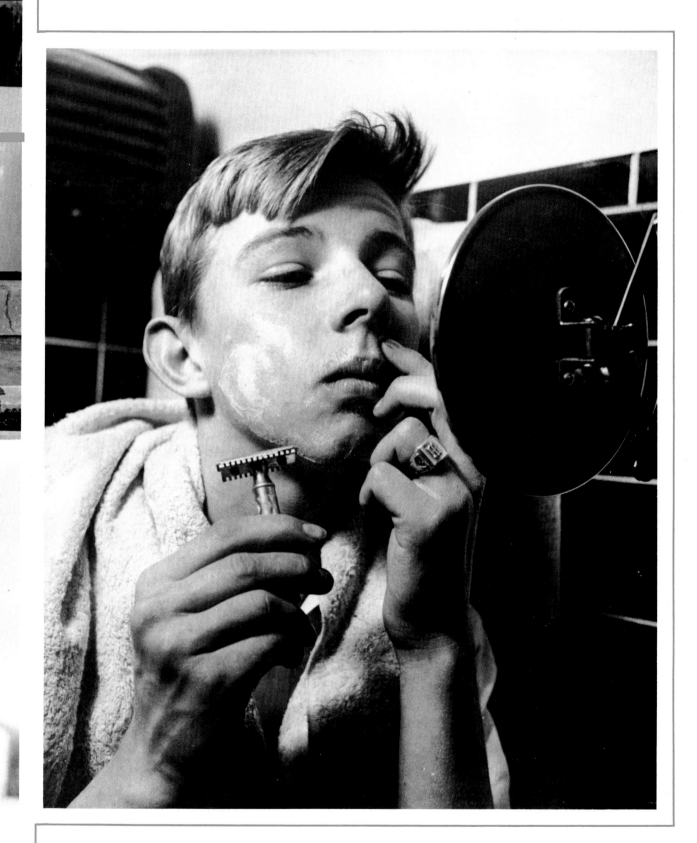

Playing grown-up around the country-club pool in
Jefferson City, Missouri, affluent kids enjoy
one another and themselves. ● Tom Moore, 17,
examines the results of his first shave, for which
only he can see a necessity. ● Sally Stephens and
Tom McCallister are already going steady at 12,
although they really do not understand the sweet
nothings they whisper into each other's ears.

*The birds and the bees
along with the books*

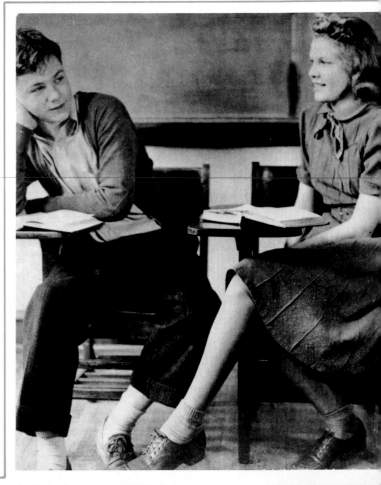

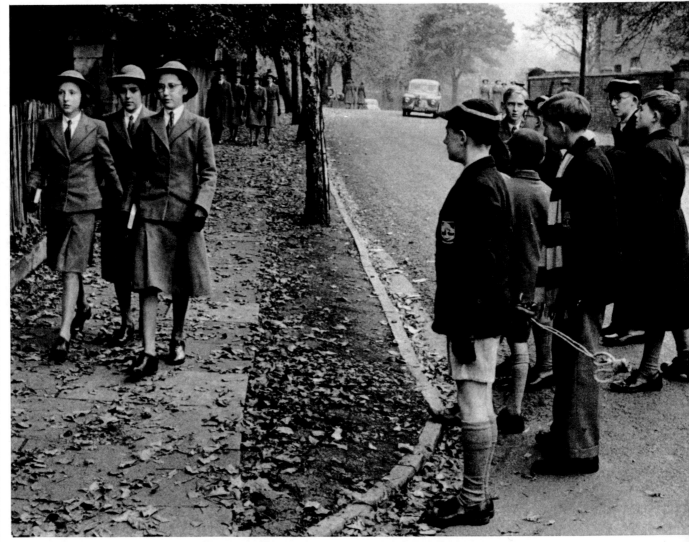

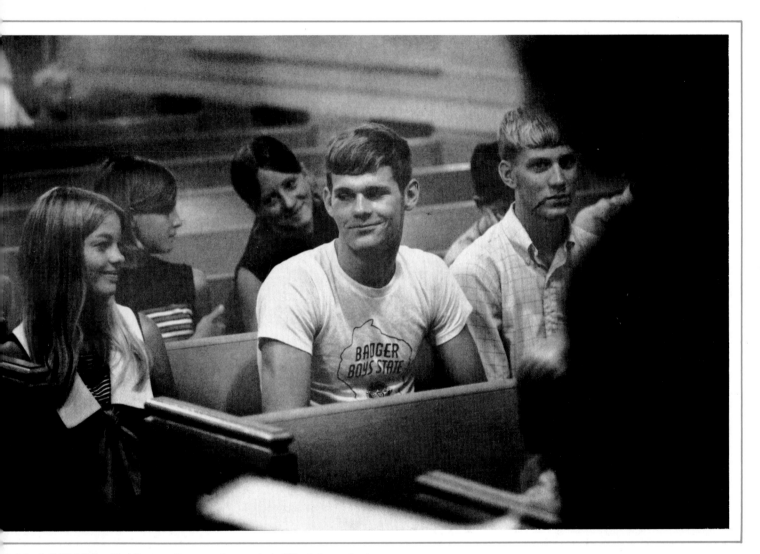

At Marshall High School in Minneapolis two students make it difficult for each other to concentrate. ● Uniformed schoolgirls in England pretend not to notice the boys on their way back from church. ● From the pulpit of his Lutheran church, which has been split by his advocacy of sex education in the schools, the Reverend John Sell preaches a sermon on the subject to young people, two of whom make it clear that, whatever the controversy, life goes on in Cedarburg, Wisconsin.

Under the dryer, just like one of the ladies—almost!

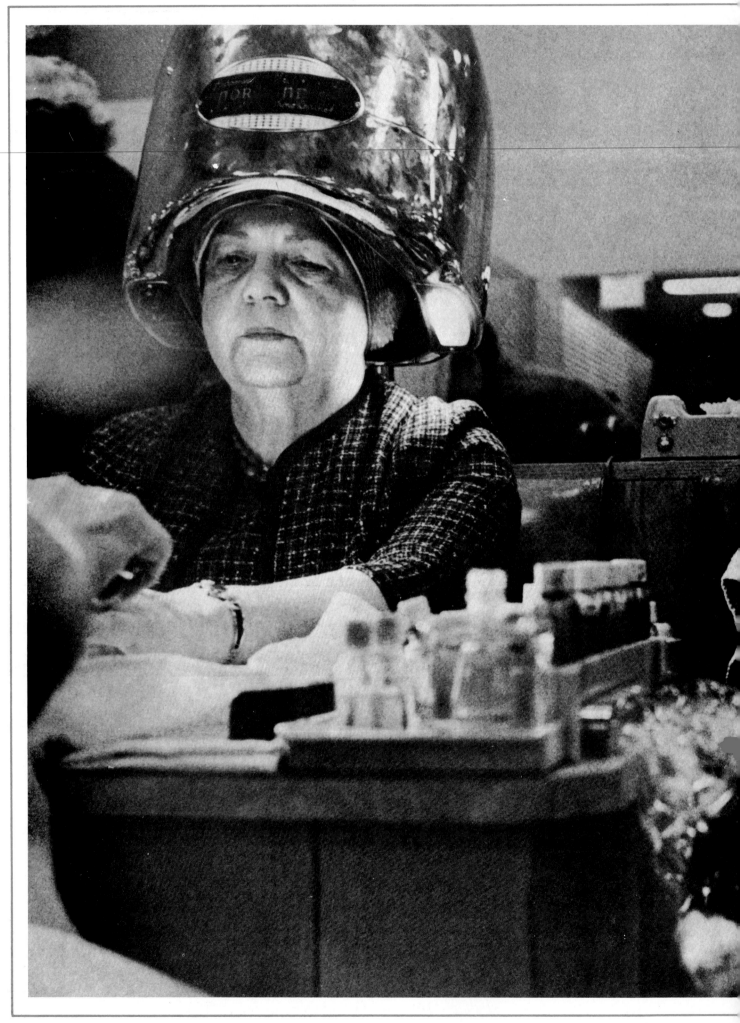

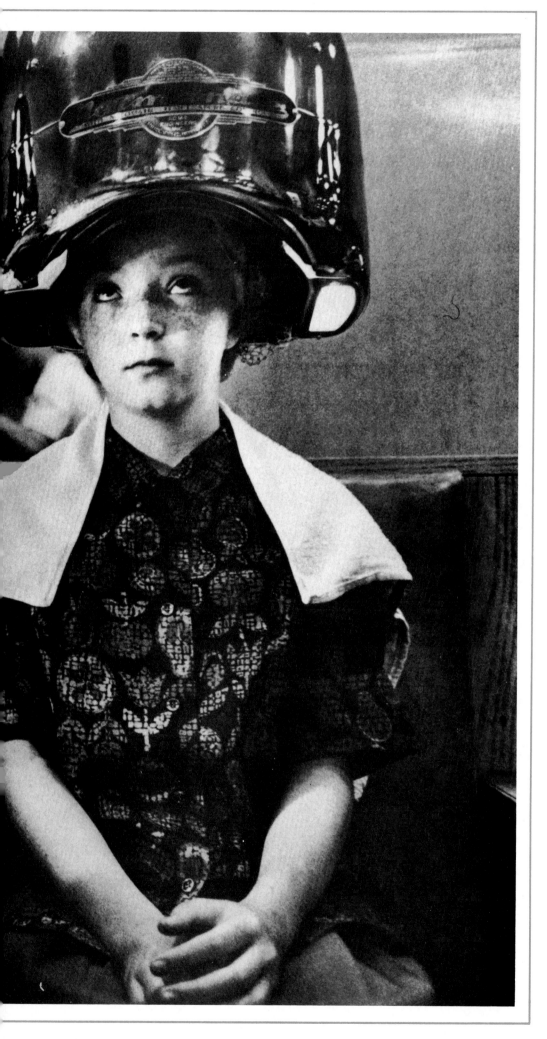

Looking a little ill at ease in the customarily adult world of the beauty parlor, subteen Darlene Schaller of Chicago waits with the rest of the ladies while her "New York cut and style" hairdo dries.

A special brand of music turns kids on

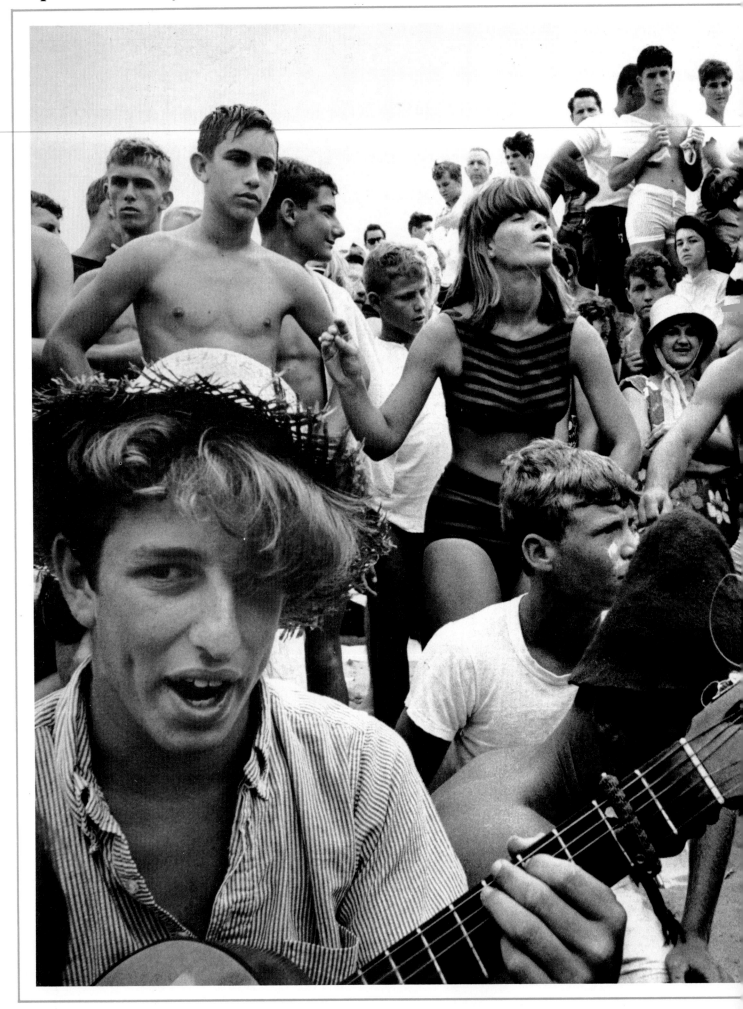

On a Florida beach teenagers gather around a rock group to listen, watch and dance on the sand. ● Back in 1948, before the big sound had blossomed, two Cleveland teenagers go gaga over the intimate voice of Frankie Laine. ● Ten years later, rock 'n' roll had become the music of a new generation with TV disc jockey Dick Clark its most powerful proponent. Here 16-year-old June Carter treasures her great moment as she touches the cheek that Clark has just kissed.

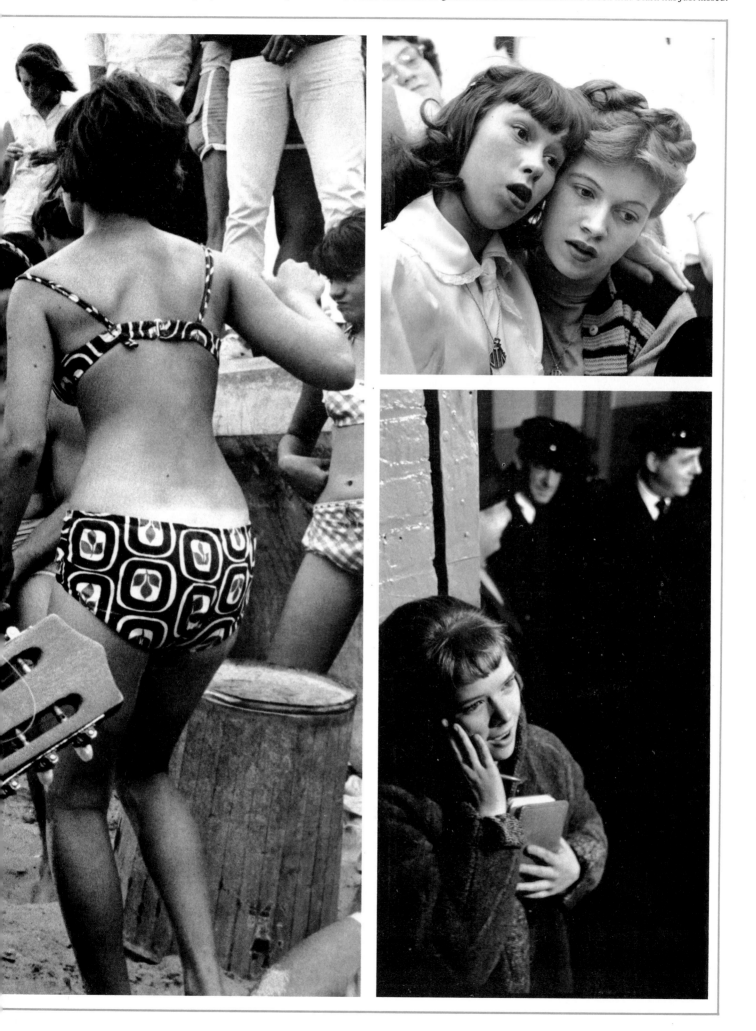

Anywhere the big beat booms, the enchanted look's the same

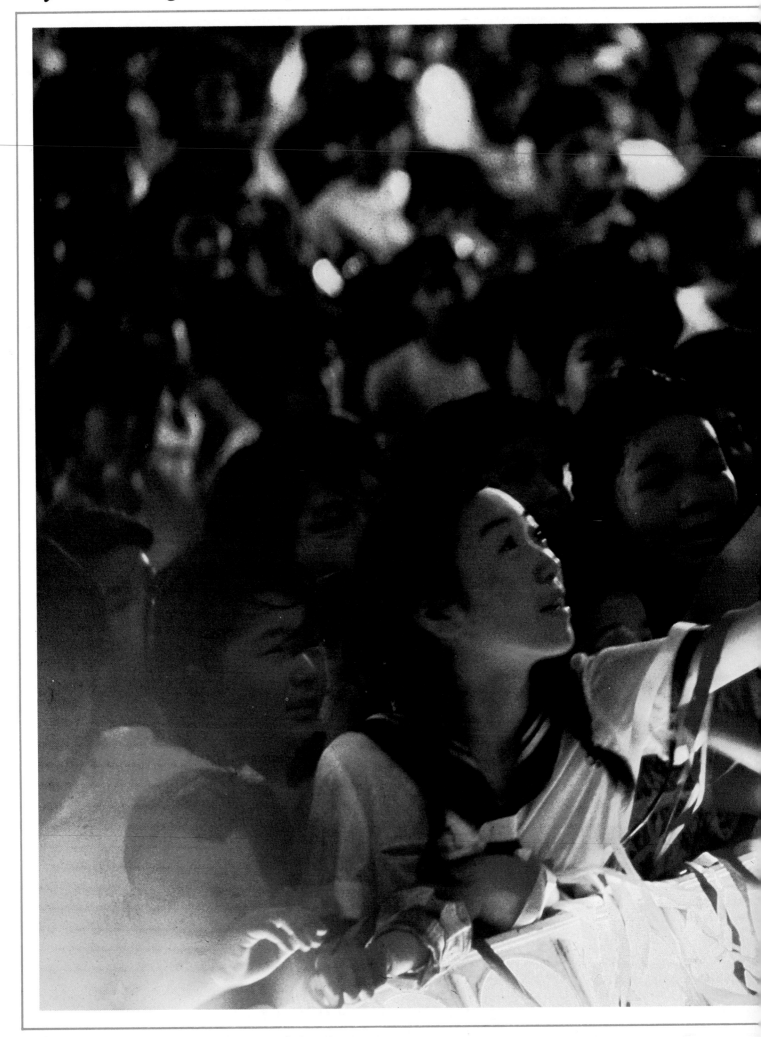

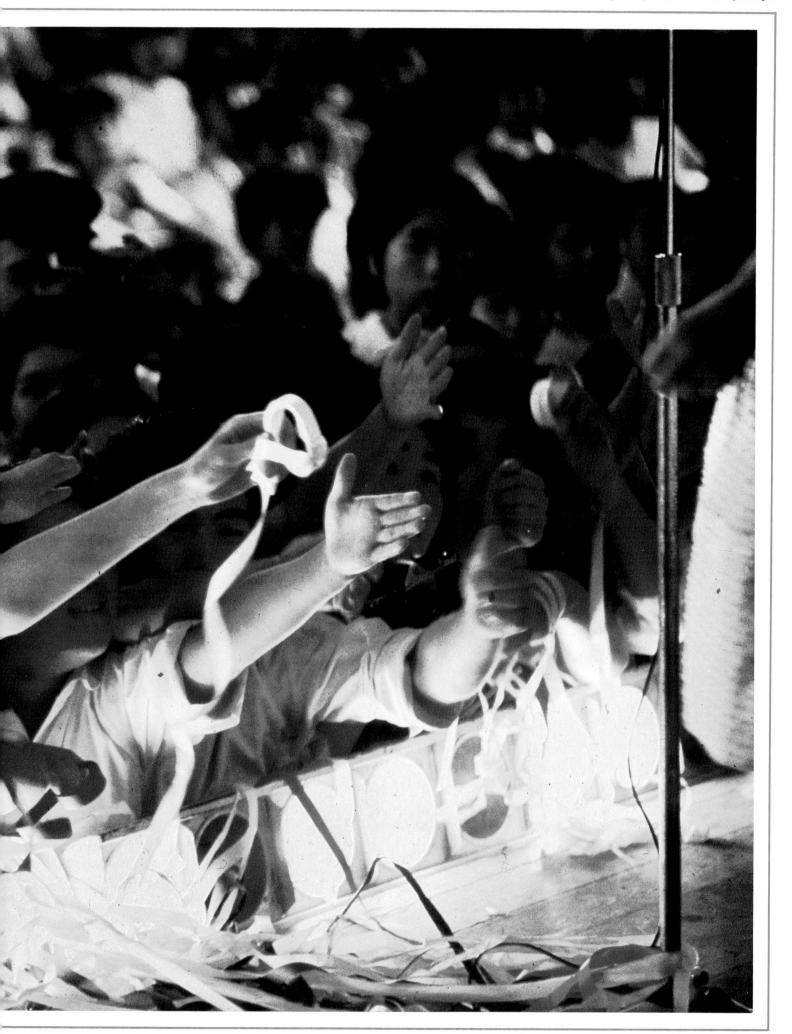

In the town of Noda, Japanese girls are caught in a moment of yearning as they cheer a Western-style singer.

In the pursuit of knowledge, moments to remember and cherish

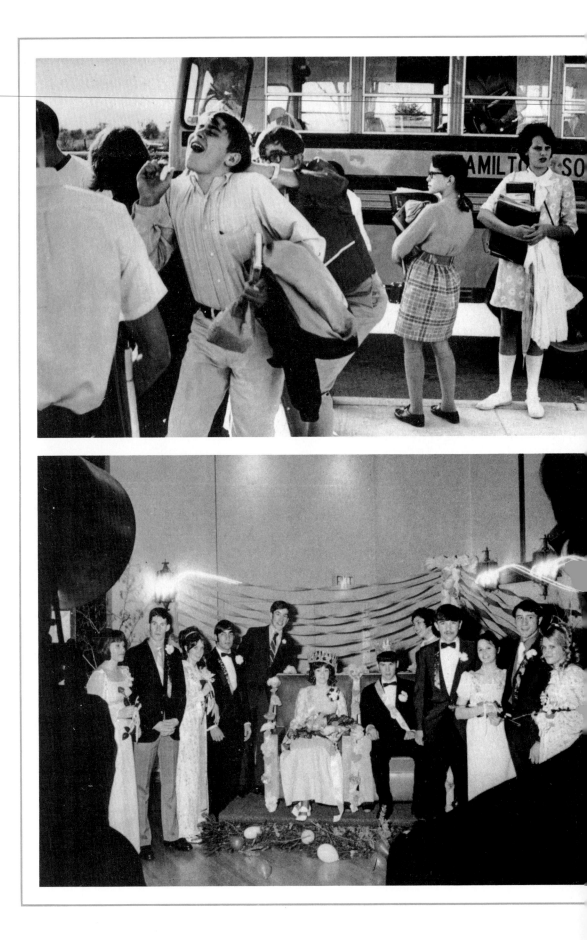

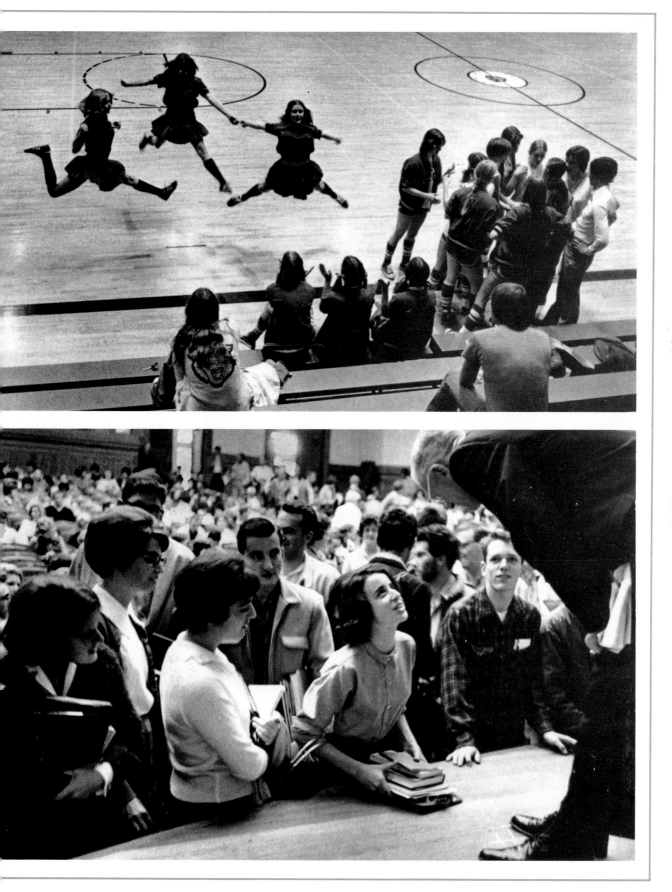

In Olio, Indiana, waiting for the school bus is a ritual in itself. ● *At Rossville High in Kansas, cheerleaders give their all at an out-of-town girls' basketball game.* ● *In Berkeley, California, a political science teacher settles a point he raised in his lecture.* ● *The royalty of the senior prom at Coeur d'Alene High School in Idaho is photographed for posterity.*

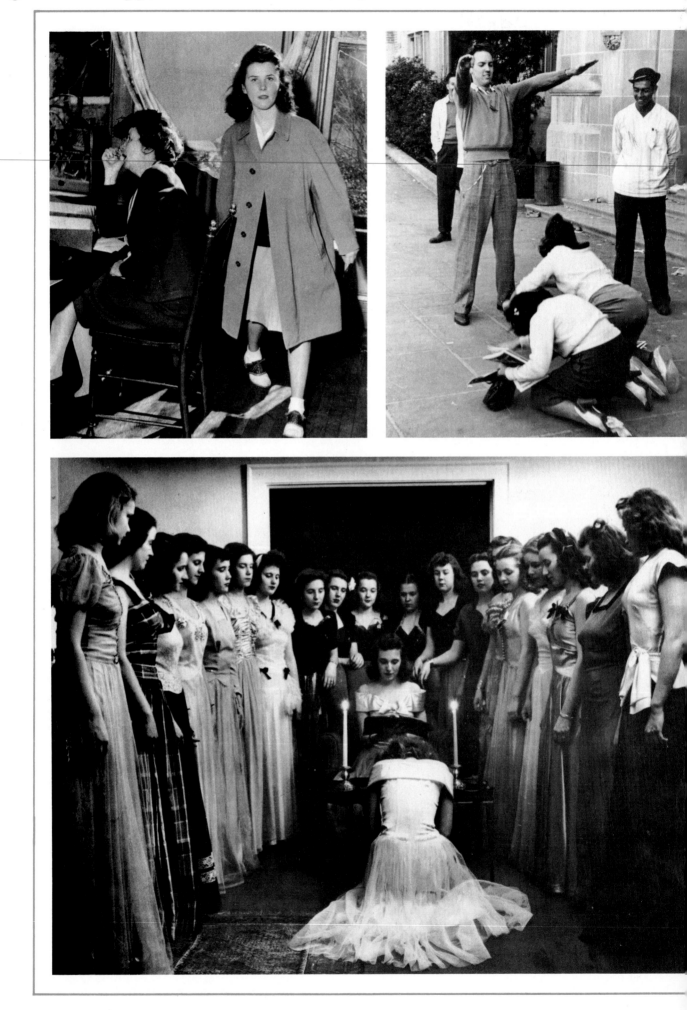

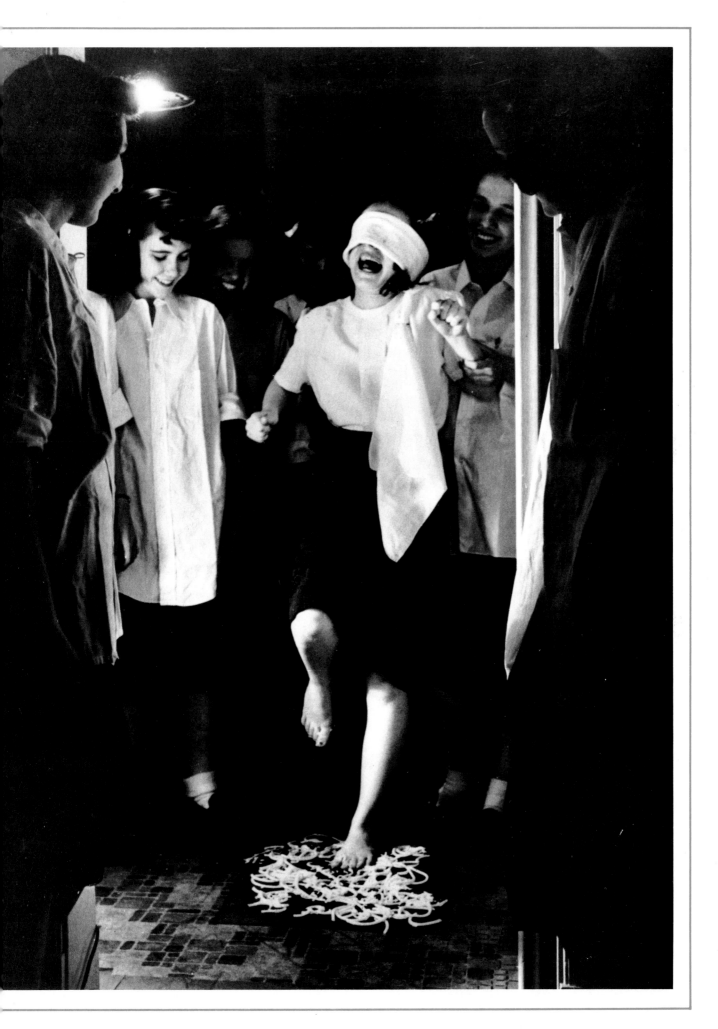

Having just learned of her rejection by a sorority, this student strides off to be alone. ● *At UCLA two freshman coeds are at the mercy of a junior who trades patronage for groveling.* ● *Pledge Rita Wiliford screams as she is led barefoot through wet spaghetti that she's been told is worms.* ● *Back in the '40s an Indianapolis subdeb club ceremoniously initiates a new member.*

Tears and partings make us forlorn

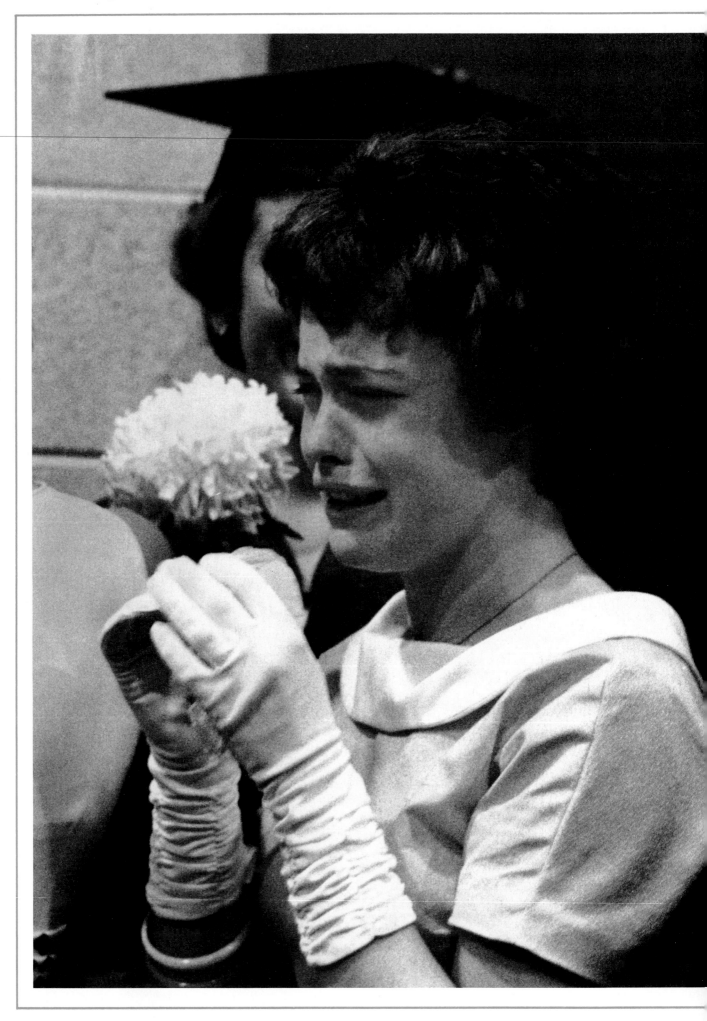

At every high school across the land, graduation is the final ritual. Oakes High in North Dakota is no exception. Milestones are passed. Childhood is over. All at once life is filled with tearful partings and fateful meetings. The real world awaits!

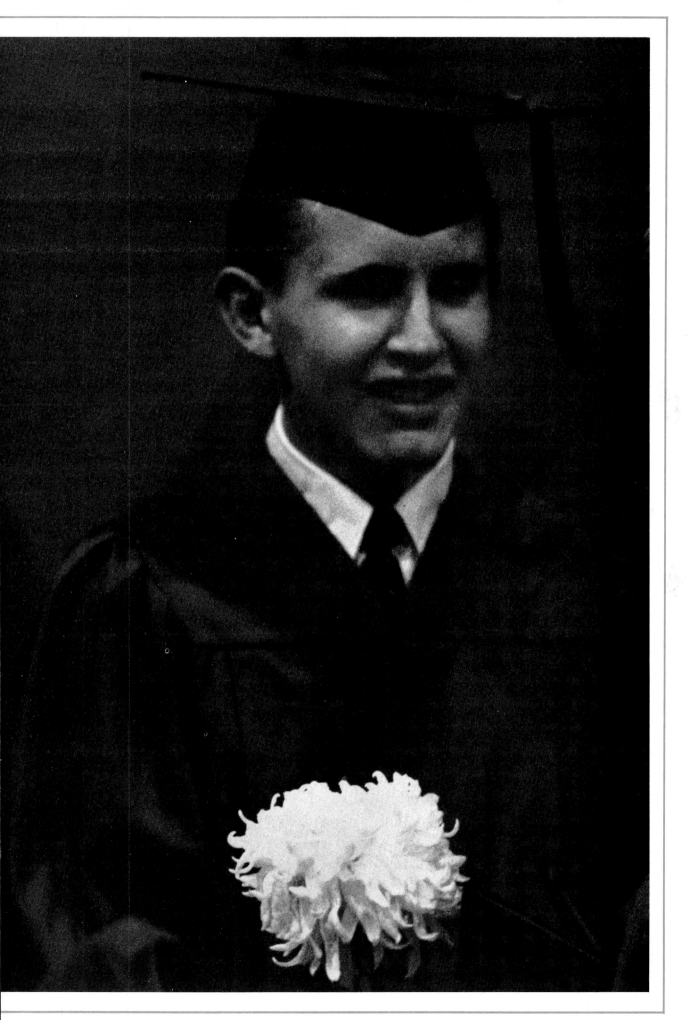

The Great Outdoors

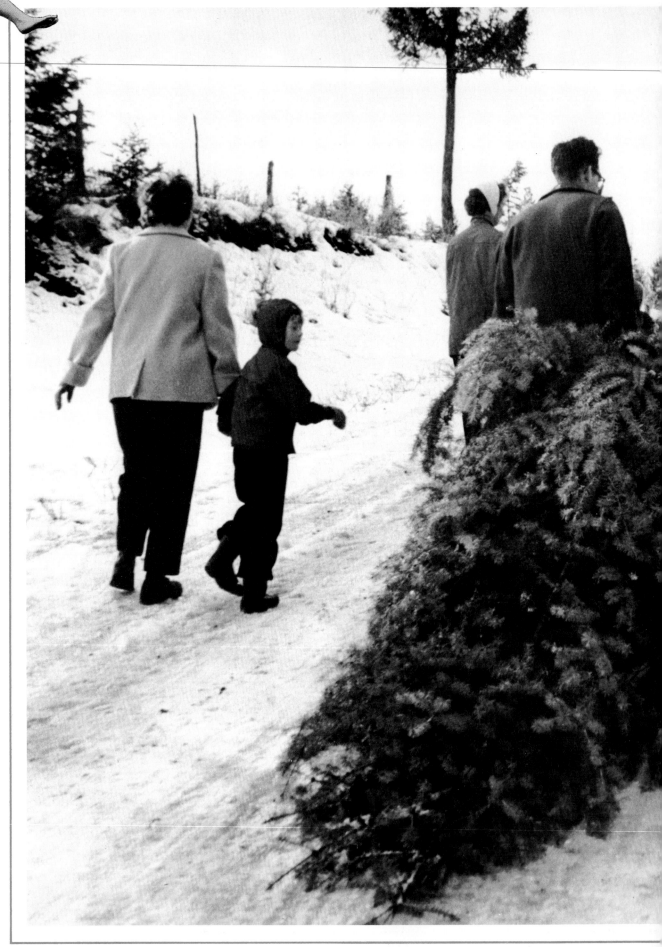

Thank God for snow and Christmas trees, for boulders, butterflies and beaches, for dappled trout and the holy silence of wilderness, for sticks to throw and waves to ride and all those pinnacles to conquer.

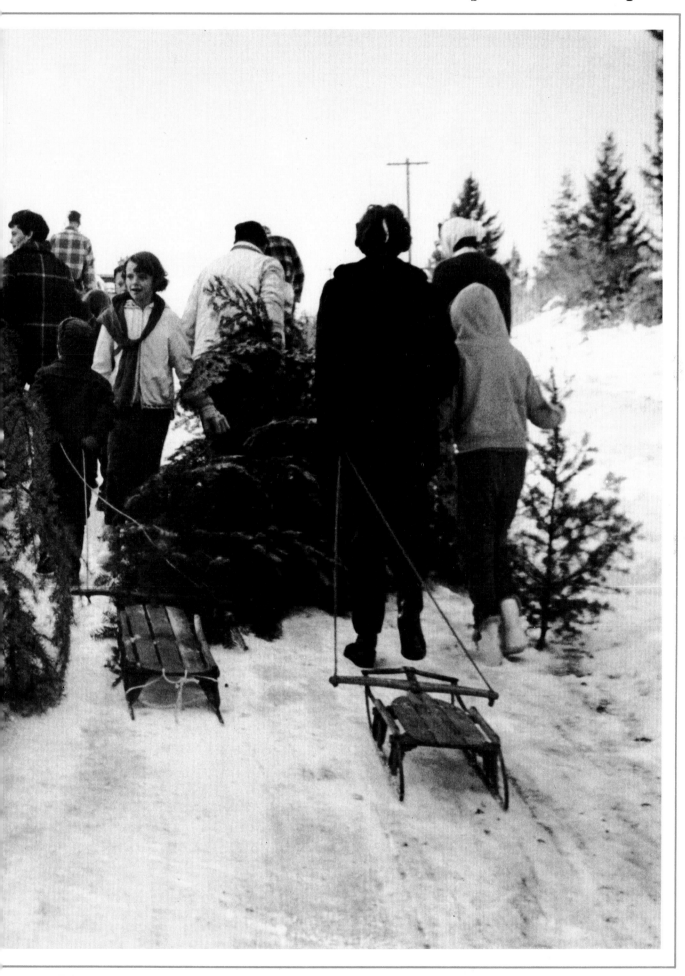

You can almost hear Jingle Bells *ring out as freshly cut Christmas trees and fast-as-lightning sleds are hauled homeward.*

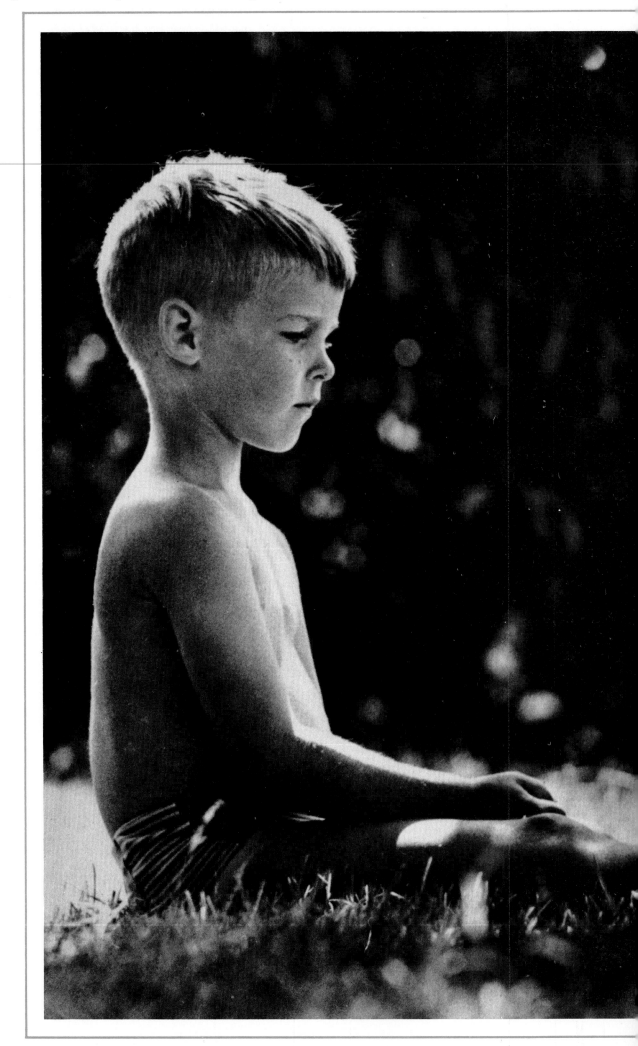

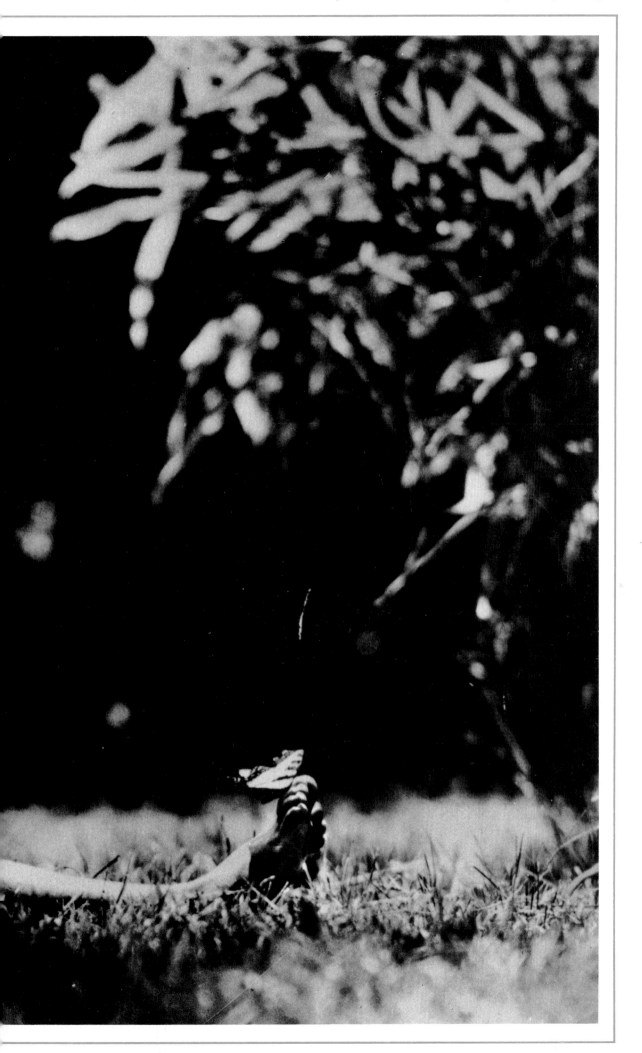

*Still as a statue, seven-year-old Christopher Wilson watches a
yellow-and-brown swallowtail butterfly balancing on his big toe.*

View of the world from a big stone

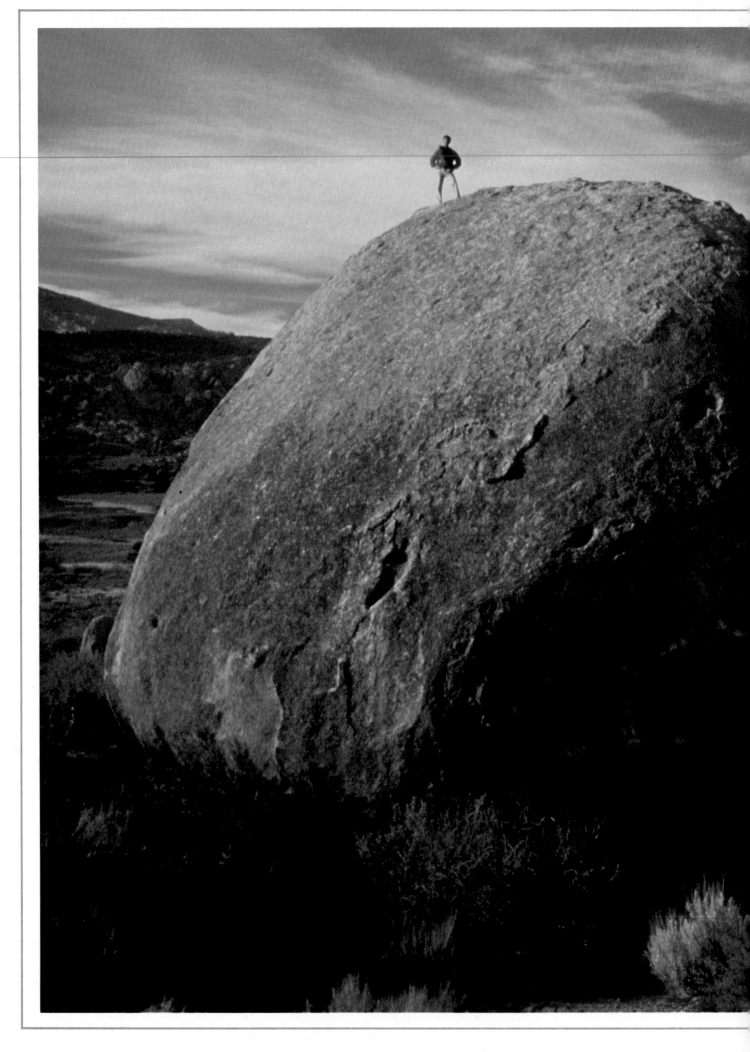

Tripping the frozen fantastic

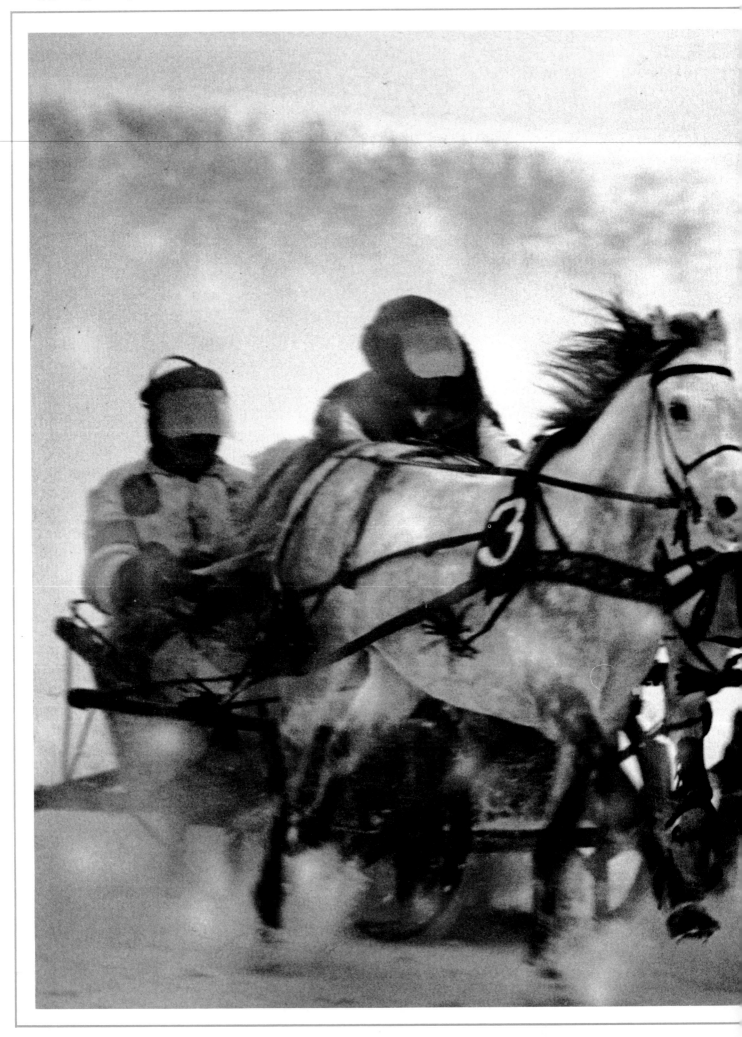

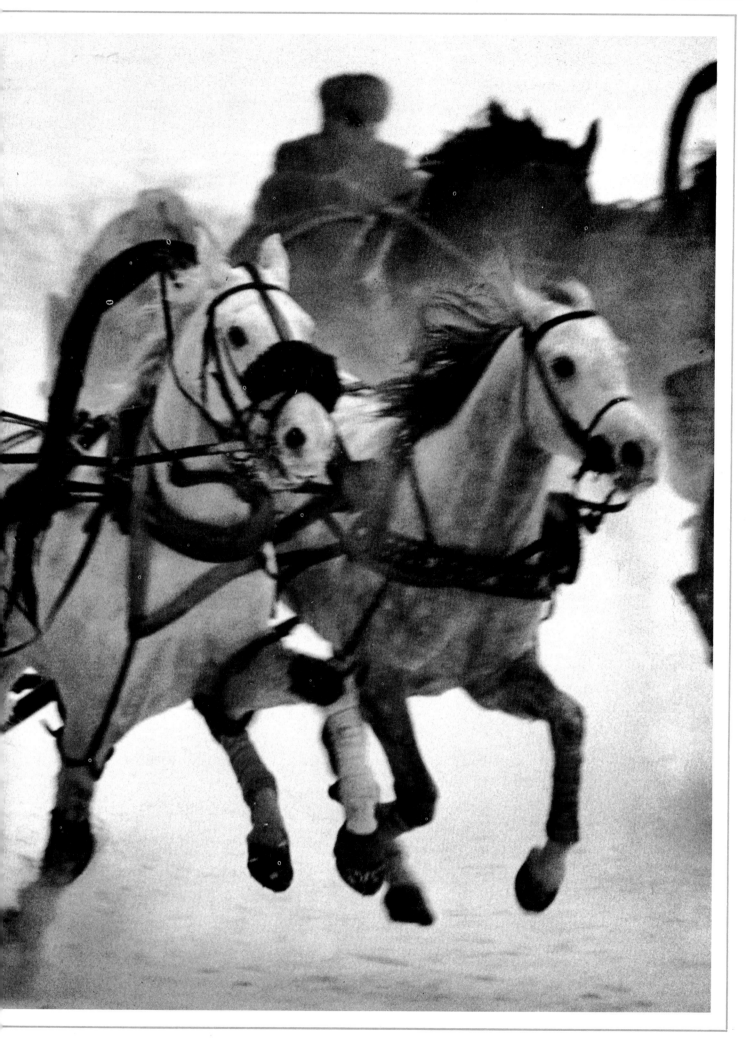

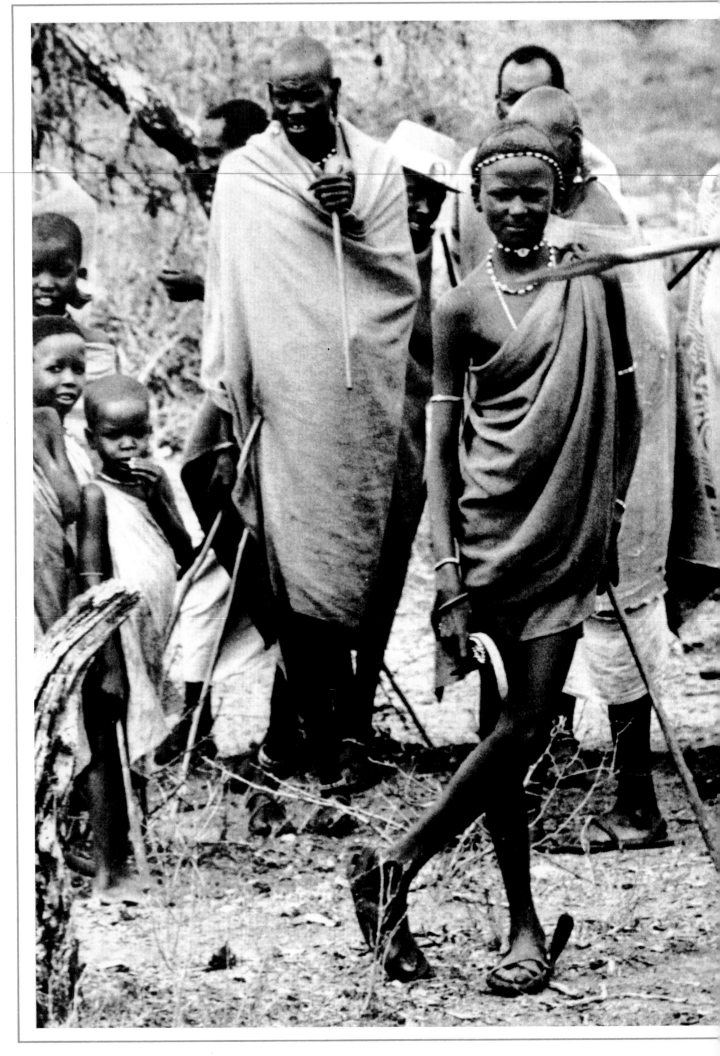

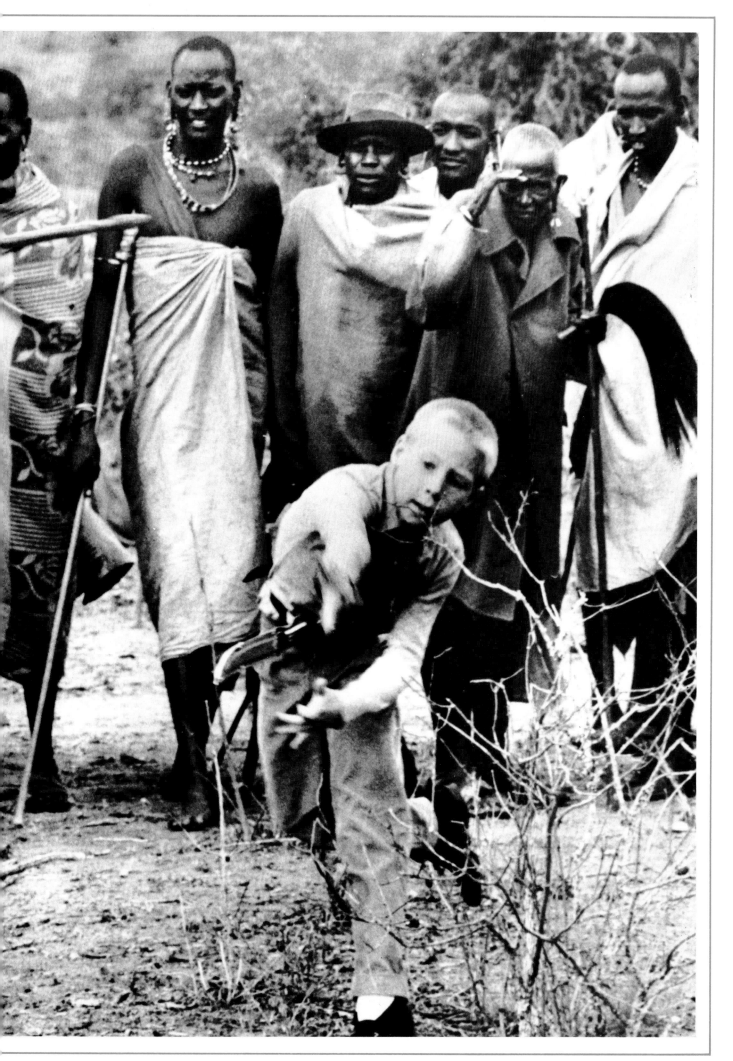

In the bush of Africa, visitor Kevin Gorman is taught how to hurl a spear by a Masai warrior.

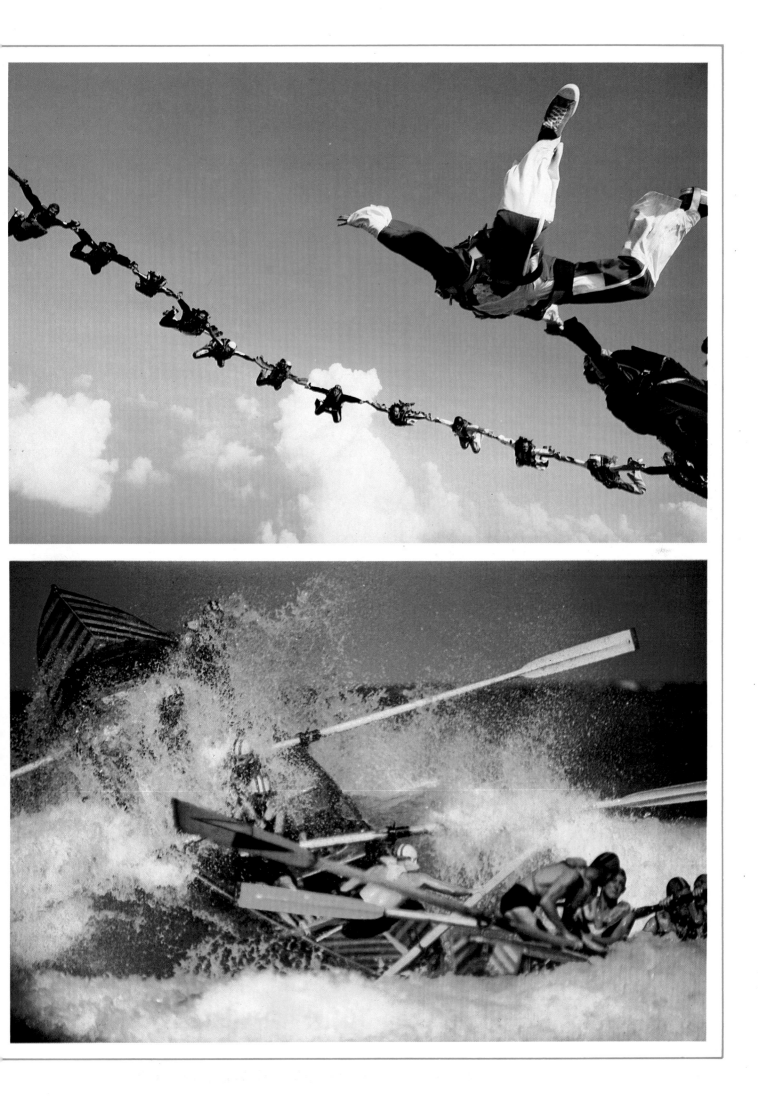

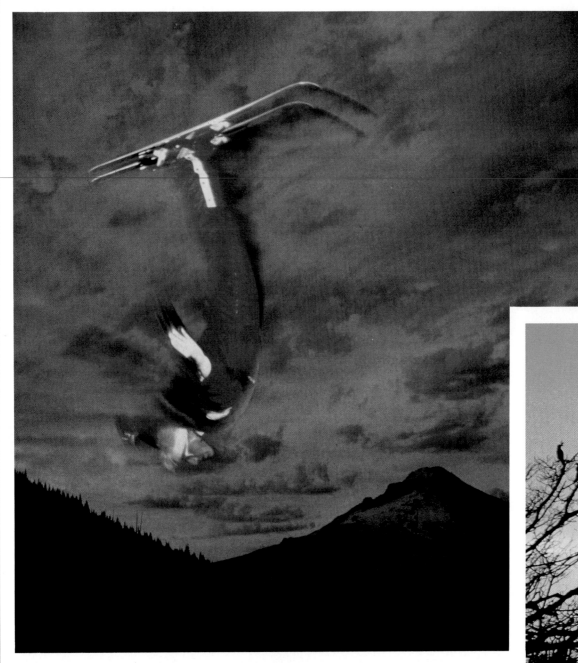

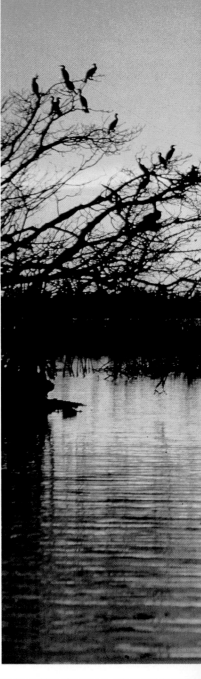

Using the evening sky as a dramatic background, Kris Feddersen does a scary aerial ski trick. ● Bird fanciers take in the waterfowl at Duck's Rock, Florida, the most populous and spectacular rookery in the nation.

In awe of things that fly

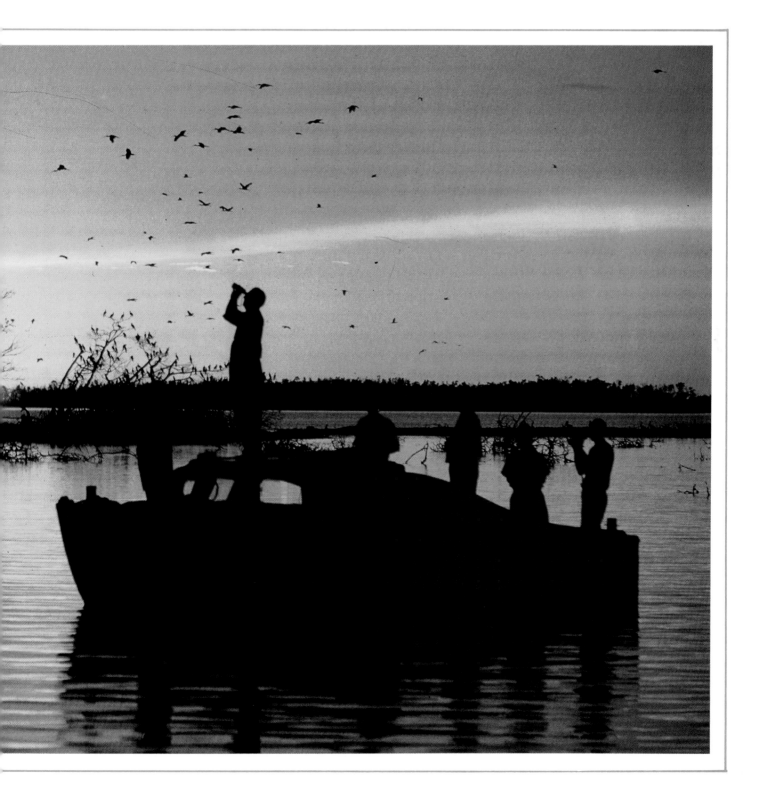

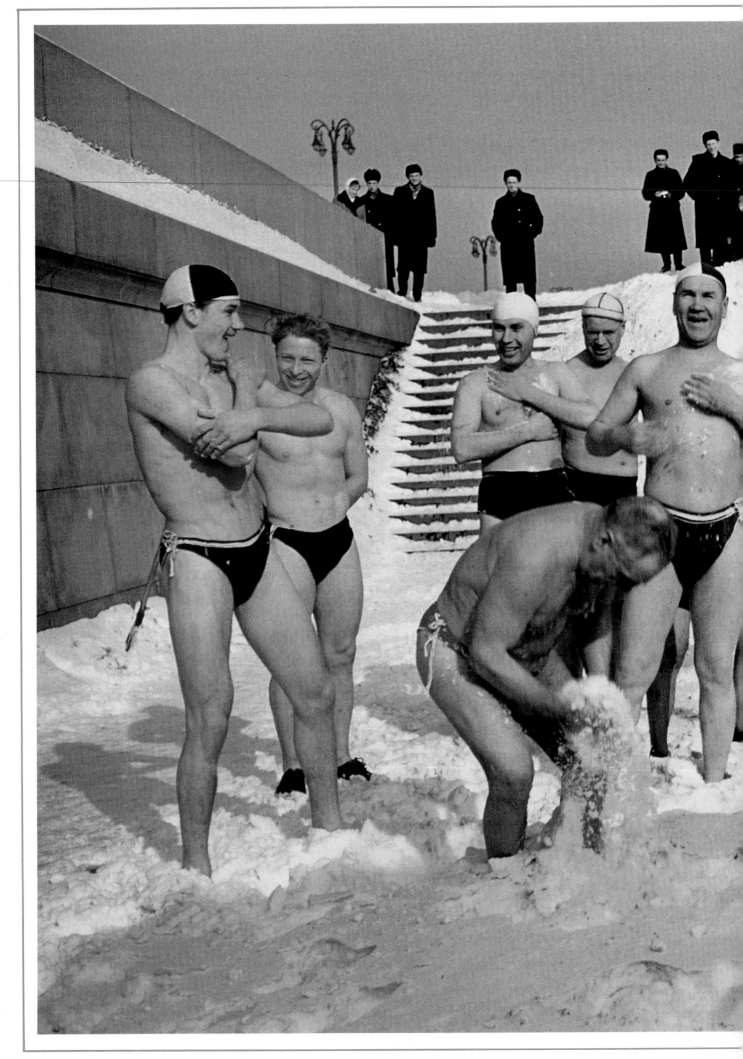

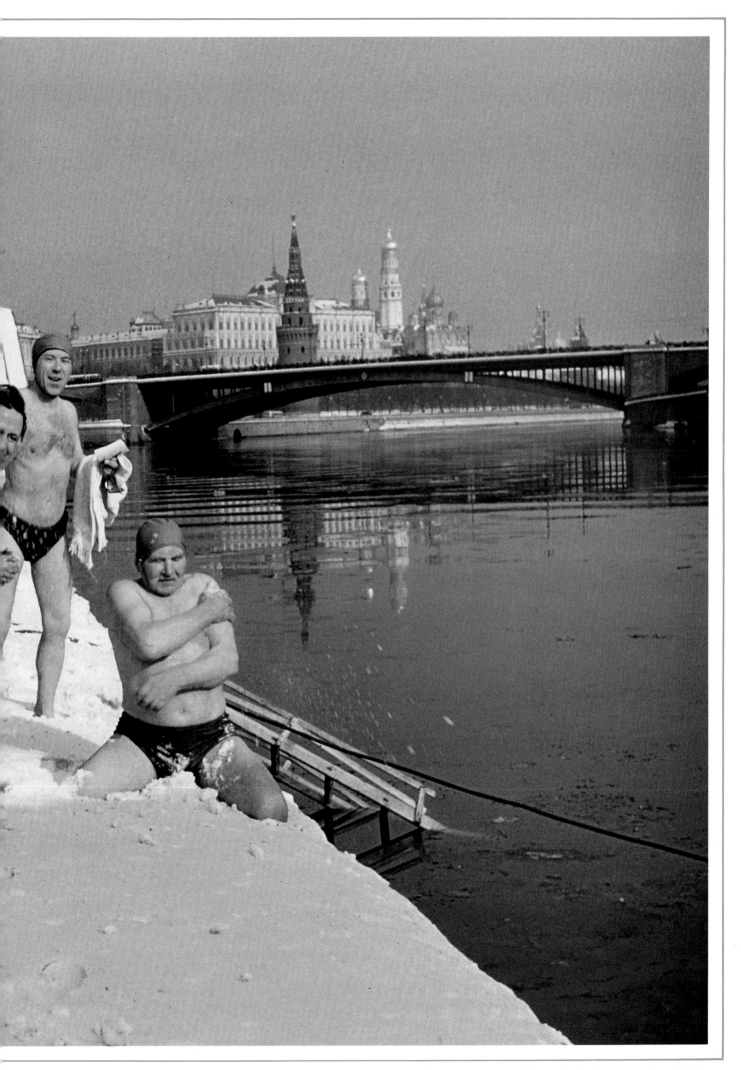

Giving themselves a rubdown with fresh snow, members of a Moscow polar bear swimming group prepare for a dunk in icy river waters.

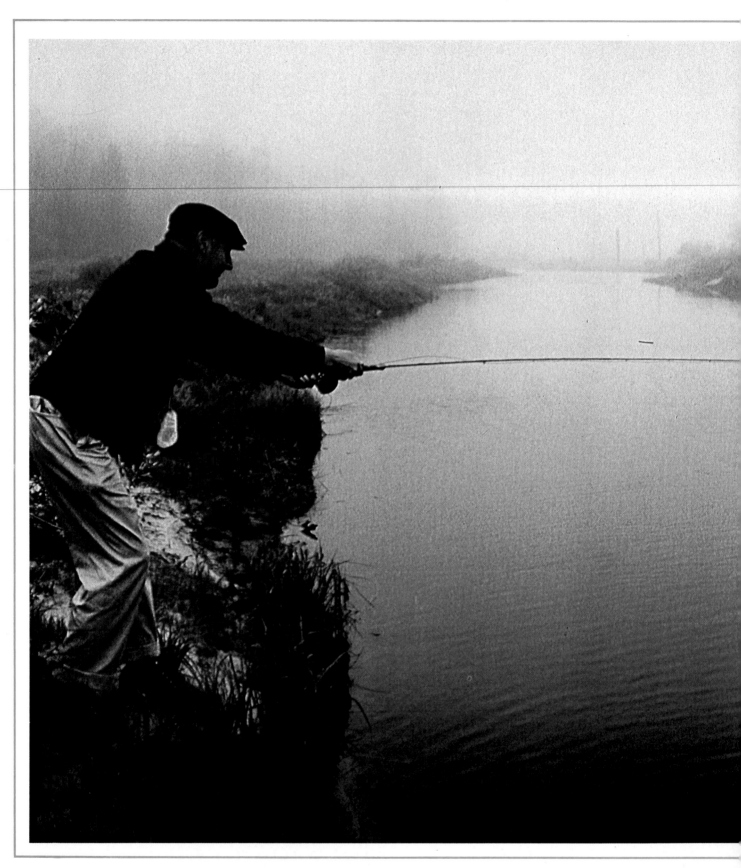

Search for sanity through the quest for trout

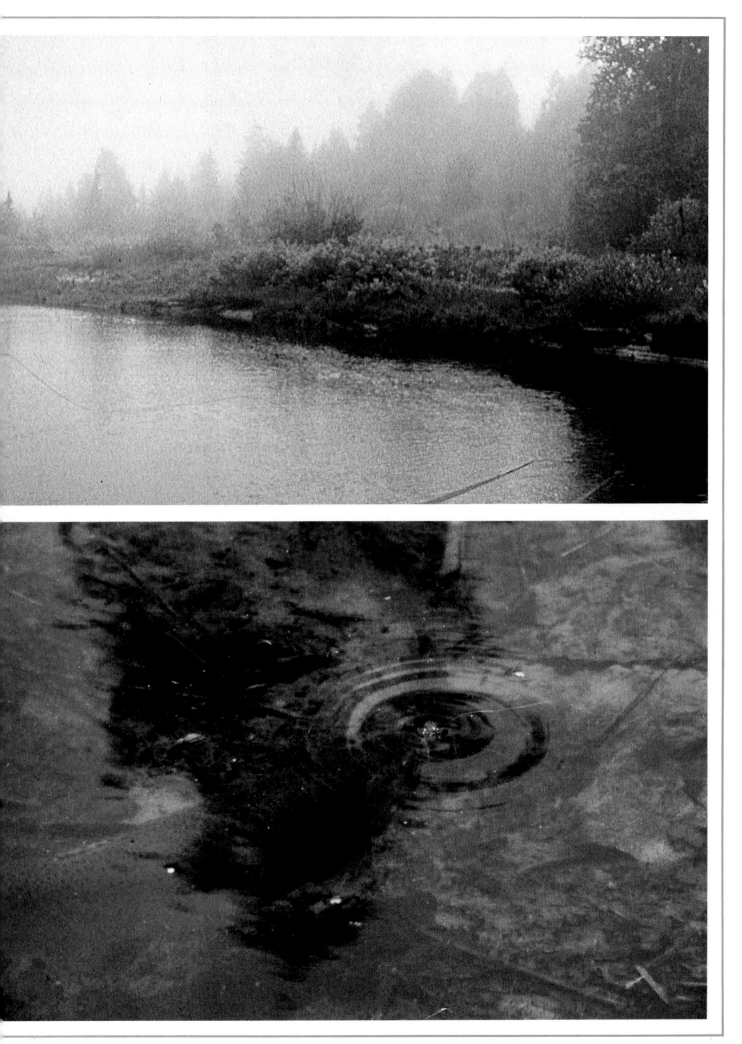

A fisherman goes after a big one in his private Shangri-la. ● *A multidotted rainbow trout is presented a perfectly cast fly. To strike or not to strike, that is the question.*

Loving

That intoxicating magic everyone seeks, that unconditional devotion between parent and child, that deep affection that springs from years of sharing, that tender endearment binding two lovers, that strength, that passion, that yearning, that giving of the heart.

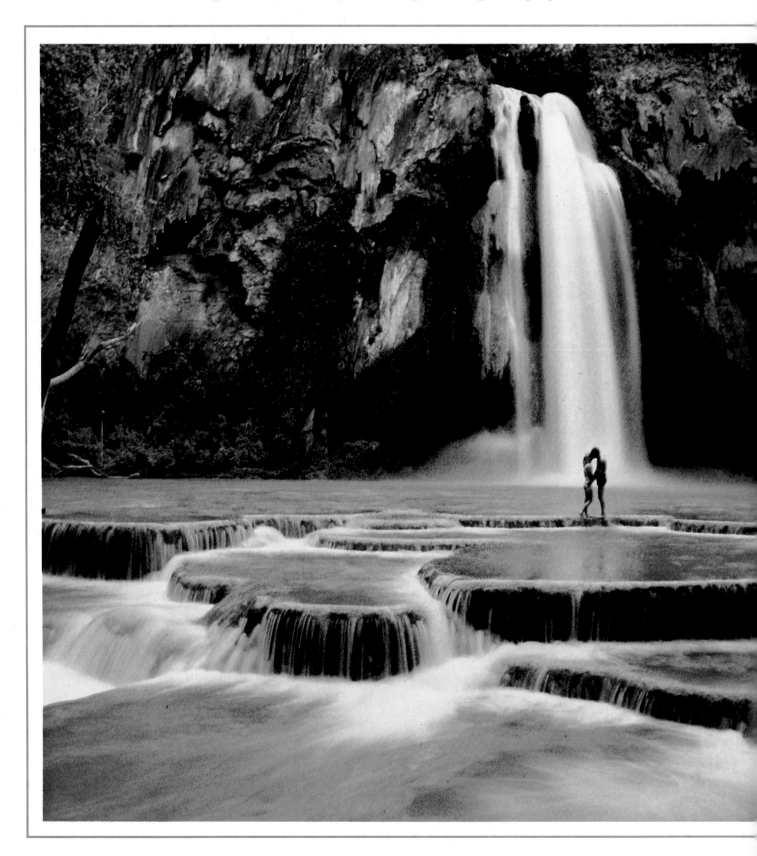

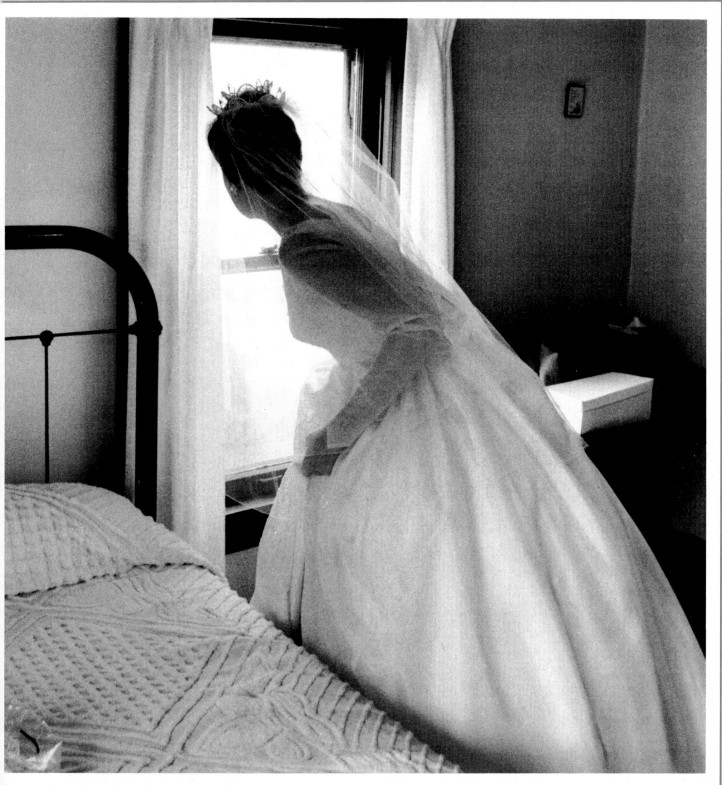

An enchanted spot for romance, curtains of travertine limestone terrace its pools and flank 100-foot-high Havasu Falls in Arizona. • A young bride in Oakes, North Dakota, waiting upstairs in the pastor's house for her wedding, seems to be peering into her future.

The thrill starts early and appearance suddenly counts

All dolled up in a rented tux, a boy checks out his hair before joining the excitement on the dance floor. ● Jeanette Miller's mother helps fix her daughter's hair for a dance. Until recently, boys were a big nuisance but now, "all of a sudden," says Jeanette, "it's something new."

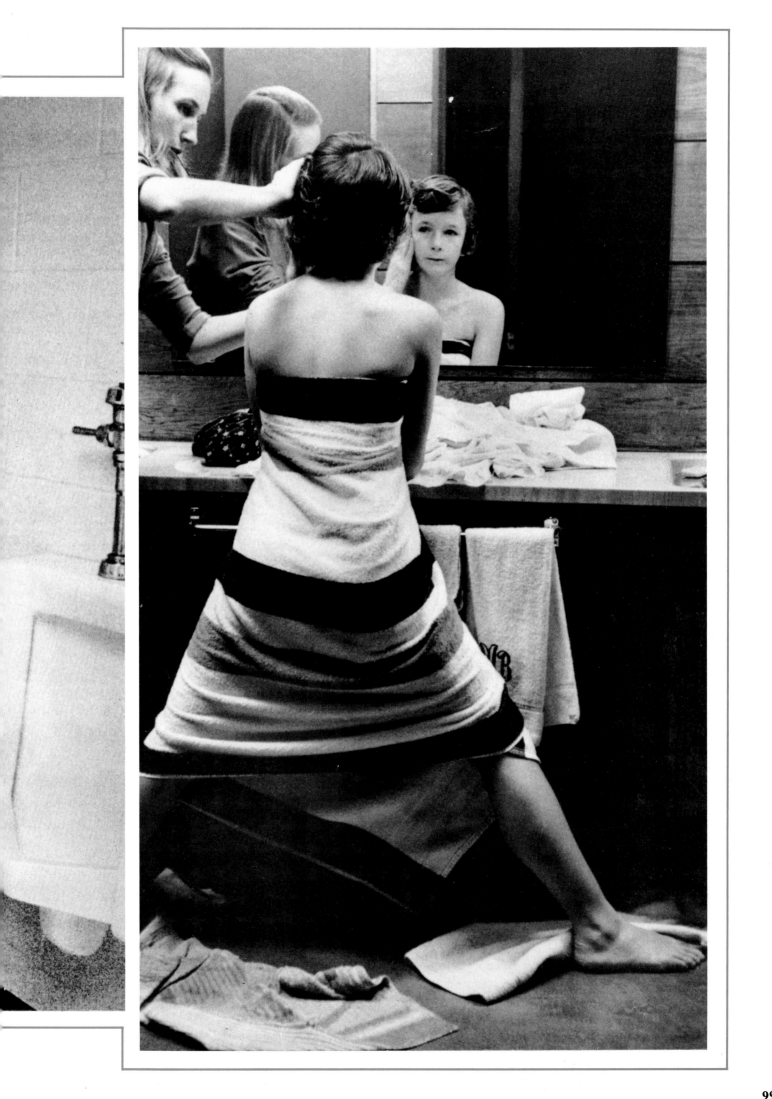

Diverse signs of devotion

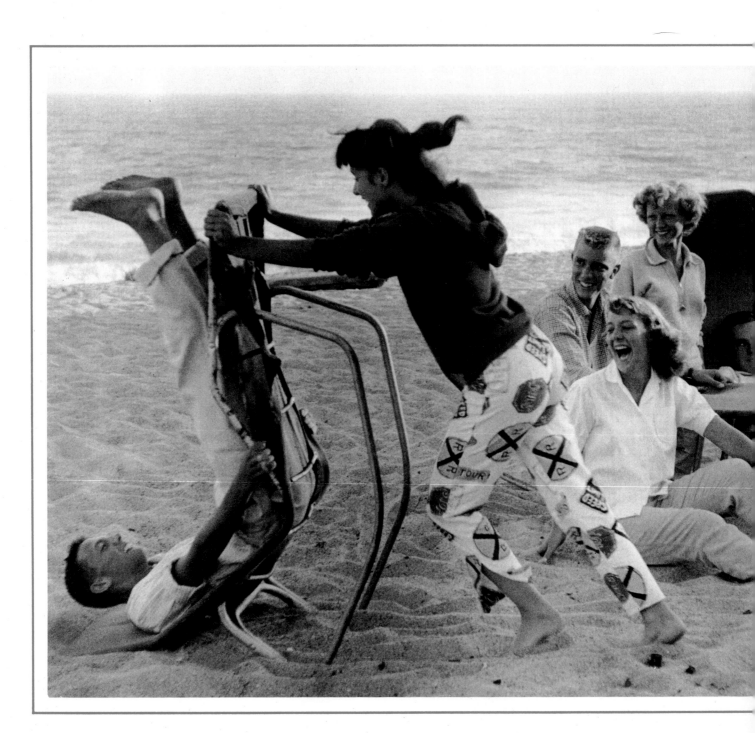

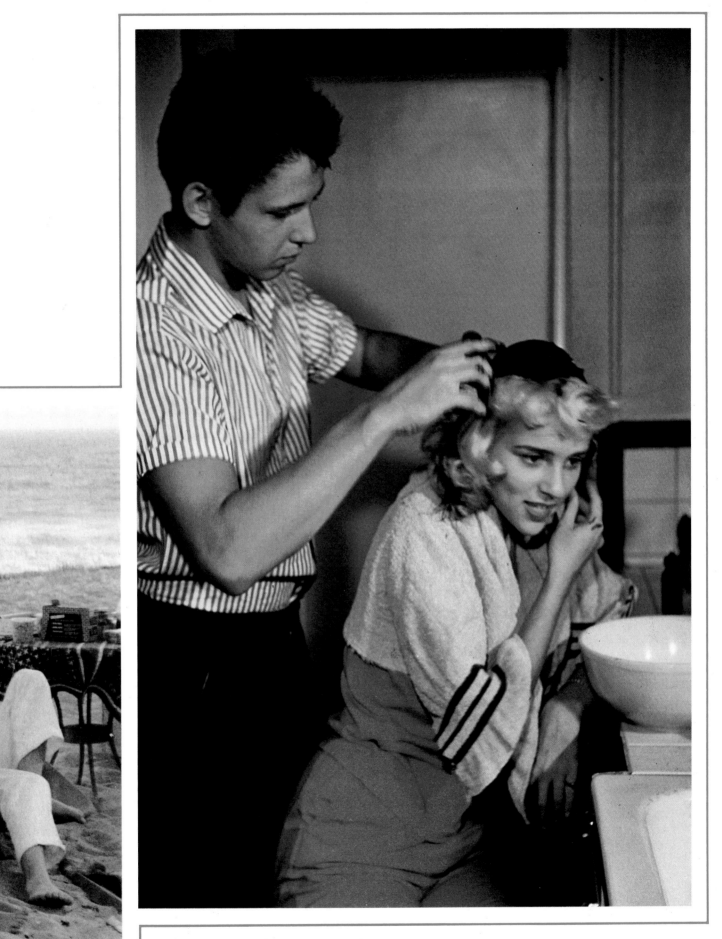

A girl proves she's head over heels in love with a boy by sending him heels over head. ● *To show the world the extent of their mutual ardor, a normally blond '50s couple in Georgia goes brunet together.*

No matter the times, wherever the place, the look's the same

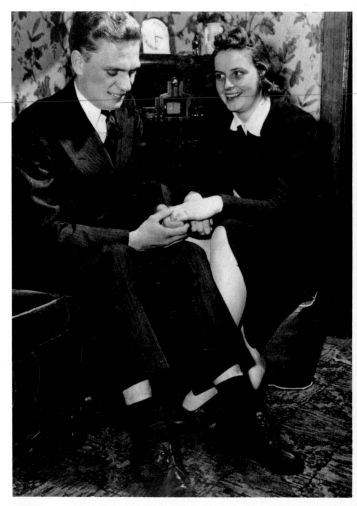

Stars in her eyes, pre-World War II. ● Friendship in a California field. ● A passing fancy runs its course on a park lake. ● All aglow with a new admirer. ● Last year's school romance is reignited. ● Leaning into love on the University of Missouri campus.

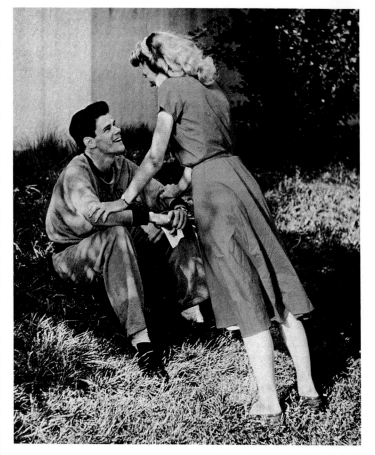

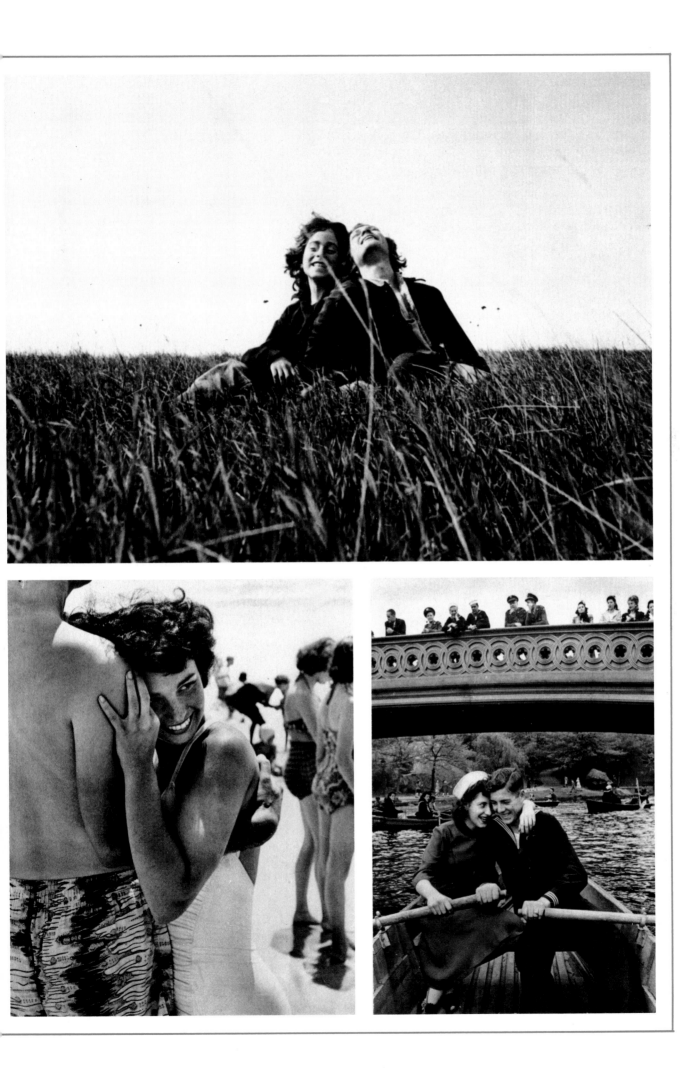

A kiss is still a kiss

Roommates buss on the Oberlin campus. ● An 18-year-old bride bids adieu to her soldier. ● An old lady, perhaps remembering times past. ● Unabashed courting for all to watch. ● Aperitif in a Paris café. ● Utter adoration!

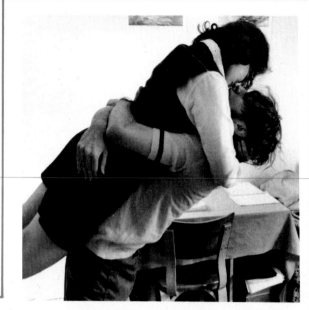

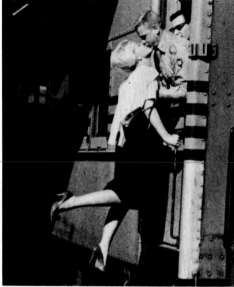

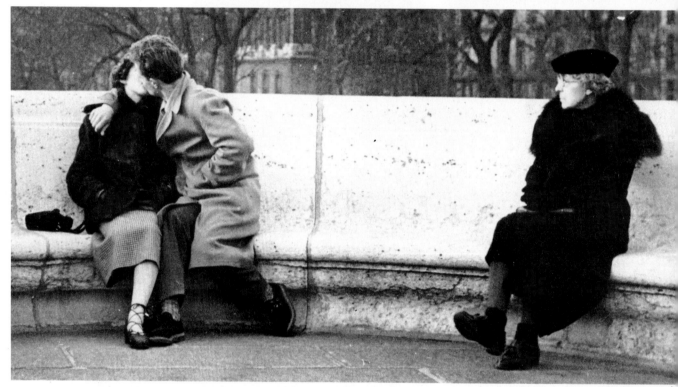

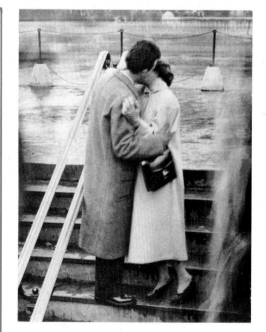

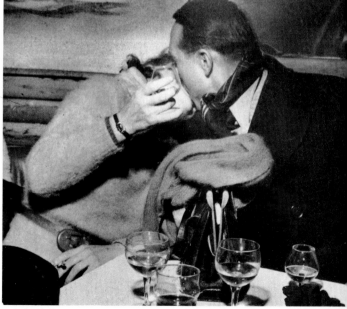

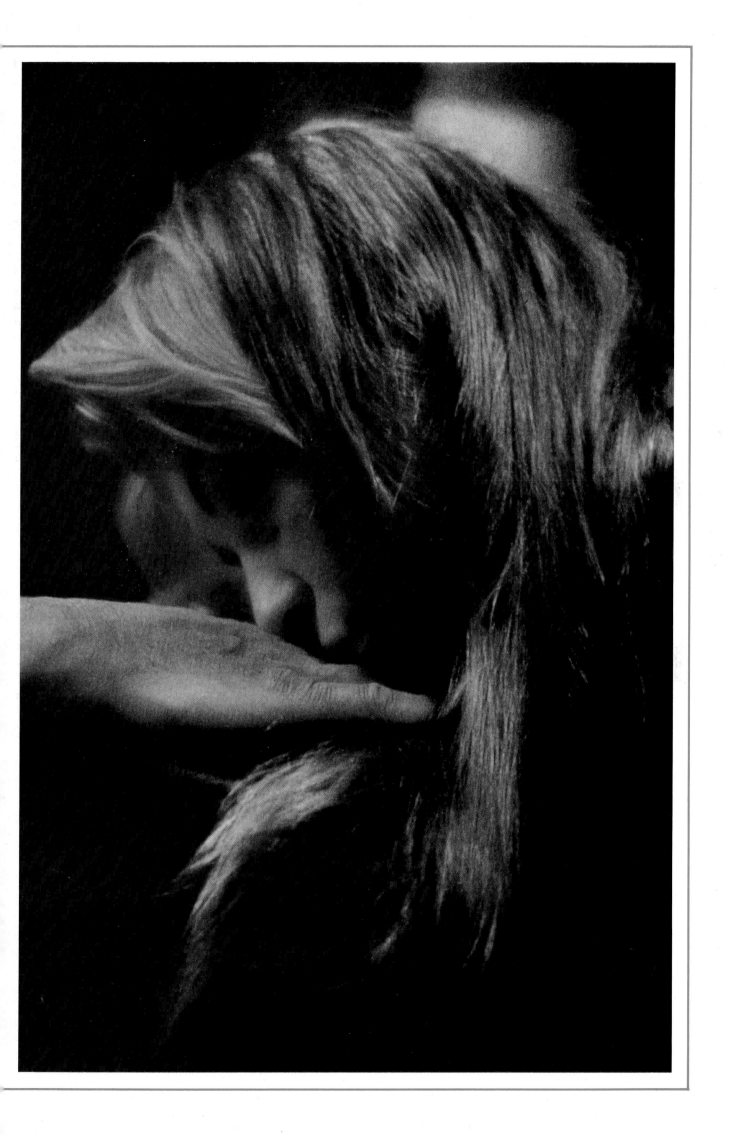

The tender cherishing of love's embrace

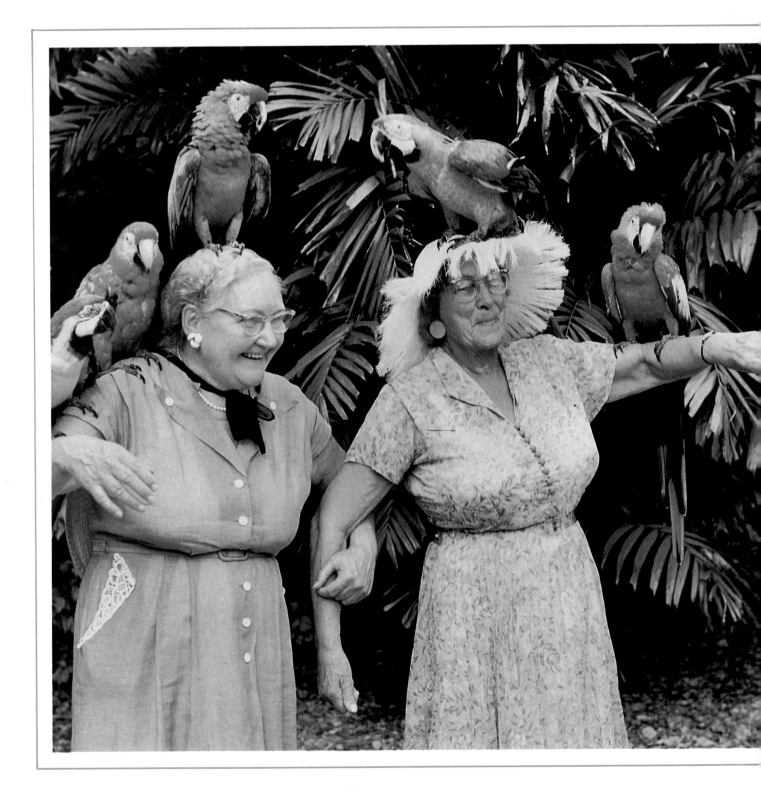

Children on laps, parents and grandparents, a few sweethearts delighting in each other's nearness—this audience in Oakes, North Dakota, is enjoying a performance of Our Town at the local armory. So real are the characters and the hometown plot, it is almost as if they are watching themselves. ● Apartment-house life includes sunbathing, men working, gardening, a baby sleeping, setting a table, a cocktail party, sewing and lots of people watching the world go by. ● Texans gather around a campfire to swap tall stories about their state. ● Less happens on the benches of St. Petersburg, Florida, where elderly people spend the time reading, chatting or just taking the sun.

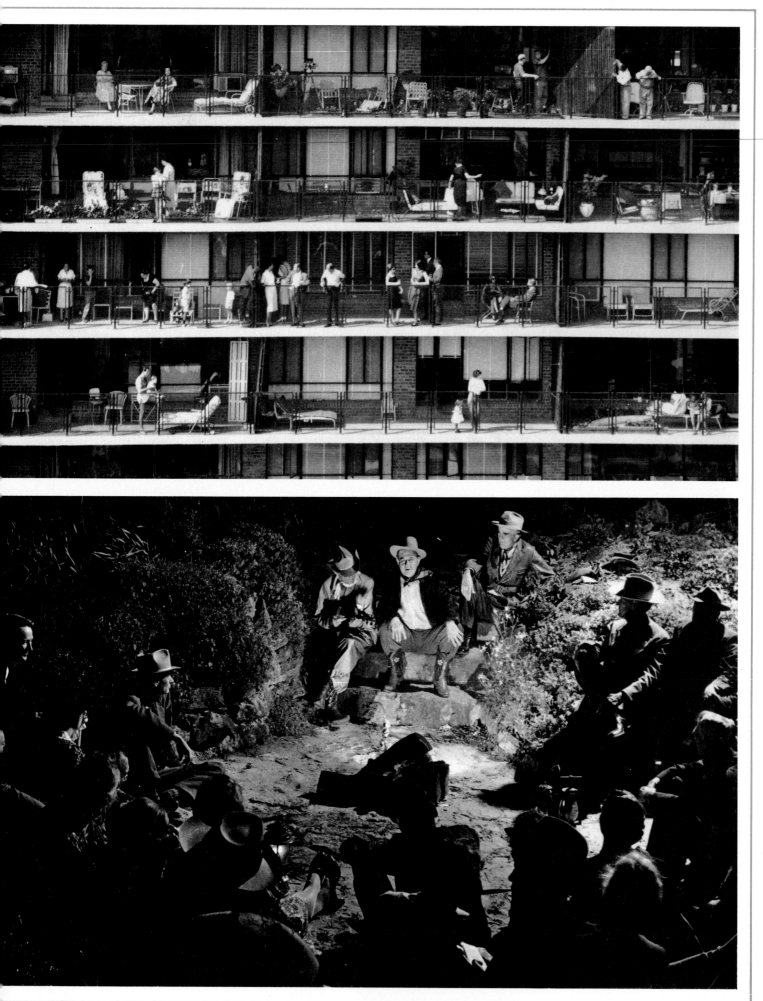

Even in a crowd, satisfactions for the taking

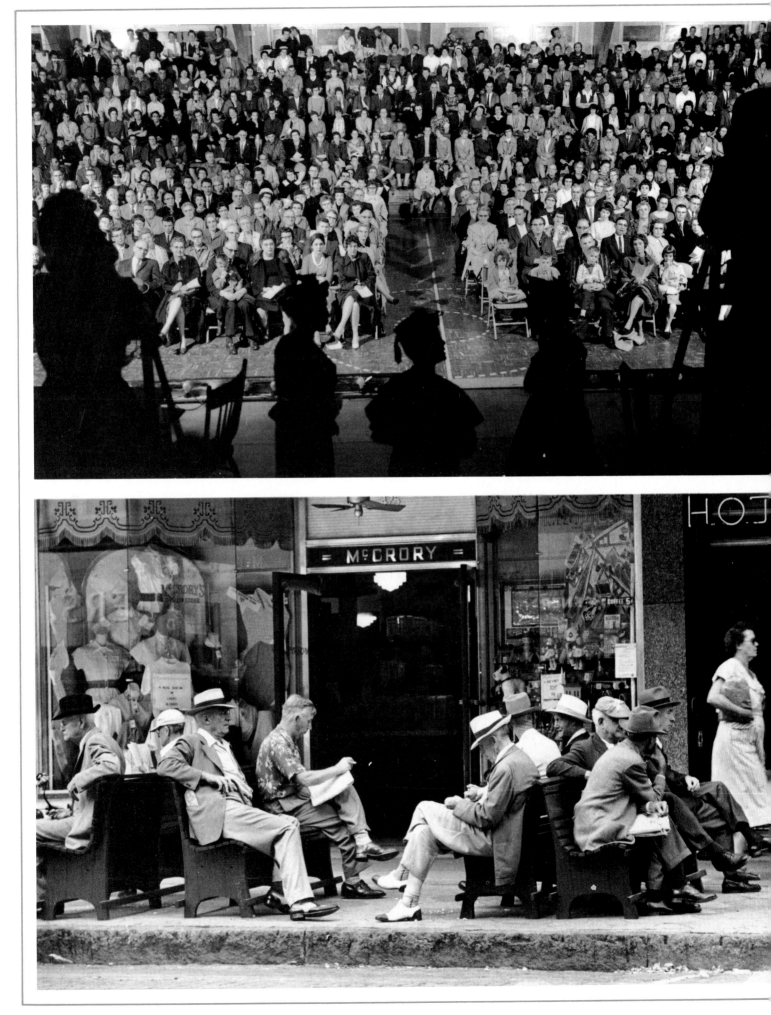

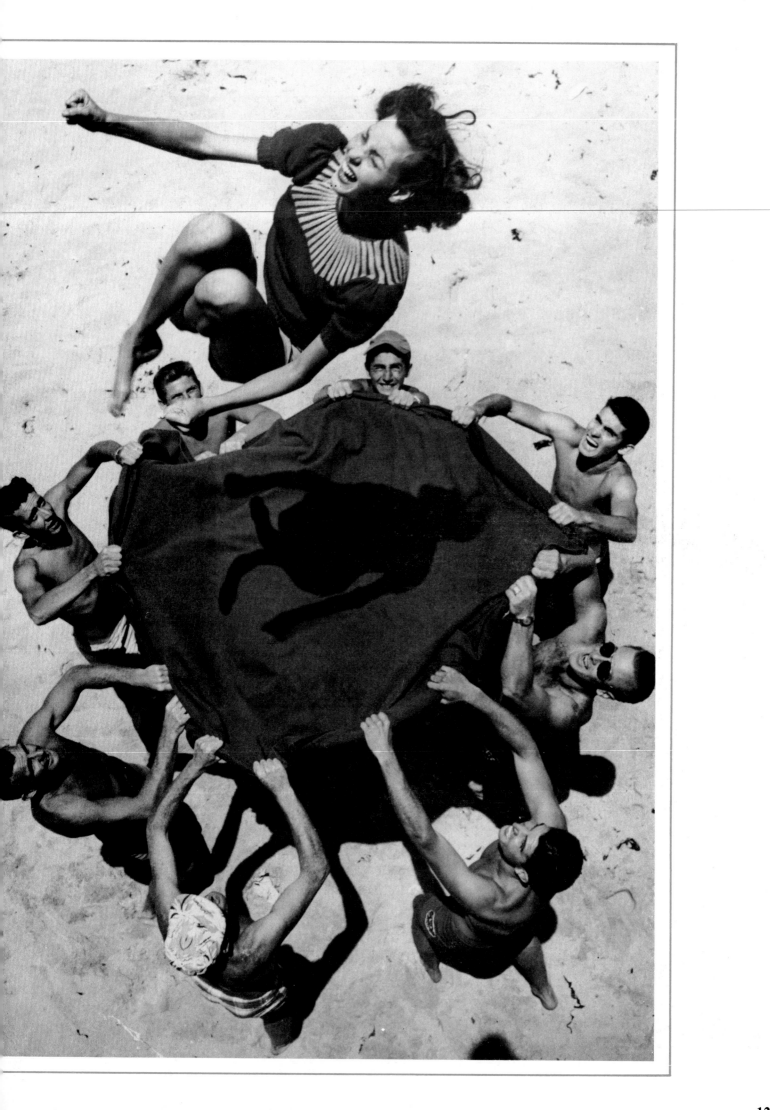

Fun and games for all ages

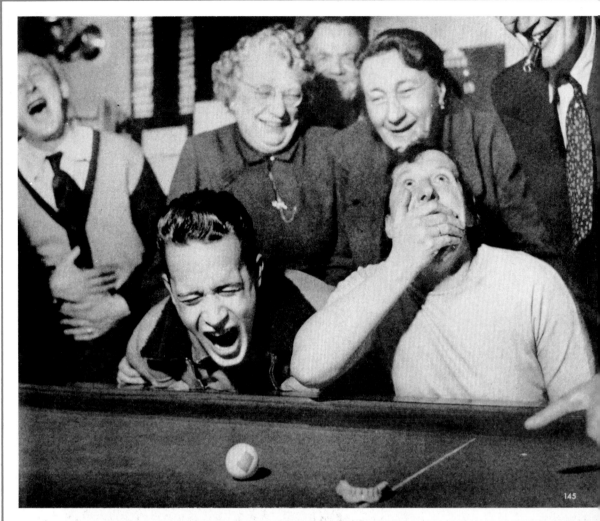

In an after-dinner egg-blowing game in Amsterdam, spectators go into convulsions of laughter when a woman blows so hard at the egg that her false teeth fall out. ● During an accuracy contest at a party for 15-year-olds, Caroline Askew doubles over and her chums cackle as her arrow misses the target completely and lands in the woods. ● Blanket tossing is a favorite—and inexpensive—pastime at Hermosa Beach. All that is needed are several pairs of strong hands, one blanket, one pretty girl.

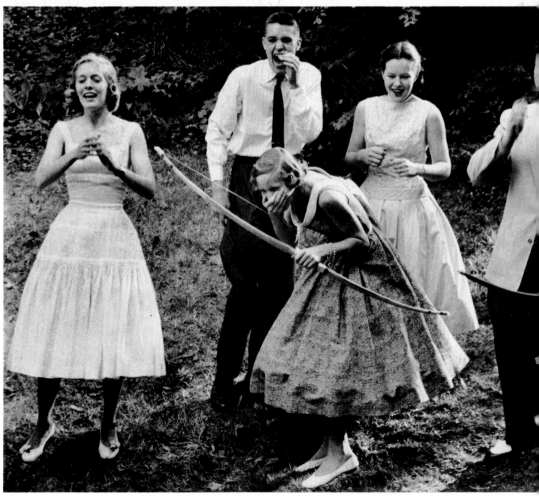

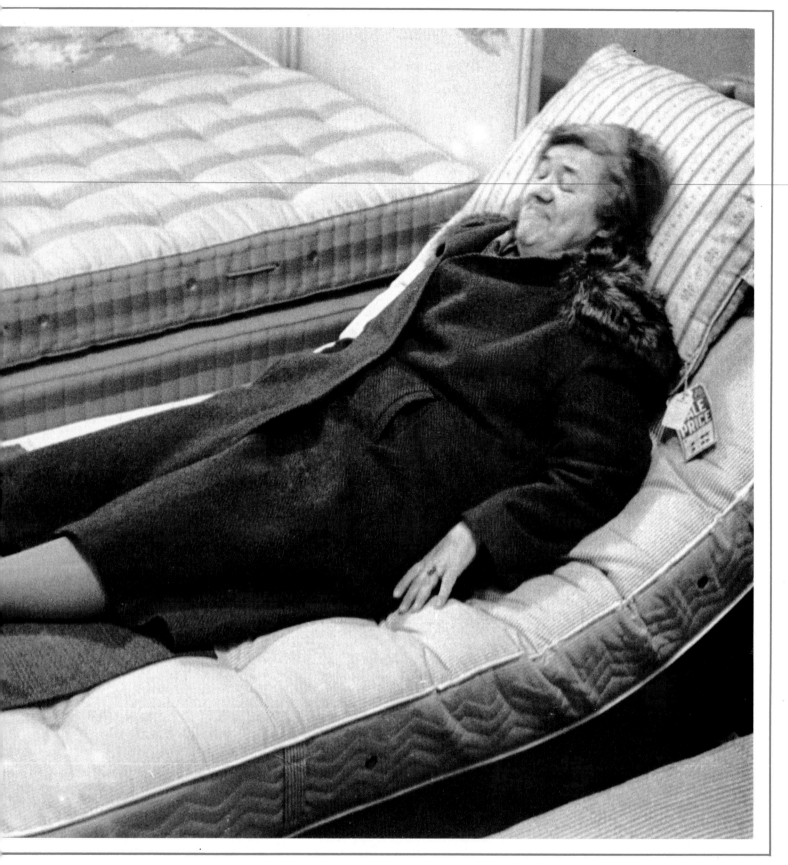

Who needs more?—A comfortable bed, a warm companion, a faithful dog and the blink of good TV. ● In delicious retreat from his four children and his electronics firm, Franklin Hobbs takes a hot soak and a cool read. ● A prospective purchaser finally finds what she's after—a backrest that props up the mattress and induces sheer contentment.

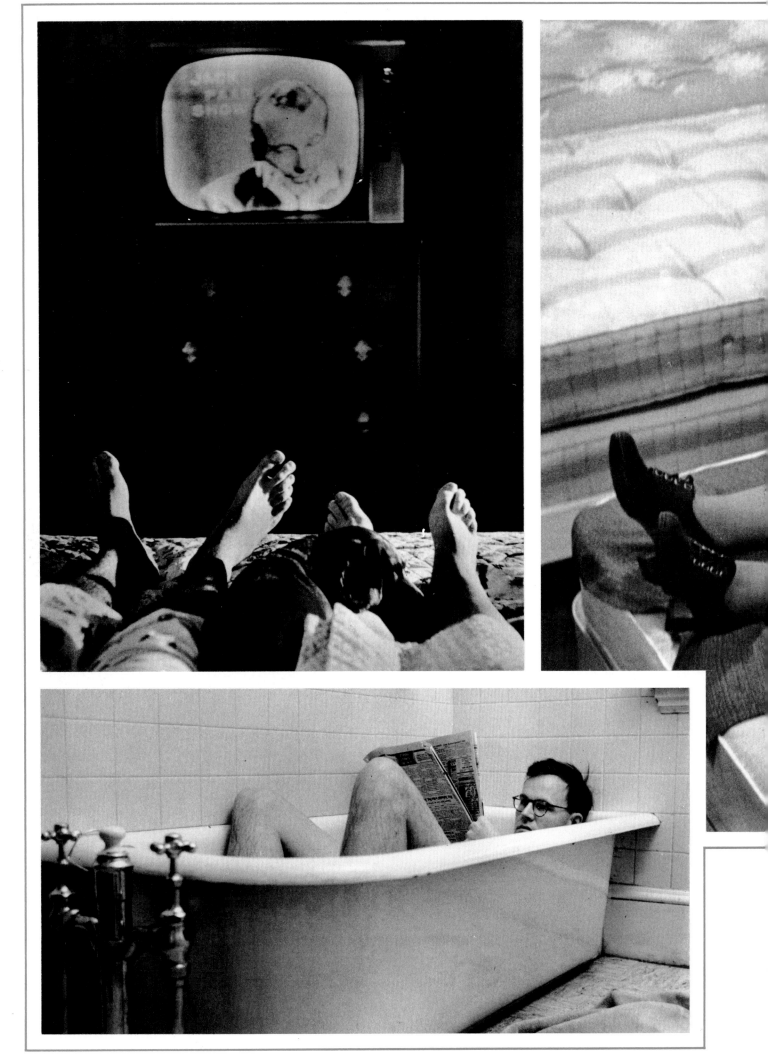

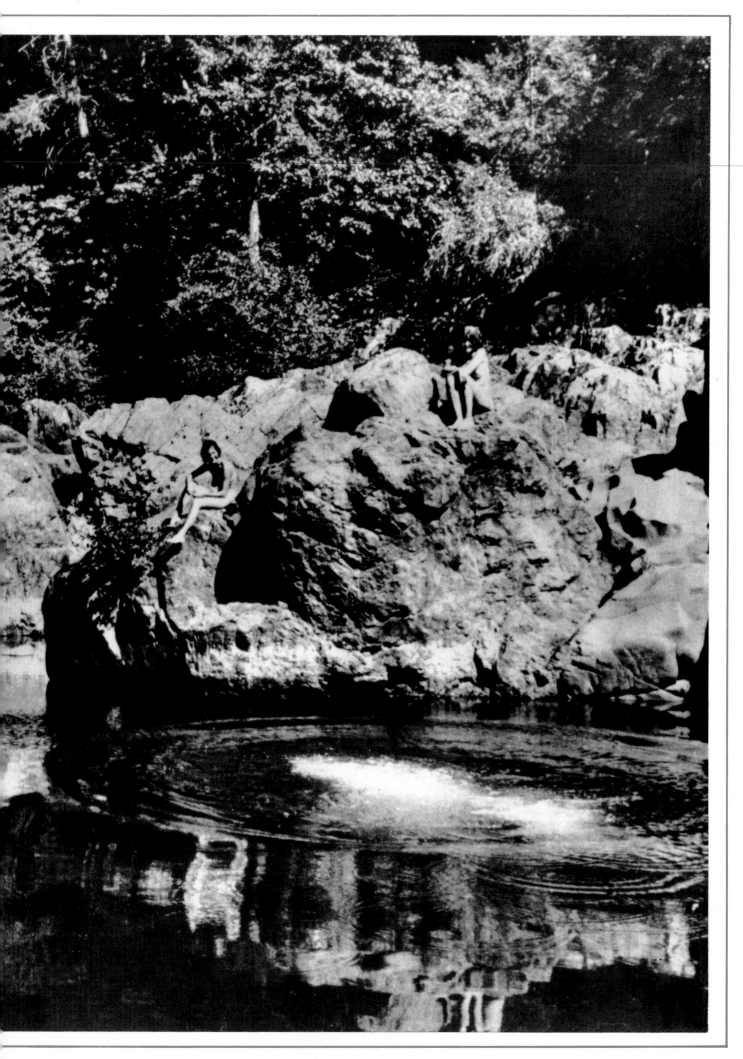

Keeping close to nature's beauty

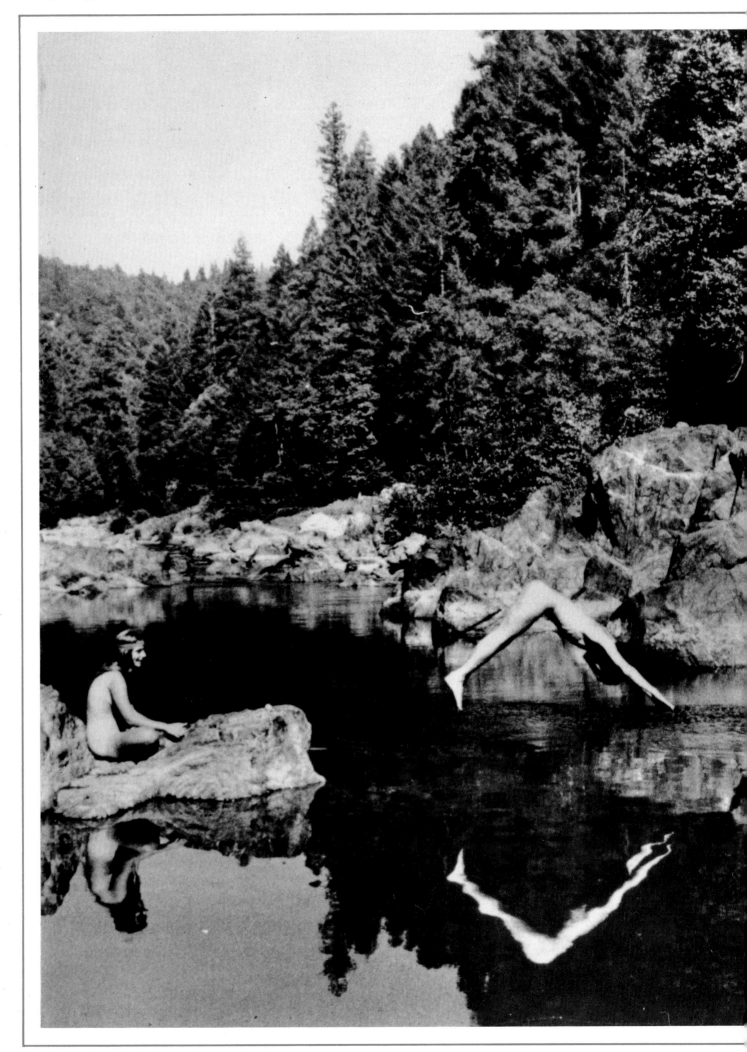

Daybreak for Virginia Newcome means a sizzling frying pan, children rubbing sleep from eyes, a long first sip of coffee. In a St. Paul, Minnesota, kitchen or through the mists above the village of Hatfield, Massachusetts, behold! another day is born.Í

Simple Pleasures

Those little things like raking leaves, or playing games, or tending house, or telling tales or even just plain laughing— they're the things that count.

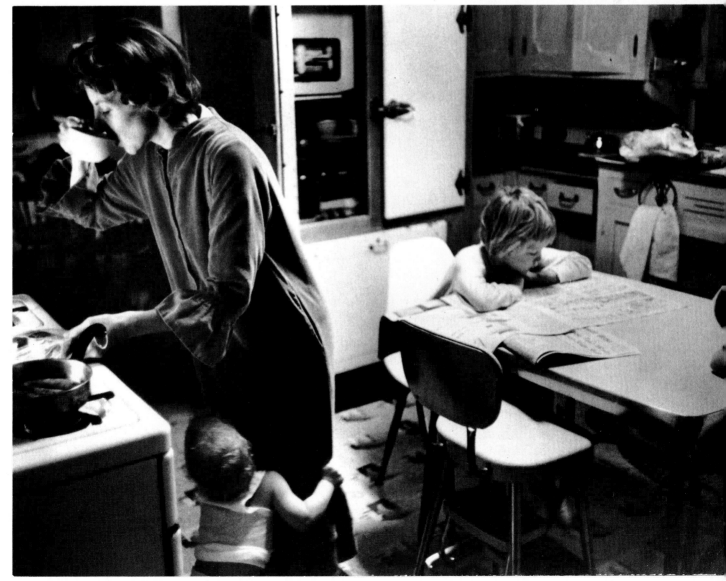

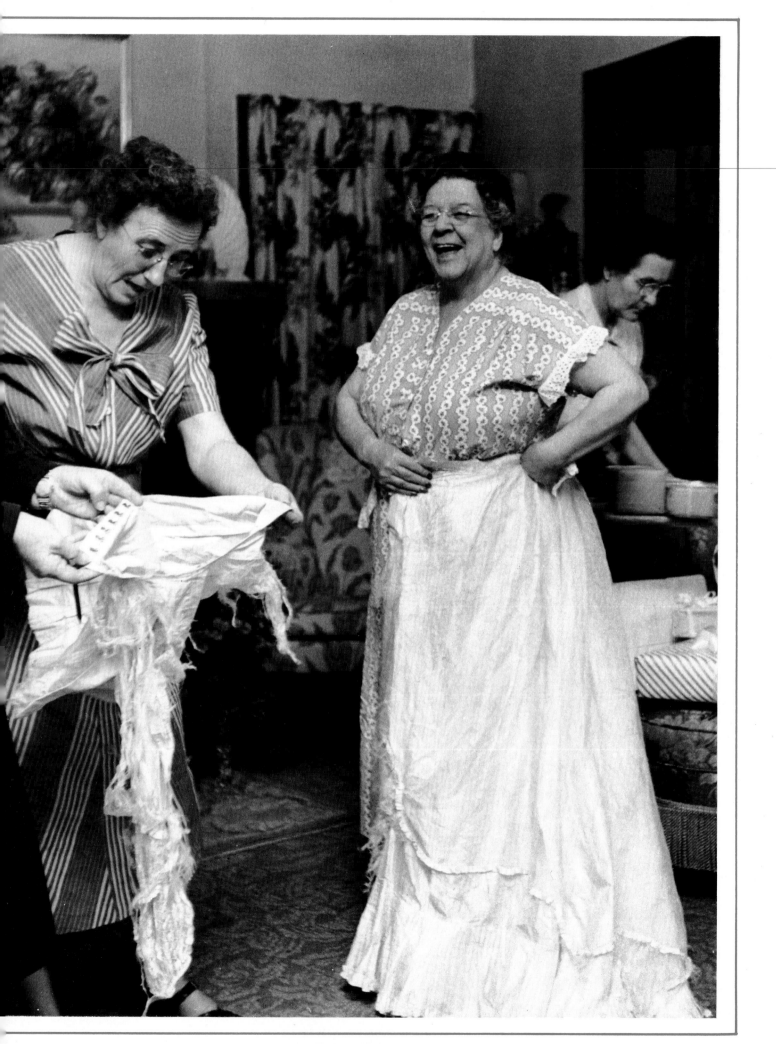

*After the ceremony, a shy inspection of the young bride's ring. ● Before another ceremony, this one
a 50th anniversary re-enactment, the bride tries on her original wedding skirt for size.*

121

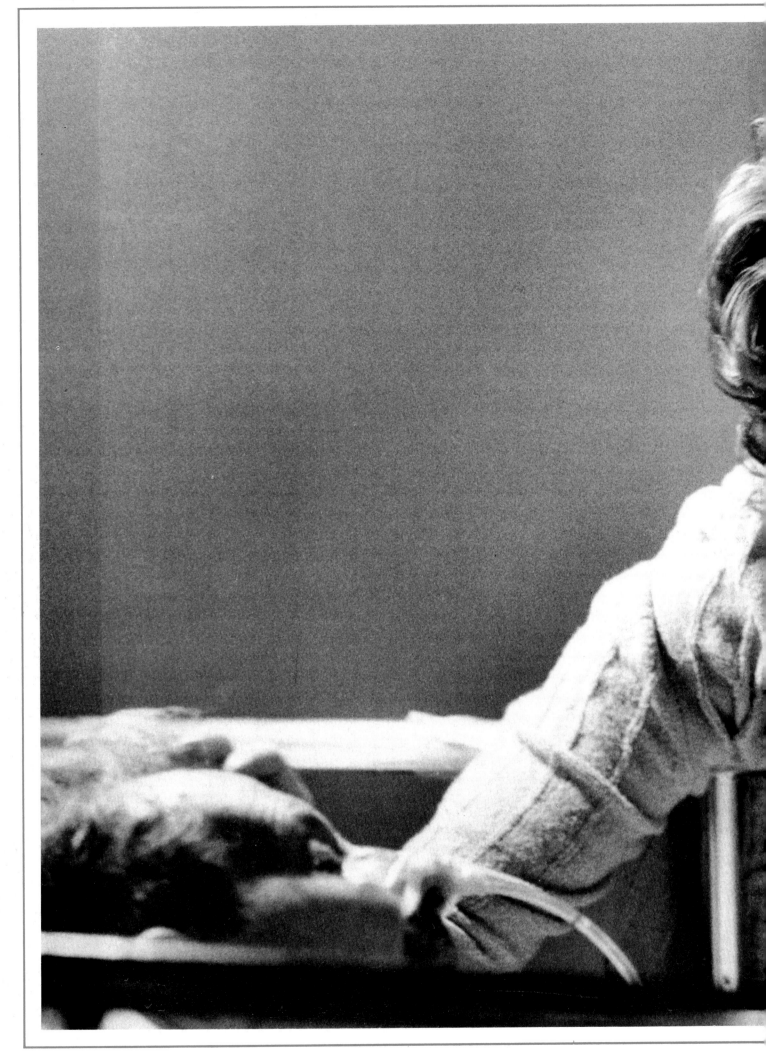

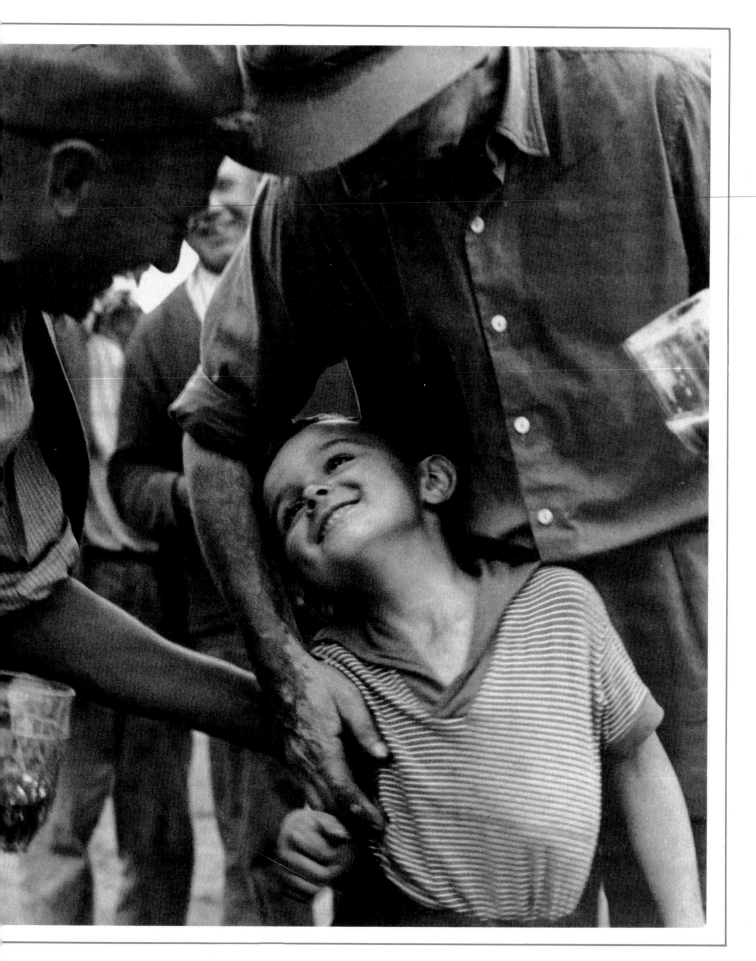

An instant of quiet affection between Alida Lessard and her daughter Sophie. • *What thoughts do they share,*
this four-year-old and his grandfather? • *A Hungarian boy enjoys the happy joshing of his father's friends.*

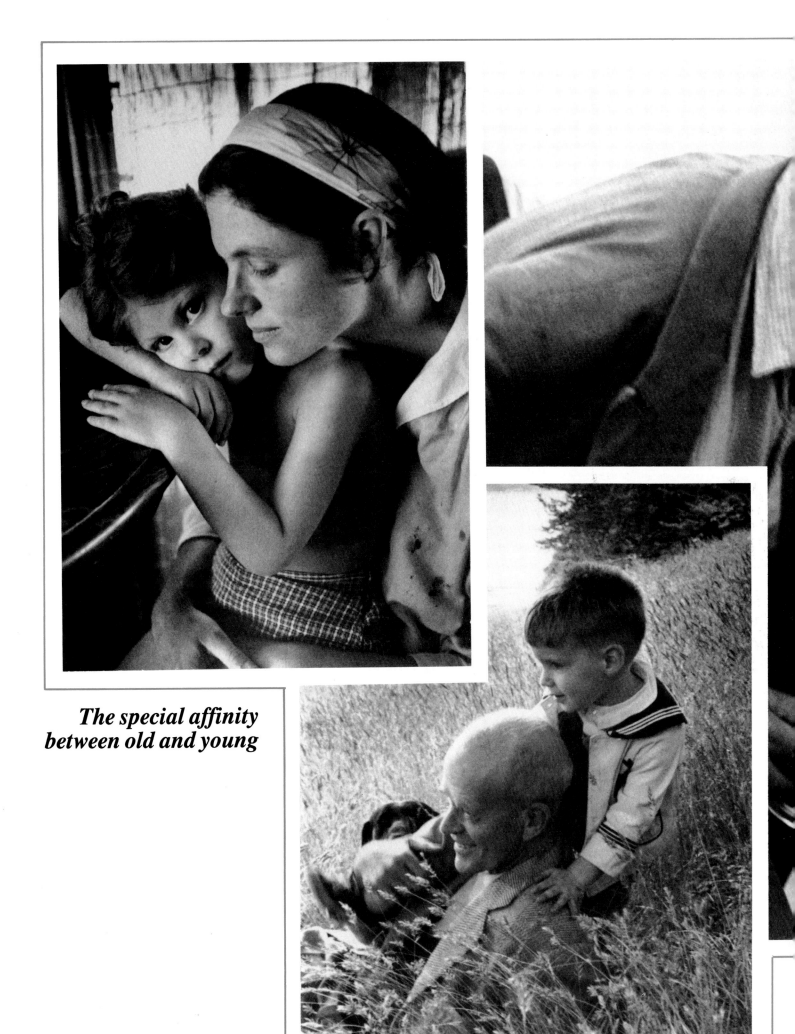

The special affinity between old and young

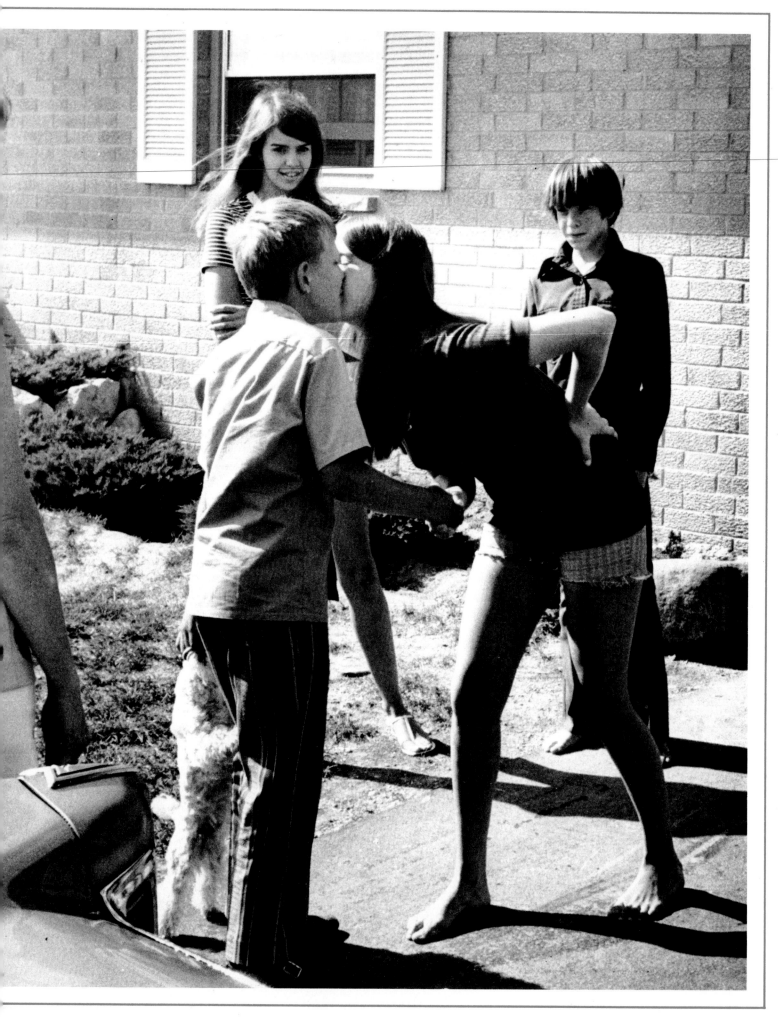

*A spontaneous, laughing nose bump of a little Hawaiian brother and sister. ● Big brother and kid sister
seeing eye to eye. ● A warm welcome for a former foster child as he is greeted by his new sister.*

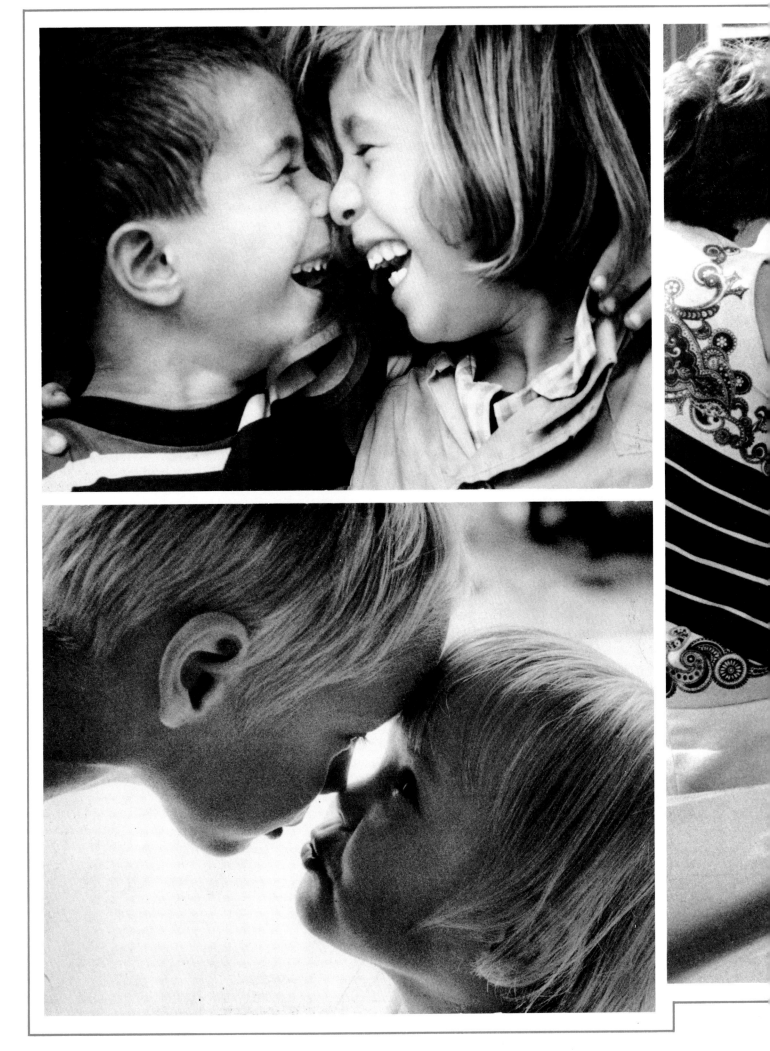

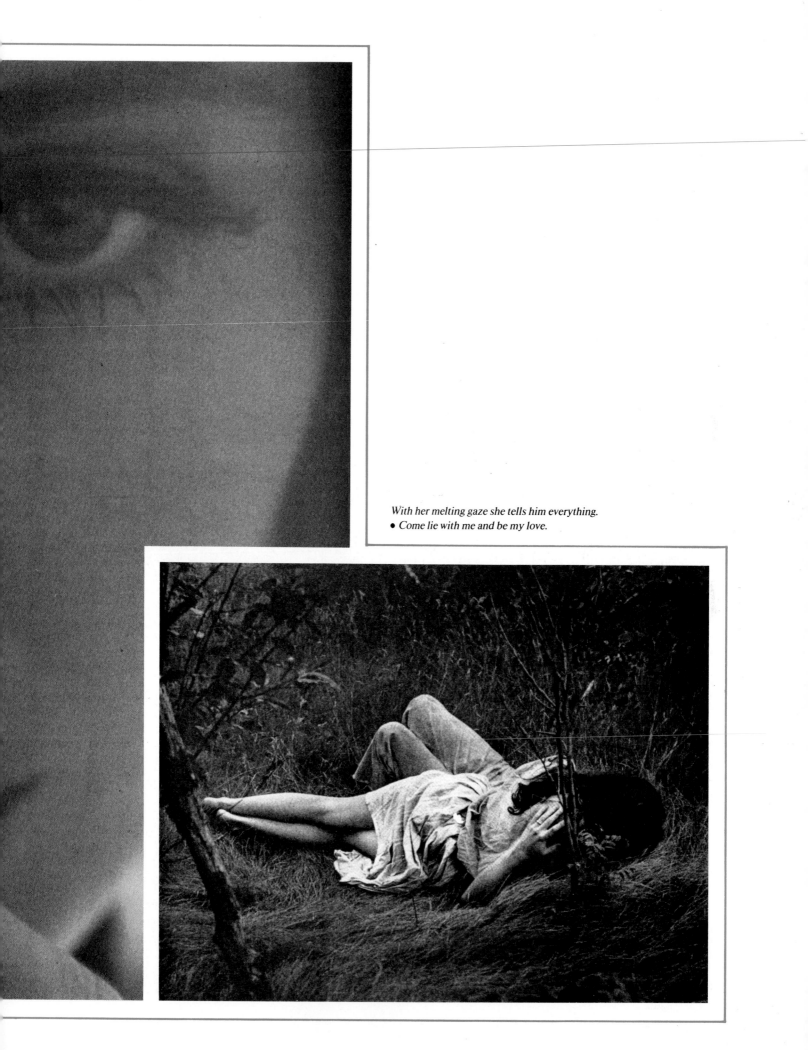

With her melting gaze she tells him everything.
● *Come lie with me and be my love.*

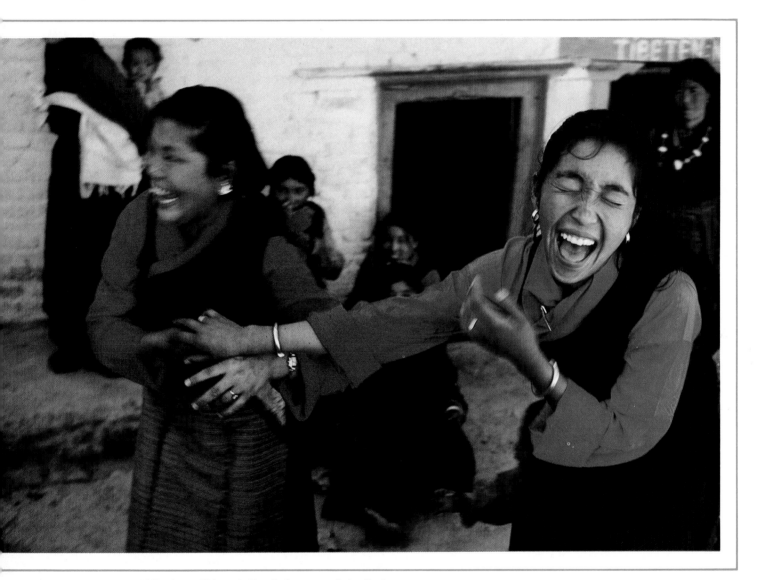

In the Parrot Jungle south of Miami, two Chicago ladies giggle away as their talkative hosts find comfortable perches. ● In Nepal a couple of Tibetan girls erupt in mirth while watching a shuttlecock game at a New Year's celebration.

Enjoying life in very different ways

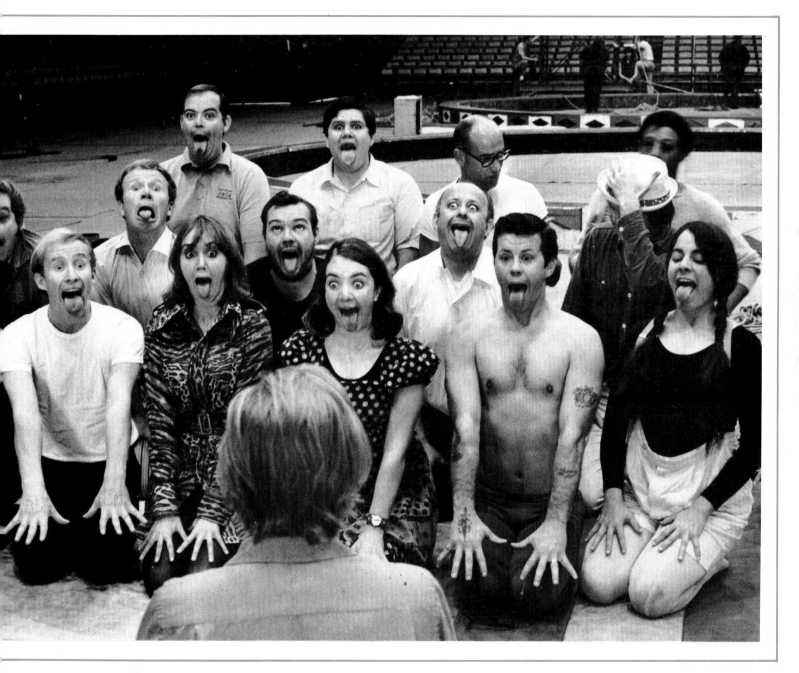

In Buenos Aires during the Peron years, aristocratic wives of Jockey Club members gather on the lawn in front of the marble pavilion from which they will watch the running of Argentina's biggest horse race. ● *At the winter quarters of Ringling Brothers Barnum & Bailey Circus in Venice, Florida, student clowns are put through a yoga exercise called the "lion" to rid them of their inhibitions.*

Amusements heightened by the element of surprise

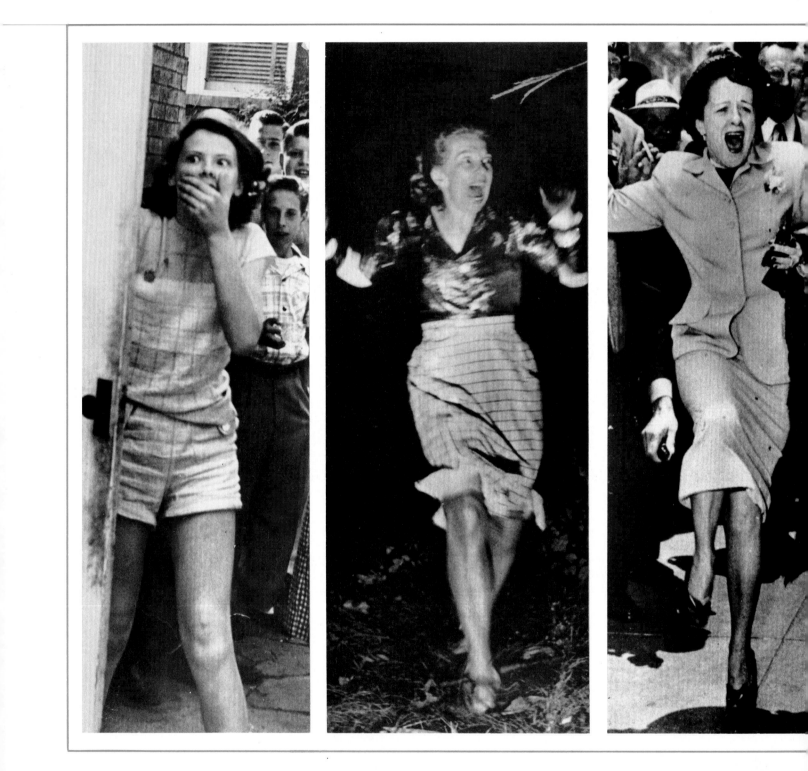

Thirteen-year-old Loretta Pechtl can't believe her eyes as she casually wanders out her back door and discovers she's at a surprise party—for her! ● At a Maryland Halloween party, "Billie" Biddison screams in terror as a ghost jumps out at her from behind a corn shock. ● A defenseless Los Angeles lady tries to elude a spray of freezing ethyl chloride administered by a celebrating Shriner. ● To help raise money for the March of Dimes, coed Joan Ruden pokes her head through the target hole and takes a direct hit in a pie-throwing contest.

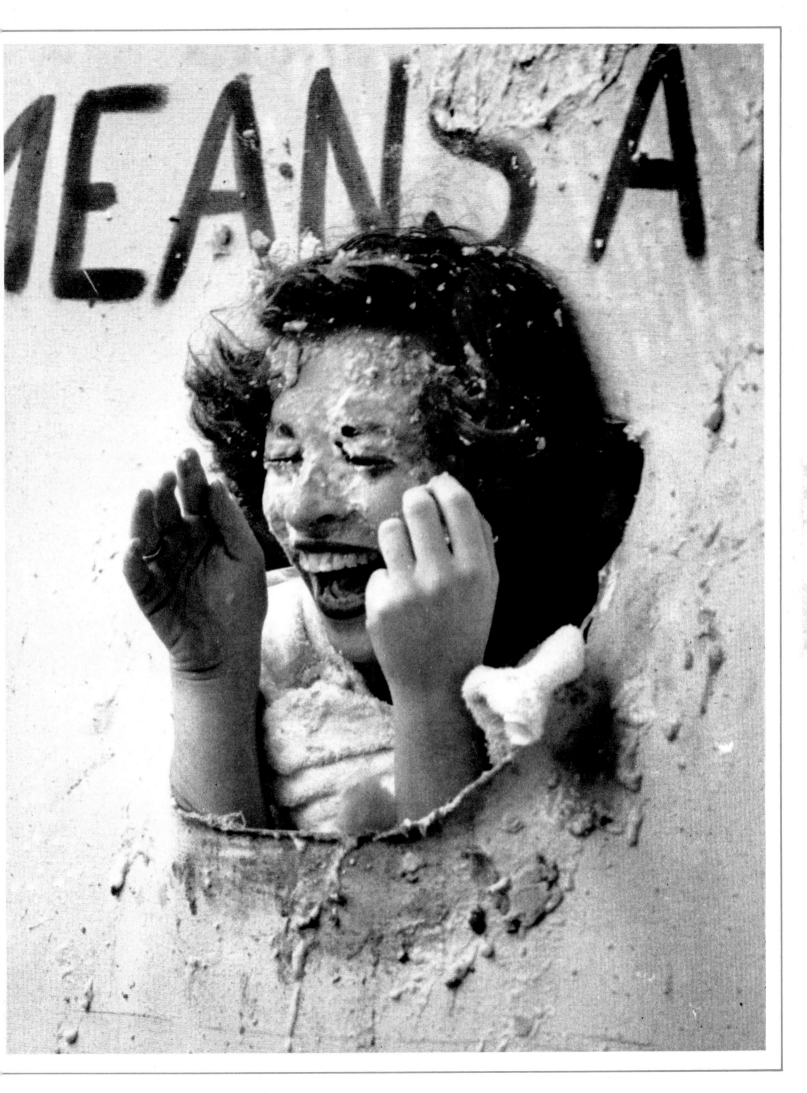

Satisfaction from an autumn burning

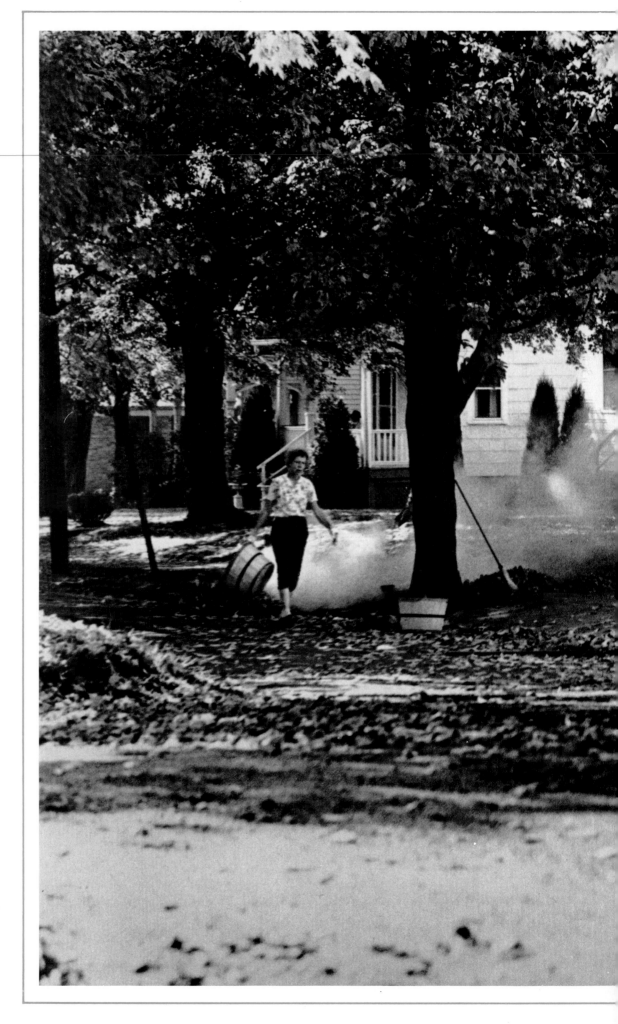

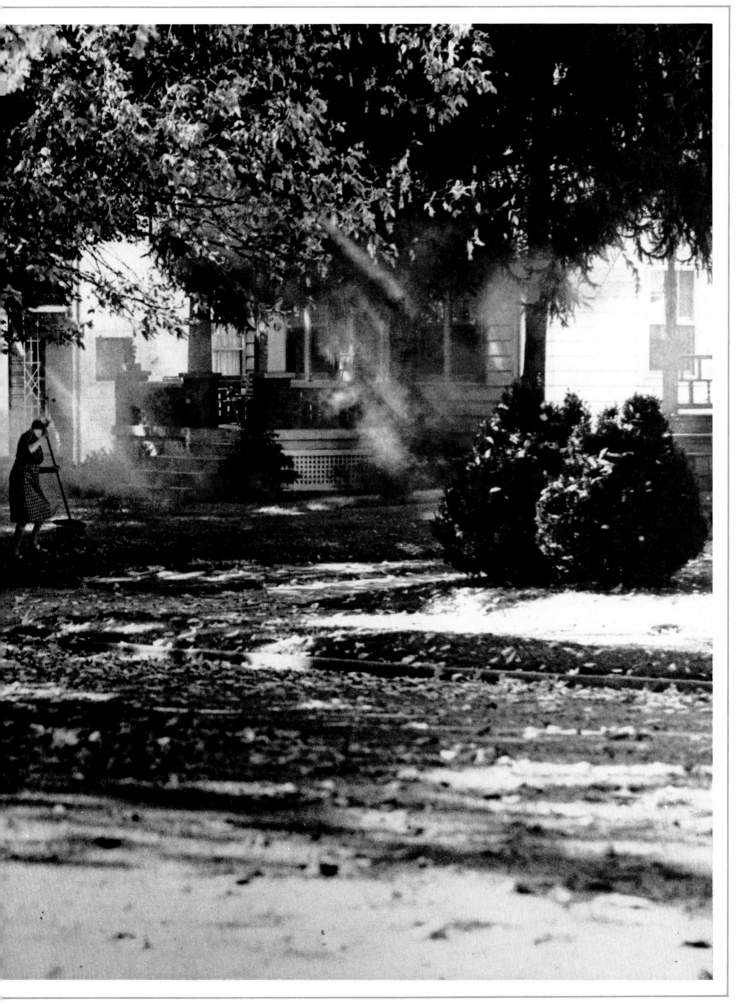

The delicious smell of leaf smoke fills the Ohio air as women rake and carry in an annual front-yard ritual.

Our Animal Friends

They purr and whinny, bark and squeak. We share their origins, these fellow members of the animal kingdom. Companions close, they give us their devotion. We care for them, they comfort us.

A graduate of Emory University, Susan Wilson rejoices over her special interest— rare orangutans, their breeding habits and their behavior as parents.

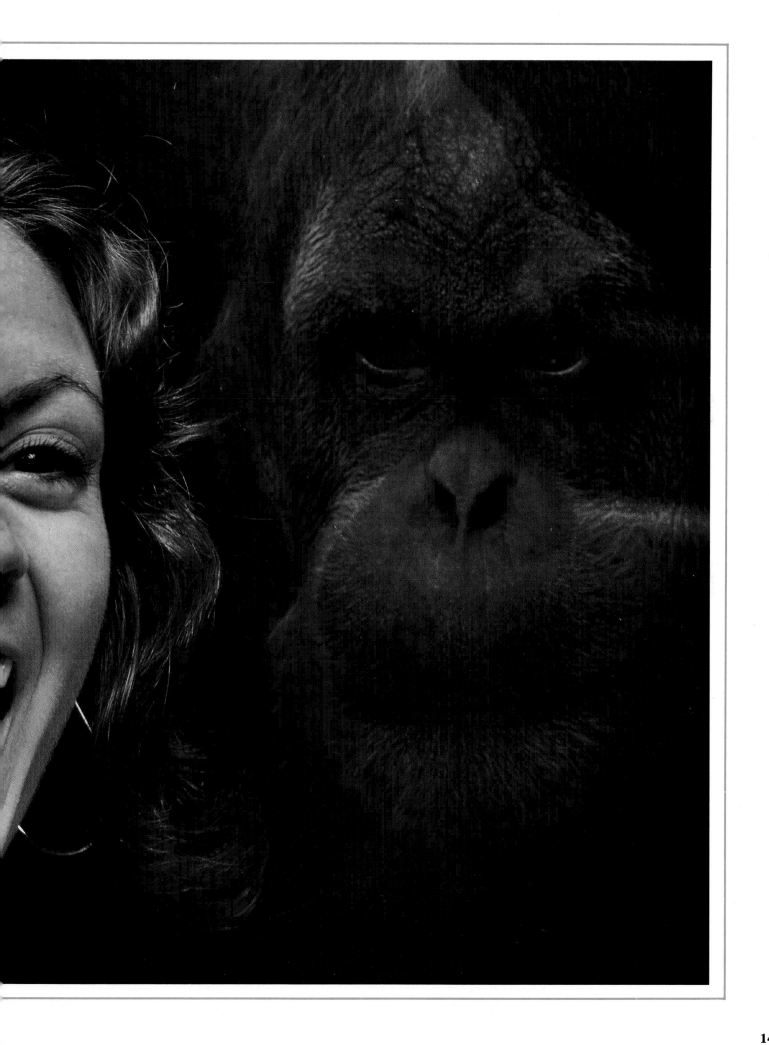

Greetings, you wiggly little balls of softness

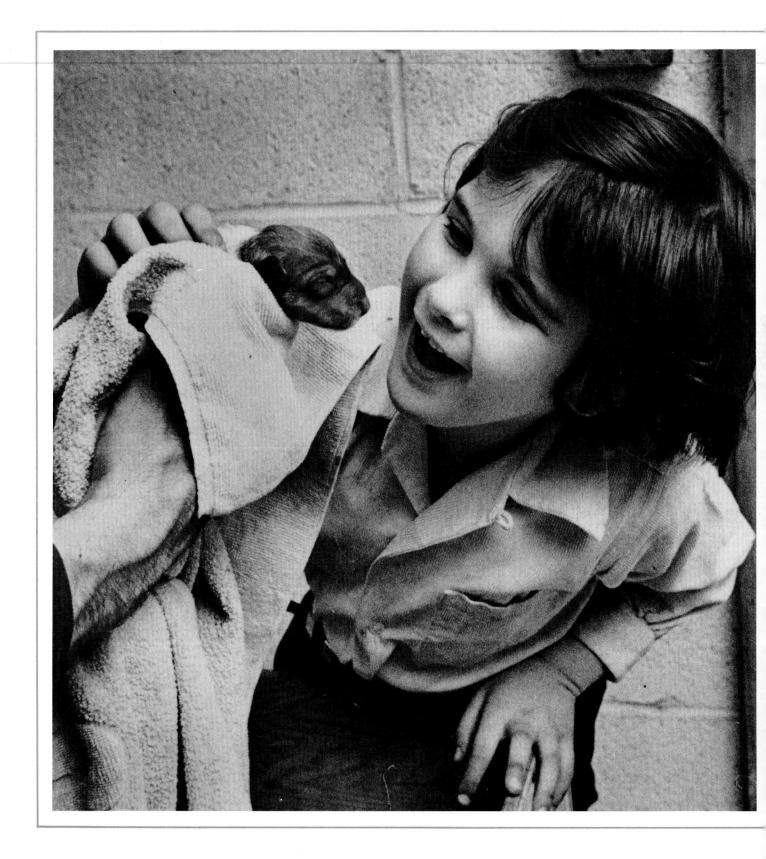

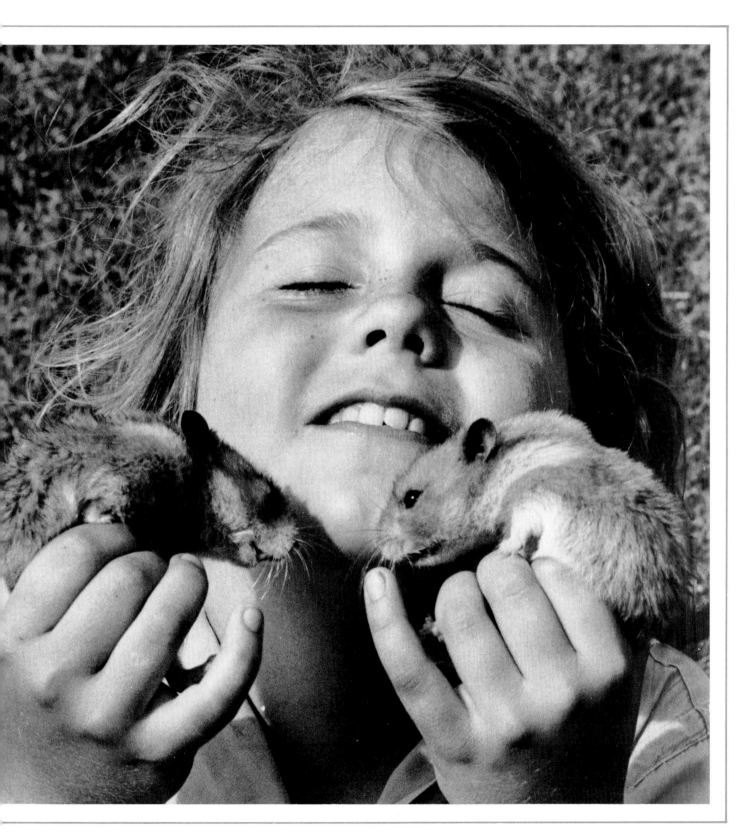

Six-year-old Marion Goldings is captivated by the tiny, wrinkled face of a new-born collie. ● *Ten-year-old Shelley Silk basks in the nuzzling of her two little hamsters.*

143

For lucky young girls, a short, happy romance

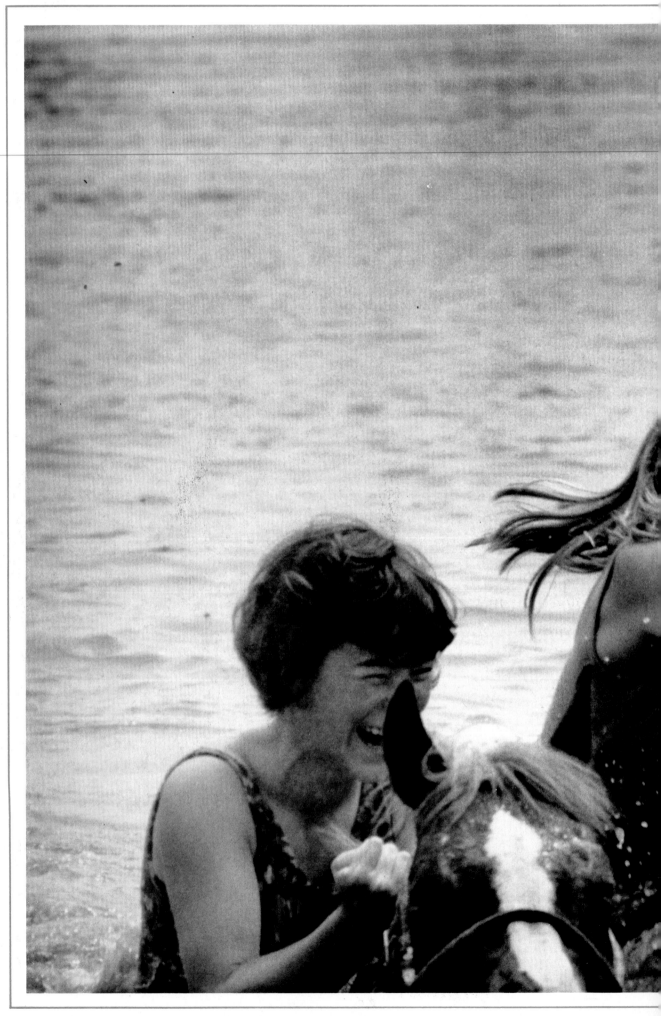

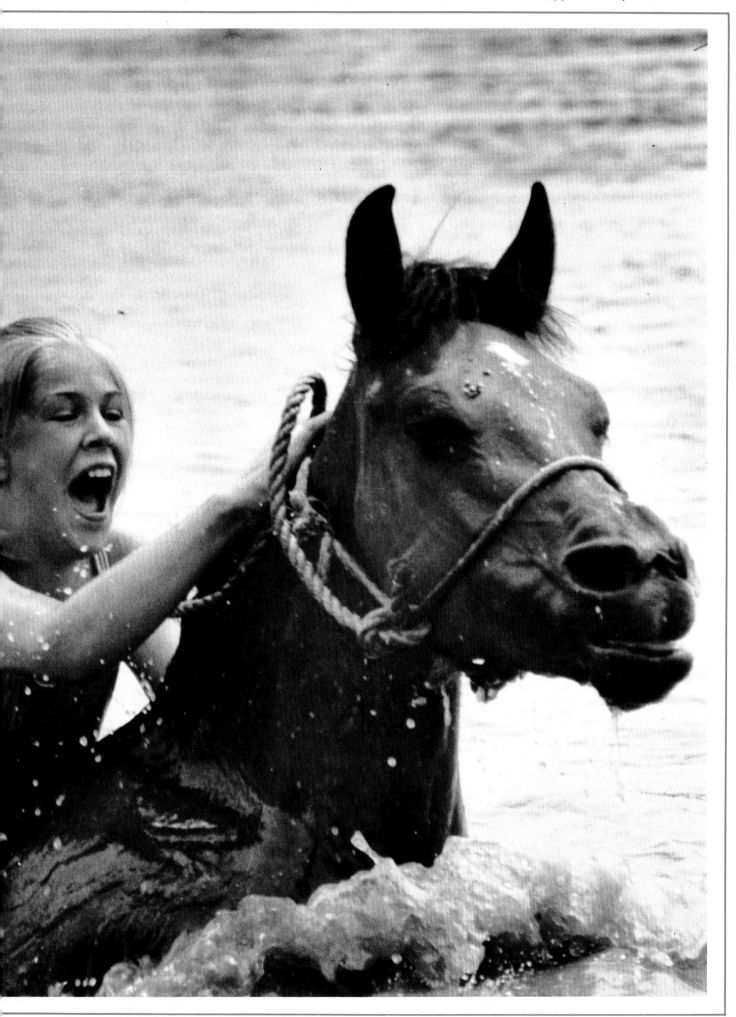

Hair streaming and eyes alight, blond Sidney Hoyle and Jane Boleyn swim Twinkle and Zero Weather across a lake. The horse-struck girls are typical of thousands who each year yearn for riding habits as their big sisters yearn for wedding gowns. Usually the crush is soon over.

Man's best friend comes in many models

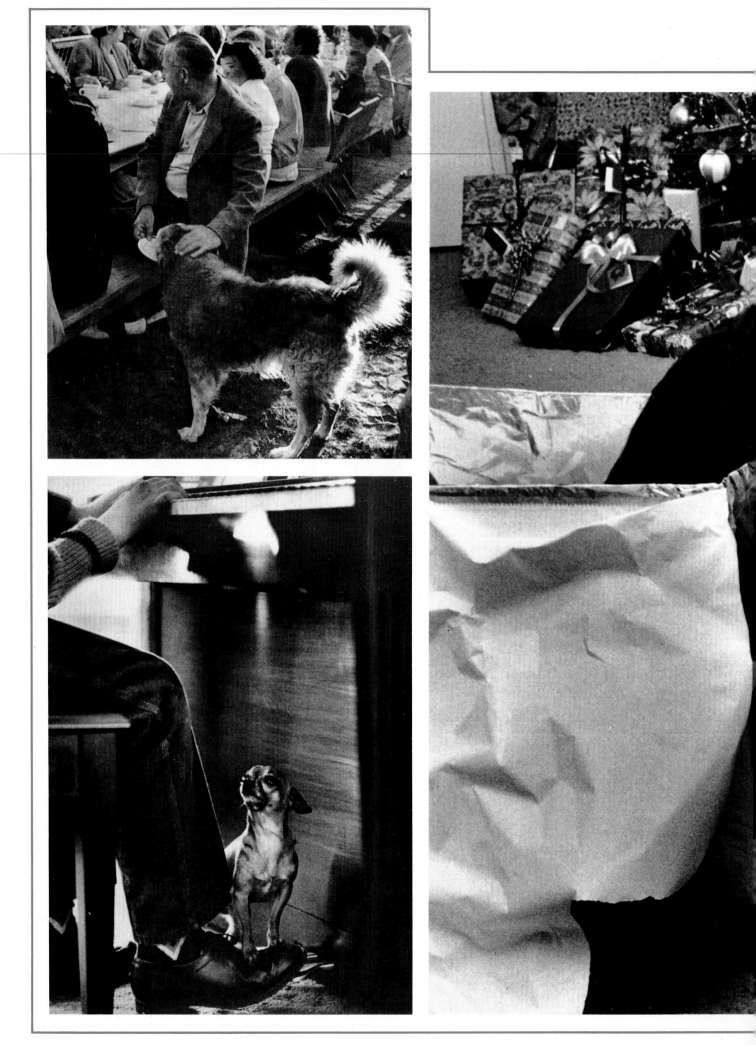

At a Grange supper on Martha's Vineyard, Massachusetts, a farmer sneaks some baked beans to a friend. ● Lending a helping paw, a Chihuahua named Sniffy presses down on the pedal foot of his master, Roger Rulifson. ● Three-year-old Susie McFarland and her brother Raymond open a present on Christmas morning and out pops Kokiuk, a 10-week-old Airedale from Santa Claus.

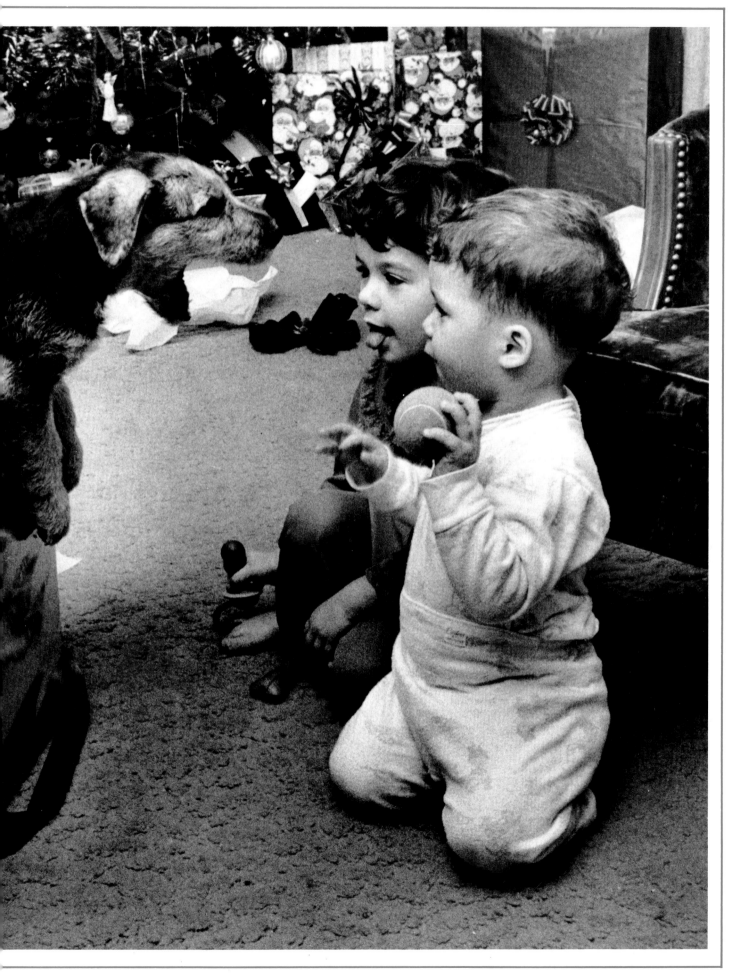

Kitty-cat, kitty-cat, just right for hugging

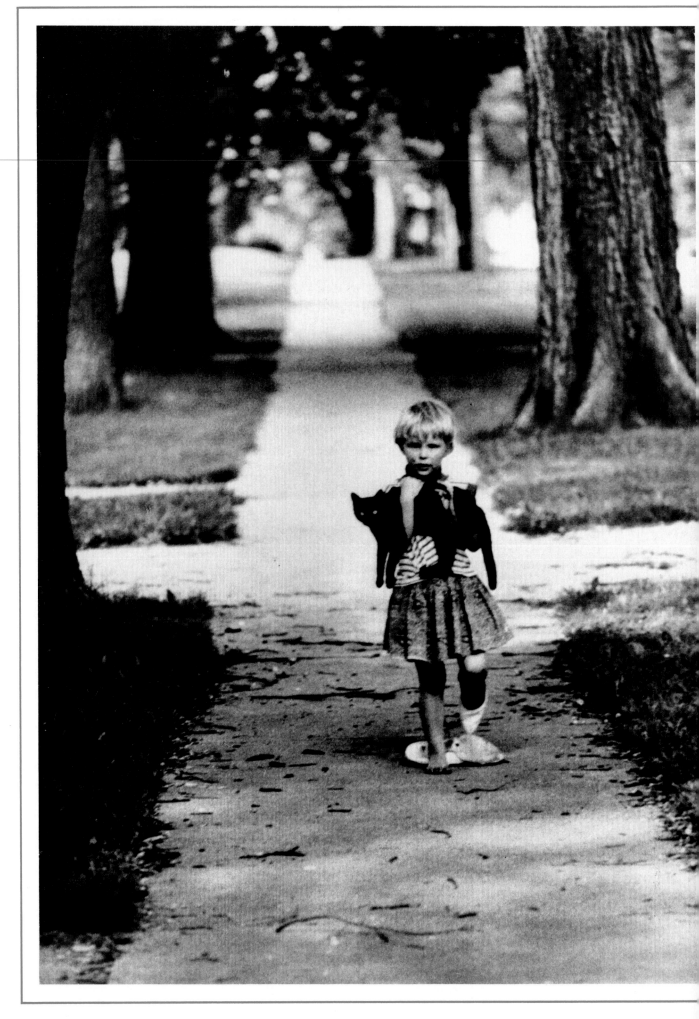

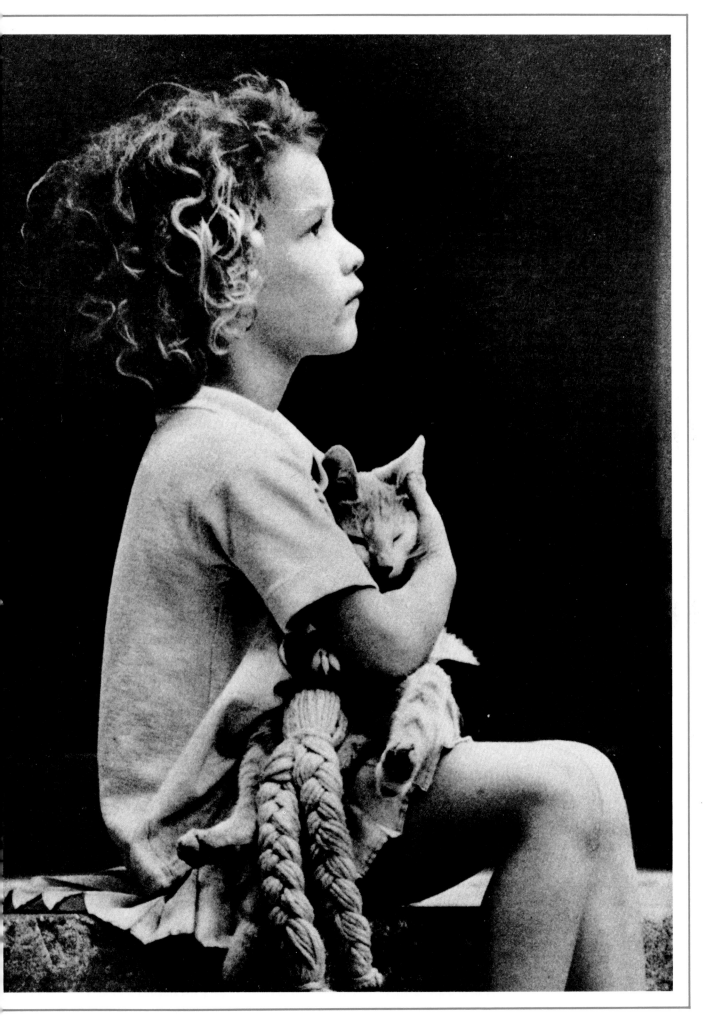

A solemn walk with a friend under the elms of Webster City, Iowa. ● A kitten and a braid doll share the lap of six-year-old Lavina Nugent, who's off in the stars somewhere.

A vote of disapproval for a couple of foxes

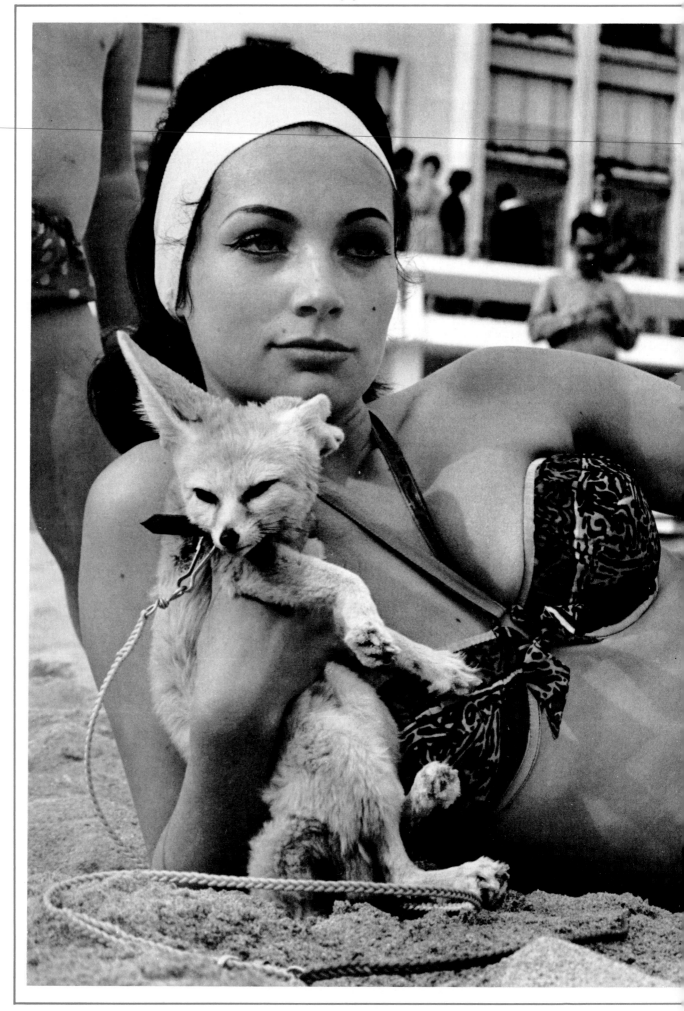

Except for this dissenter, almost everybody at the Cannes Film Festival admired the miniature fox and its mistress,
Philomène Toulouse, an art student from Paris, doing her darndest to break into the movies.

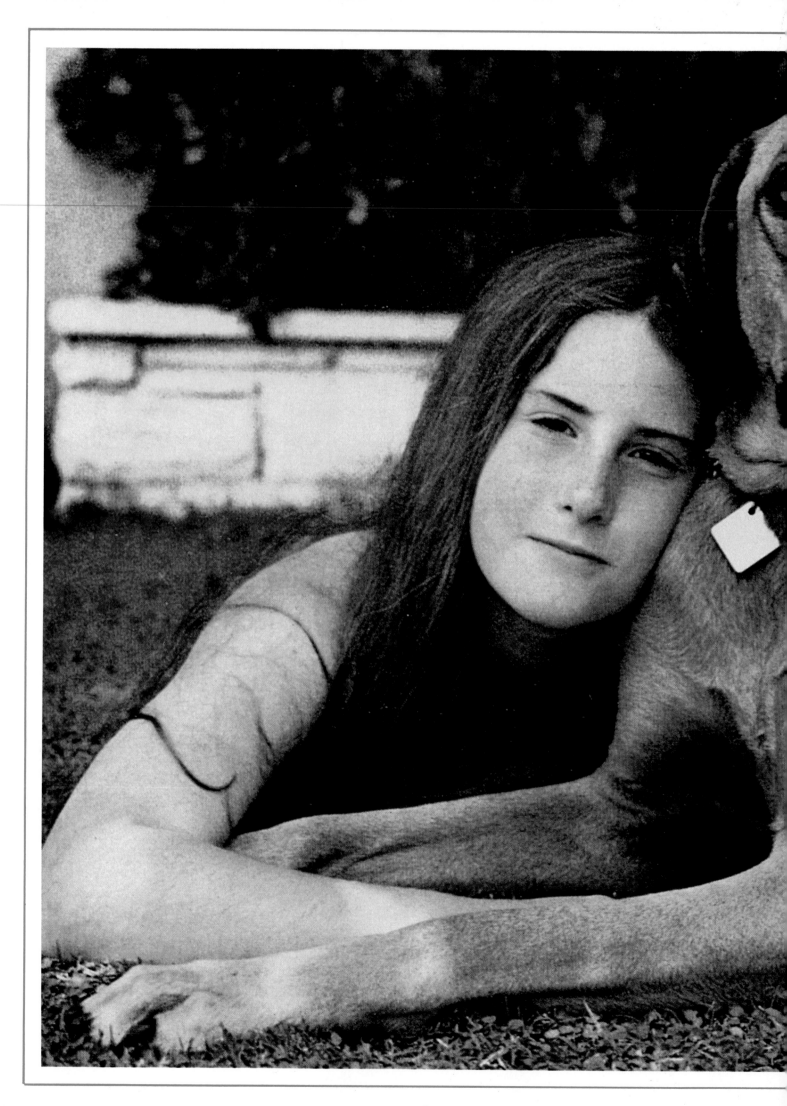

Camaraderie that melts the heart

Katie Whitmore, 11, with the family's Rhodesian Ridgeback. ● Fourteen-month-old Craig Anderson and four-month-old Blazer.

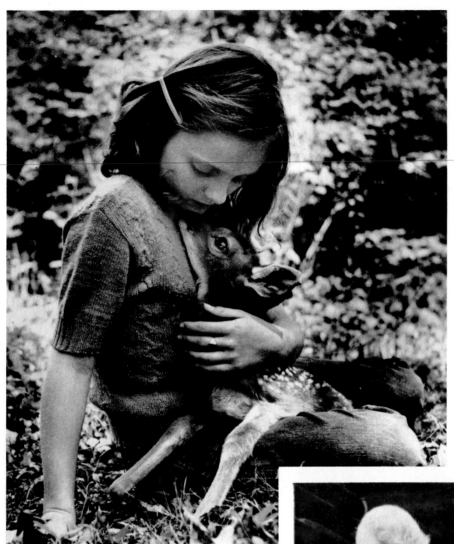

Looks and licks that hog the spotlight

A lost fawn nestles up to 10-year-old Dawn Duncan, who fed her new pet milk from an eyedropper and carried him everywhere until New Jersey officials decreed that Toby was dangerous and banished him to a game refuge. ● A pet of a Salt Lake City doctor, this 135-pound African lion cub demonstrates its affectionate nature on the head of Jim Carroll, a total stranger. Lions' tongues feel like No. 1 Grade sandpaper. ● At the 1959 National Western stock show in Denver, Byron Meech puts a Poland China barrow through its paces. Meech's hogs took 10 first prizes and six seconds.

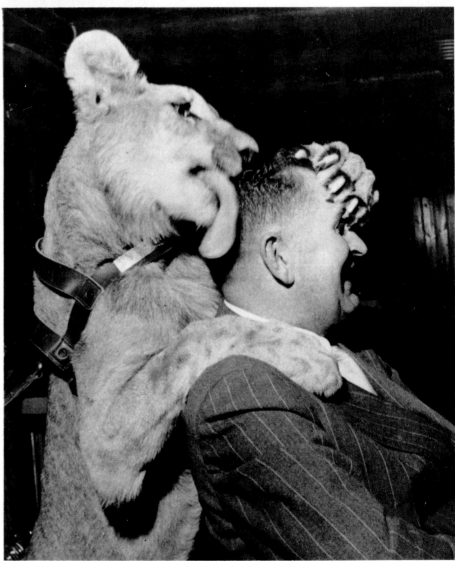

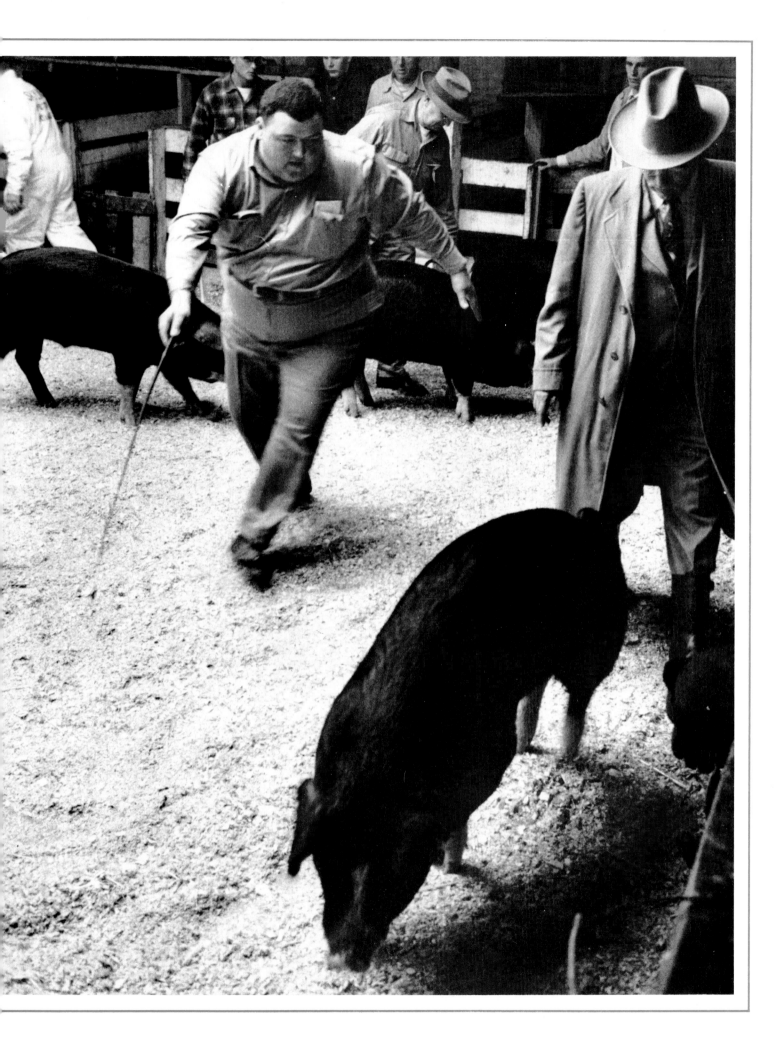

You-bad-dog-go-on-home-do-you-hear-me?

Opening day of school is a sad day for dogs the nation over. Now their summer playmates have to leave them home with stern orders not to follow, just what eight-year-old Judy Lynn Bates of Winston-Salem is telling Rusty.

Steppin' Out

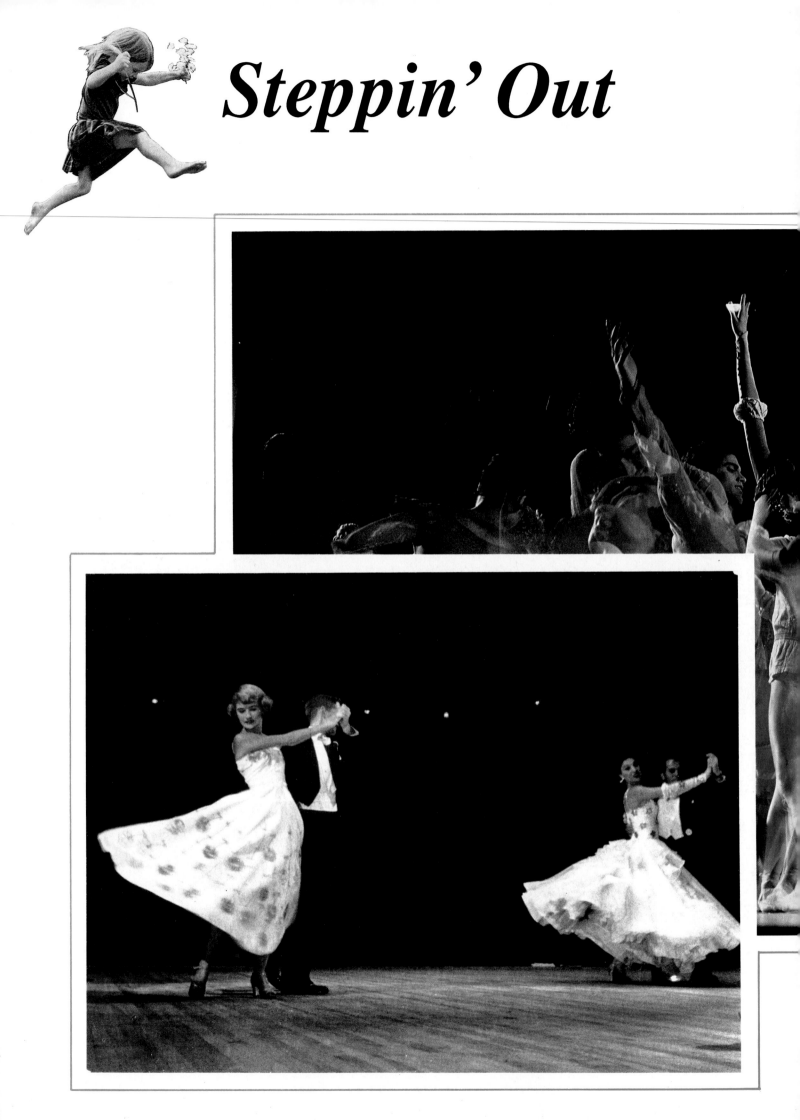

When work is done and darkness falls,
comes time for music and bright lights,
for spiffing up and tripping the light fantastic.

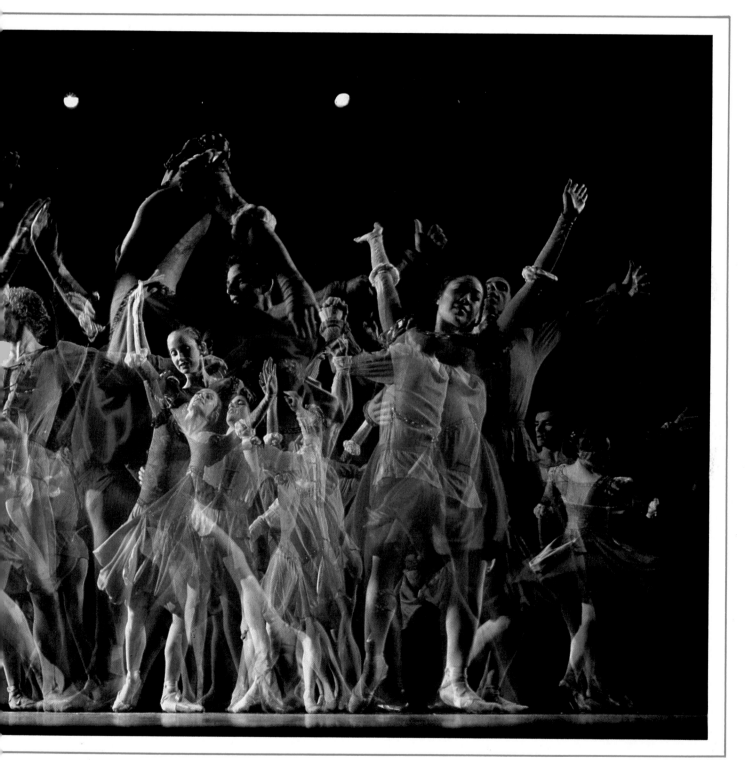

Her skirt aflare, 16-year-old Nancy Charleson and her 17-year-old partner strut their stuff at the Harvest Moon Ball. ● Aflame
with color and motion, this triple exposure captures the rhythmical, riotous beauty and exuberance of dancing.

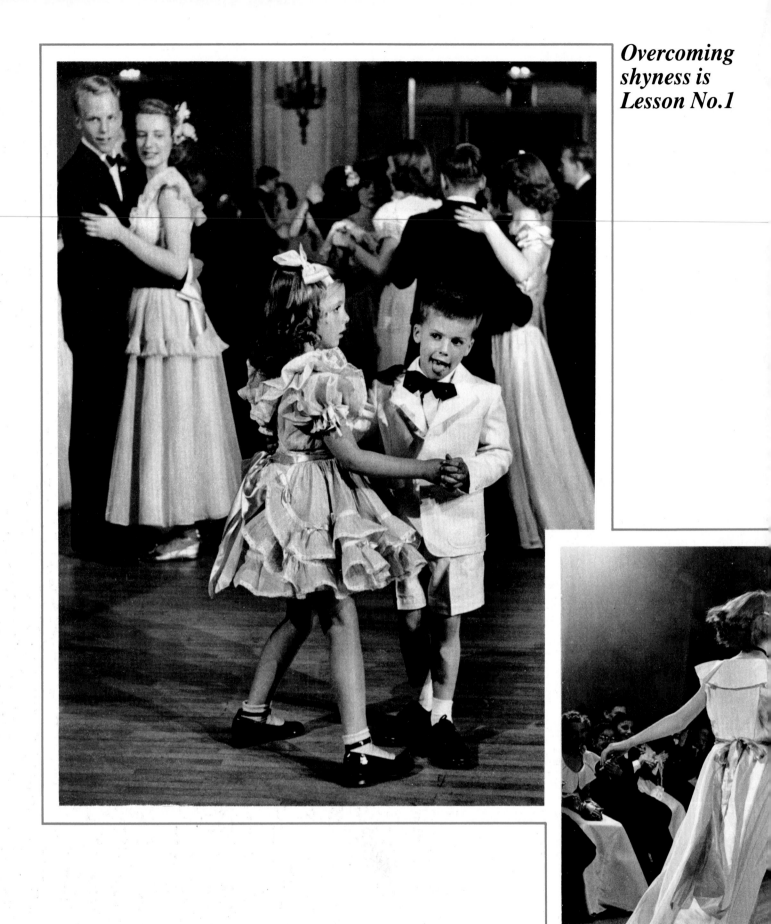

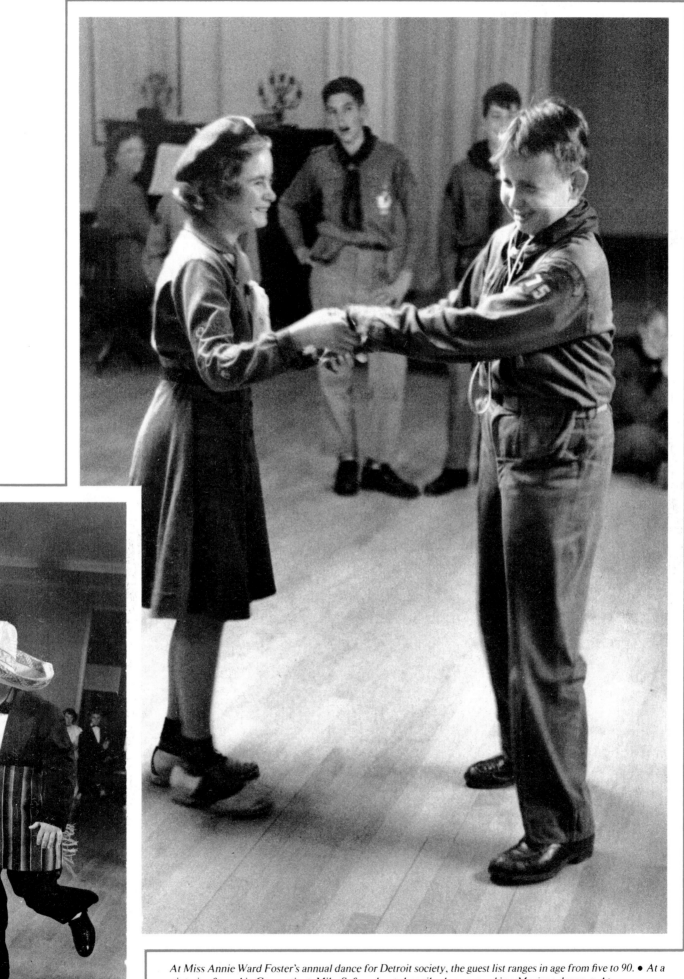

At Miss Annie Ward Foster's annual dance for Detroit society, the guest list ranges in age from five to 90. ● At a pint-size formal in Connecticut, Mike Safranek gets happily slung around in a Mexican dance. ● At a California scout mixer, hesitant partner James Zinn shies away from pretty Pat Archibald.

*With a little more growing up comes
intimacy and loss of inhibitions*

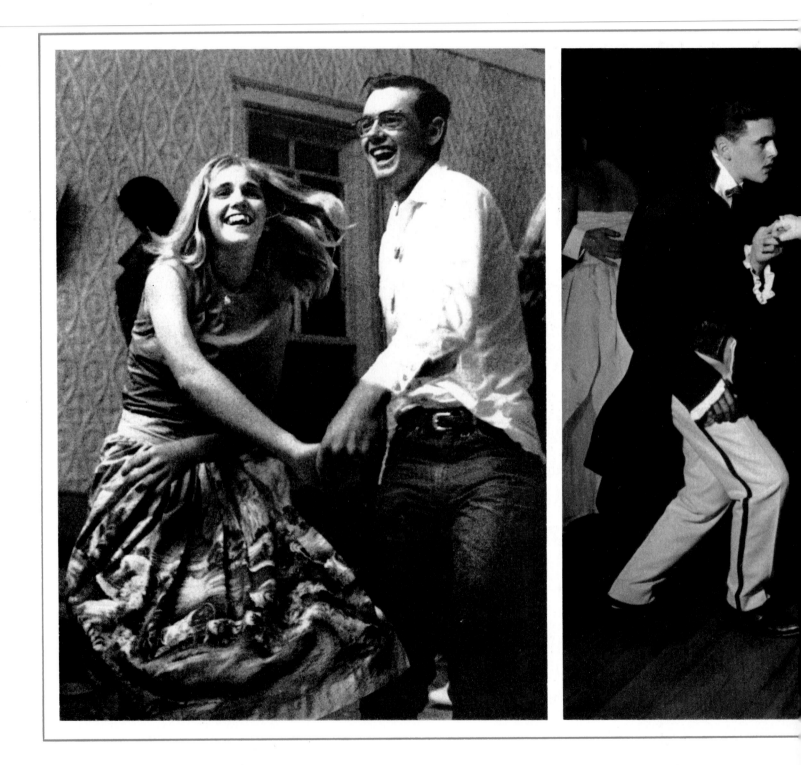

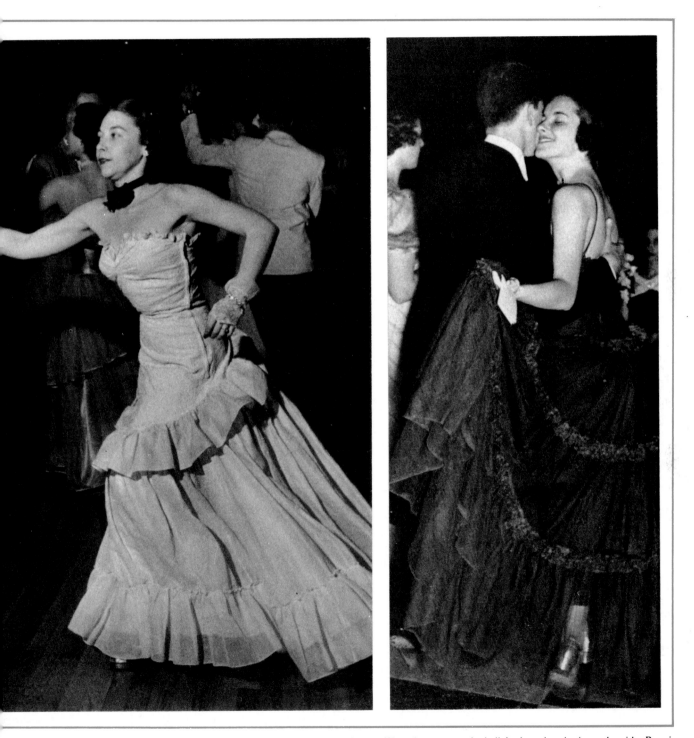

In the Casper, Wyoming, community hall, junior prizewinning rodeo rider Bonnie Graves, who is just discovering boys, twirls ecstatically in the lindy. ● Between strains of Dixie and the rebel yells at Auburn's Old South Ball, Sid Fillinjim helps honor the Confederacy and secession with a jitterbug maneuver that catches Jean Edgemon off-guard. ● A Rosemary Hall belle forgets all about midterms with a Yale man during a well-chaperoned formal at the all-girl Connecticut boarding school.

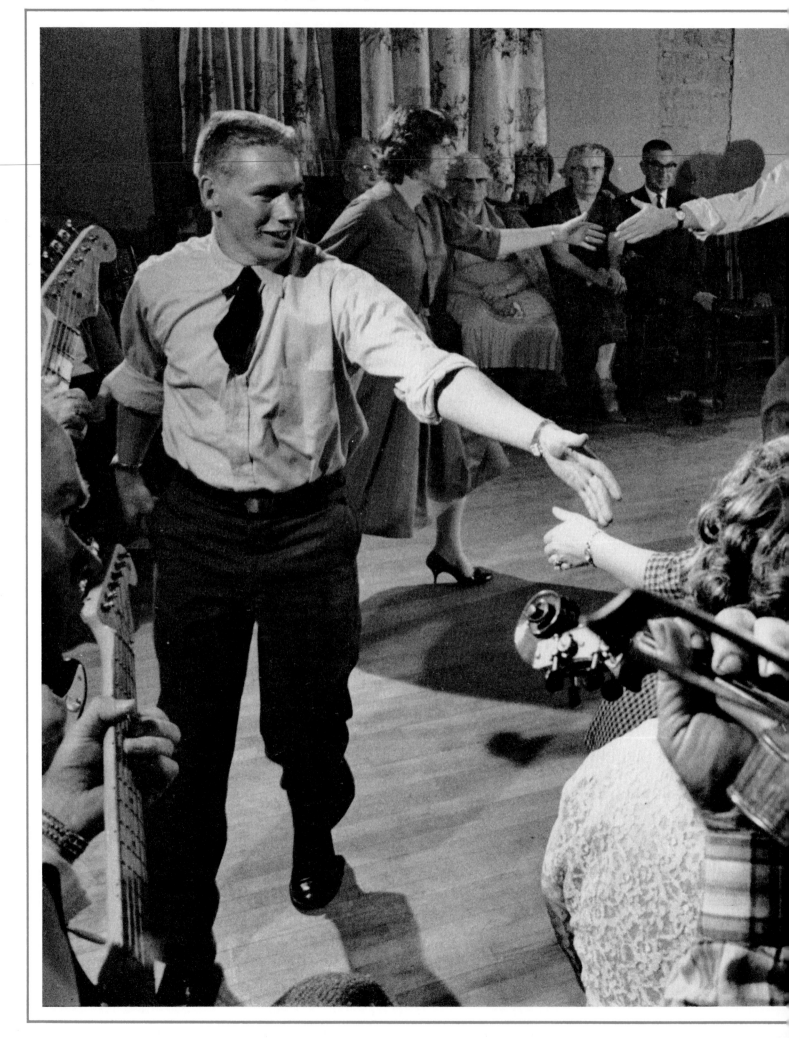

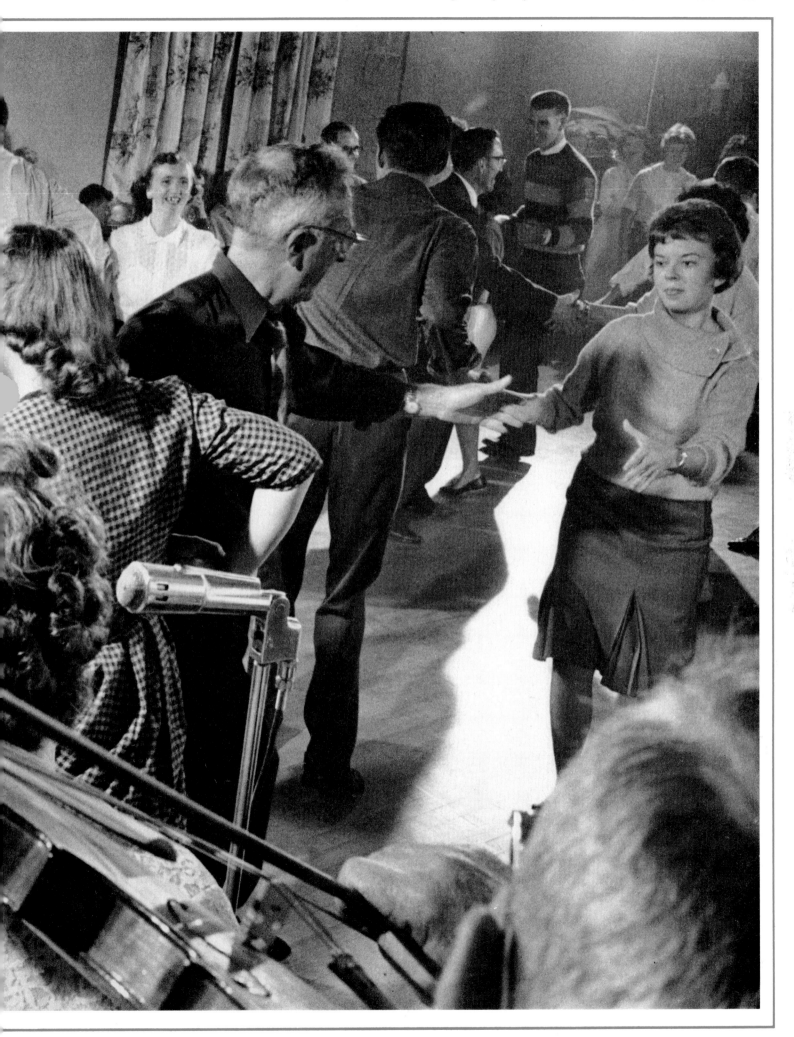

Wisconsin farmer Maynard Mittlesteadt, 22, has a last fling around the floor at a going-away square dance given for him and his brother, both of whom are being called up in a special mobilization of their National Guard division.

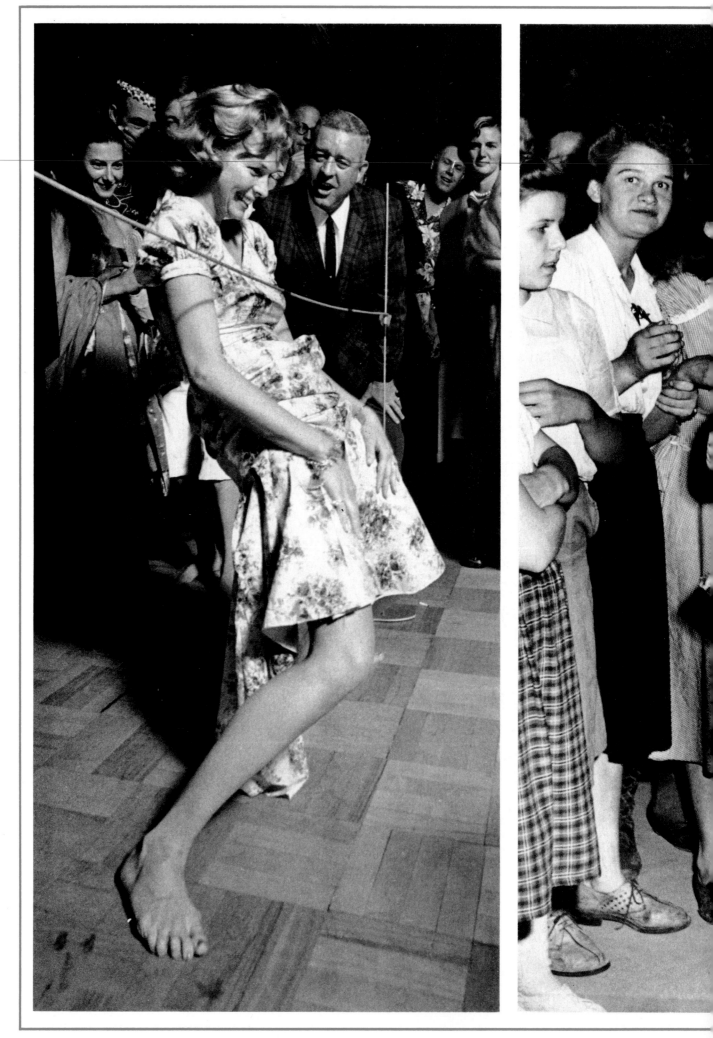

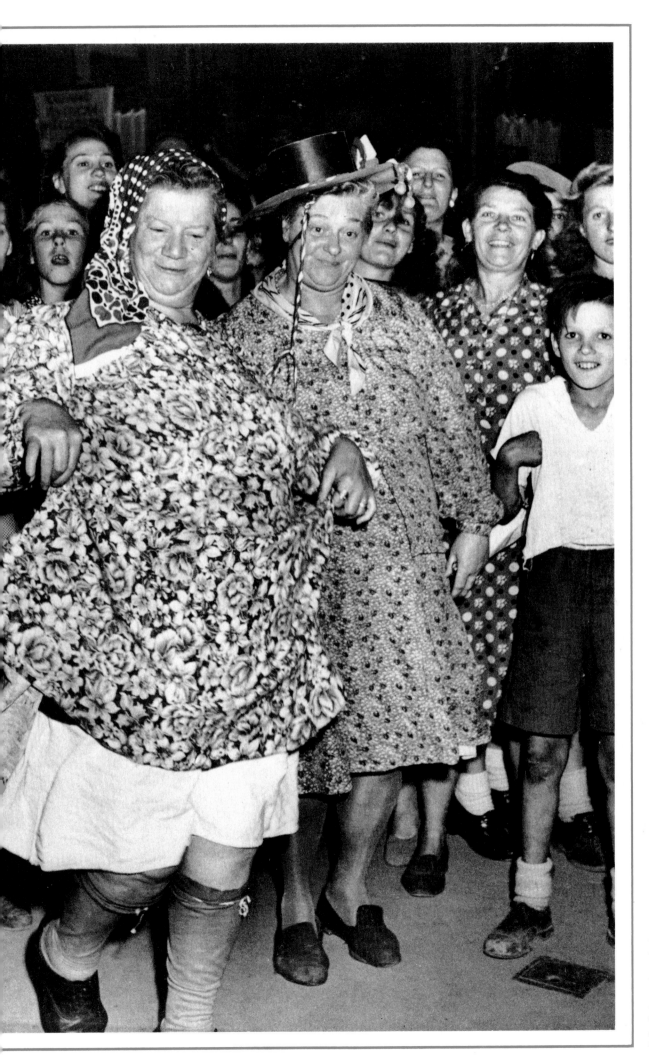

Taking a fling at
the limbo,
Darah Preble
approaches the bar,
which she must
snake under without
touching the floor
with anything
but her feet. The
bar gets lowered
with each
success. ● In an
Amsterdam slum,
where the beer
and gin have been
flowing liberally,
two housewives do a
dainty jig to the
intense appreciation
of the crowd.

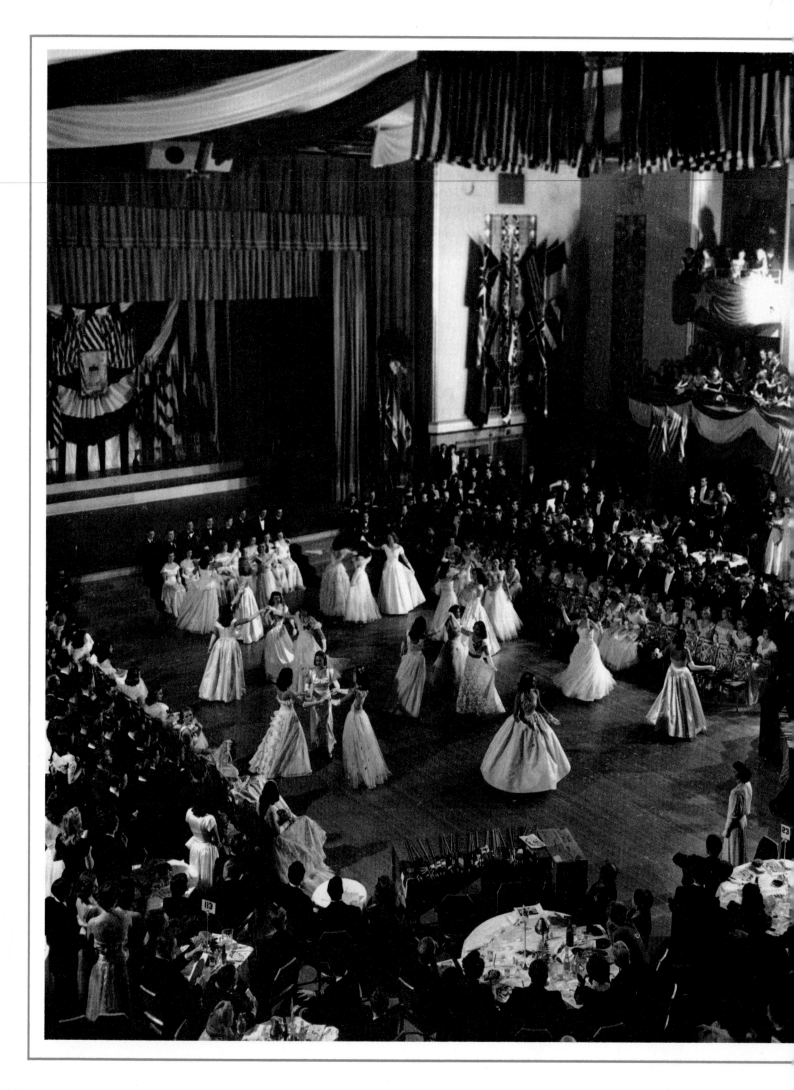

"Coming out" in ballroom elegance

At a cotillion at the Waldorf-Astoria, New York debutantes perform a genteel waltz, part of the proceedings that somehow launch them into society. ● Bowing in at Ottawa society, 18-year-old Canadian deb Anne Plaxton practices the difficult curtsy she is about to make to the governor general at the lavish Garrison Ball.

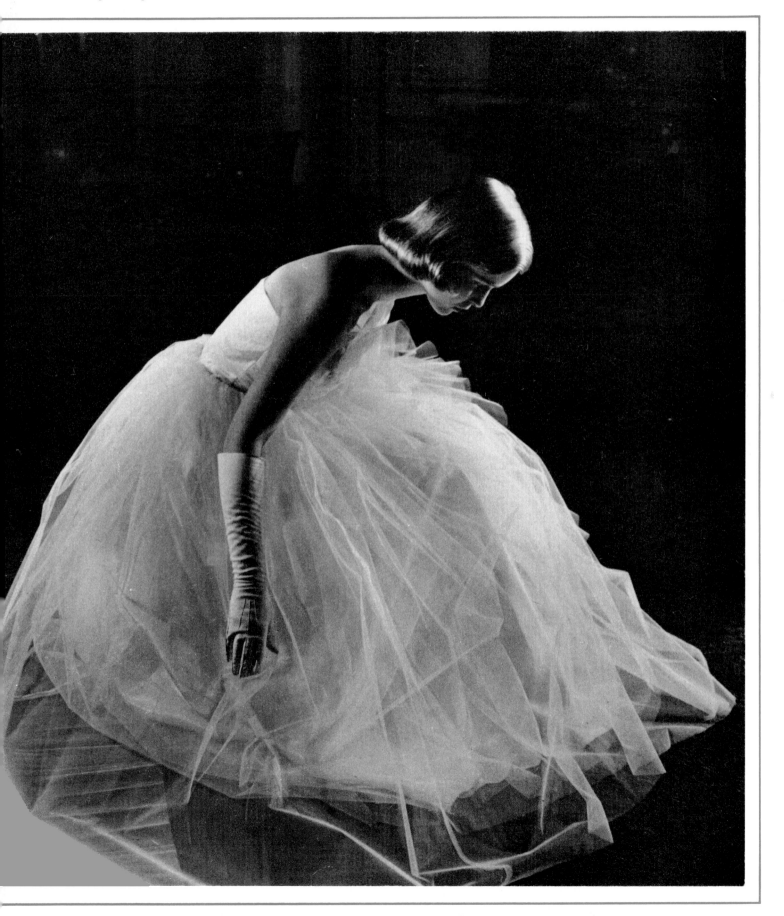

Different brands of entertainment from showgirls worlds apart

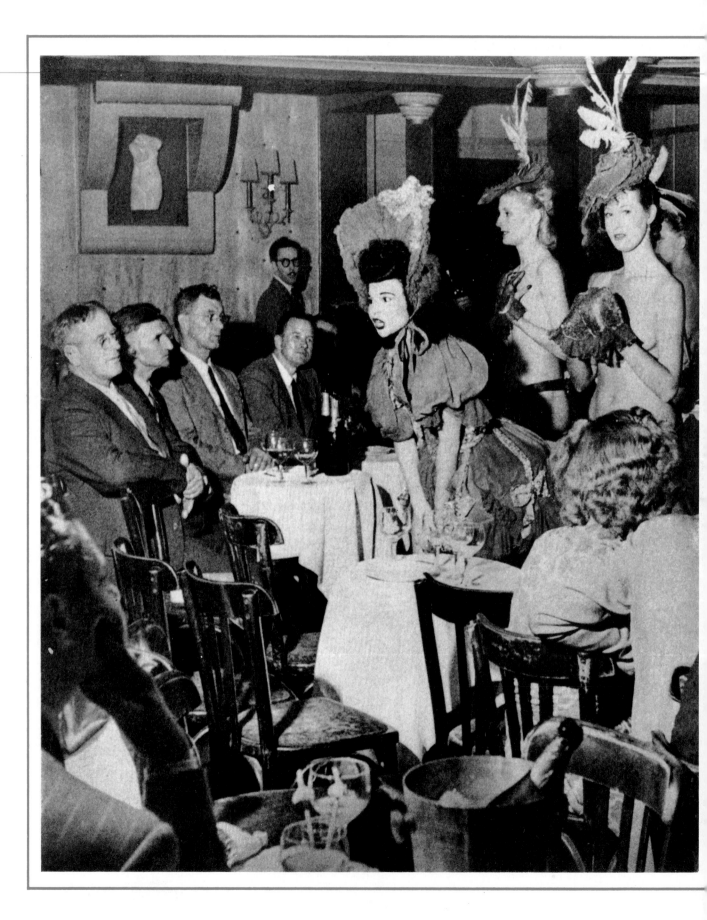

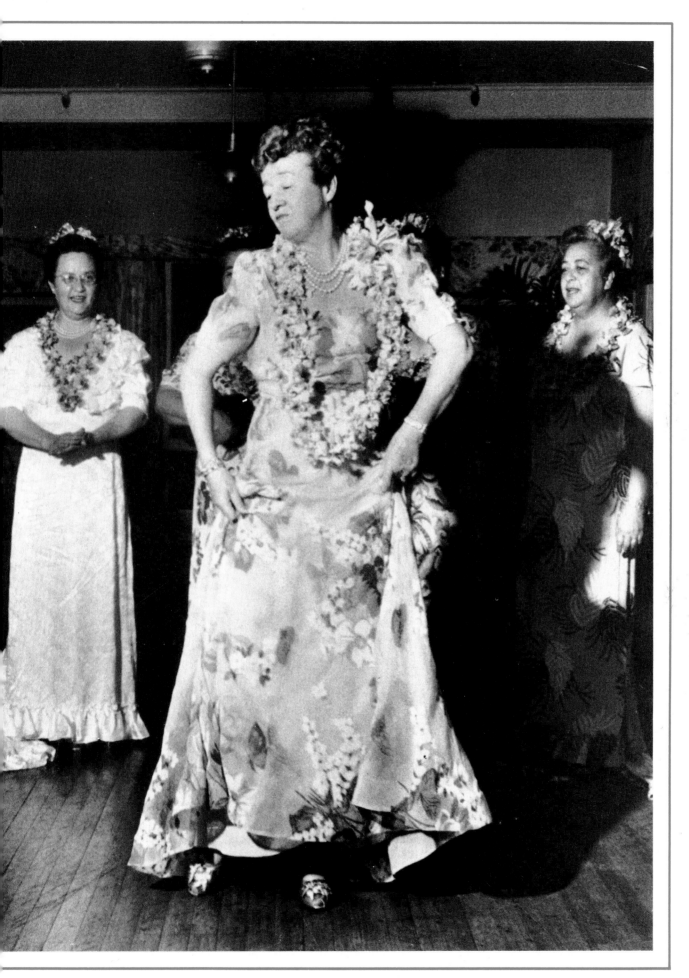

At a nightclub in Paris' famed Place Pigalle, showgirls cover up their scanty costumes as Iowa farmers are presented with a modern version of the old question: "How ya gonna keep 'em down on the farm . . . ?" ● *An official hostess at the Republican Convention in Philadelphia, Mrs. Worthington Scranton livens a party with a hula.*

Any excuse at all for a shake, shimmy or shuffle

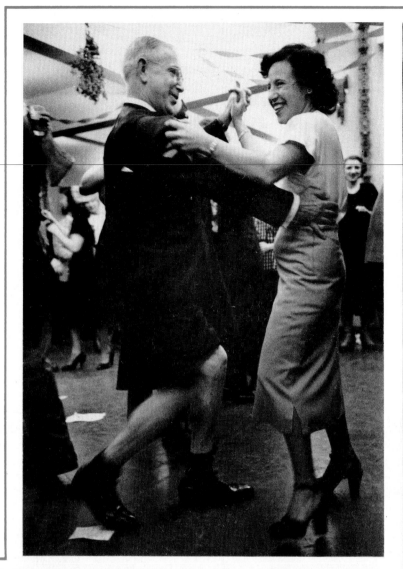

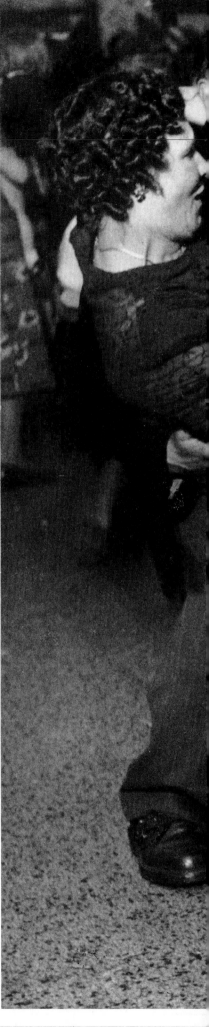

That great leveler, the office Christmas party, features, in this case, insurance broker vice president John Griffin and a giggling stenographer. ● Forming a chorus line for a Chicago high school show, students dance the Rockin' Cha during an after-class rehearsal. ● At a wedding party in Holland, where dancing games are being played, laps are made for partners to sit on whenever the whistle blows.

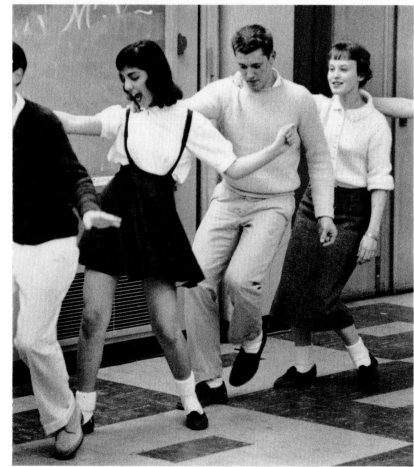

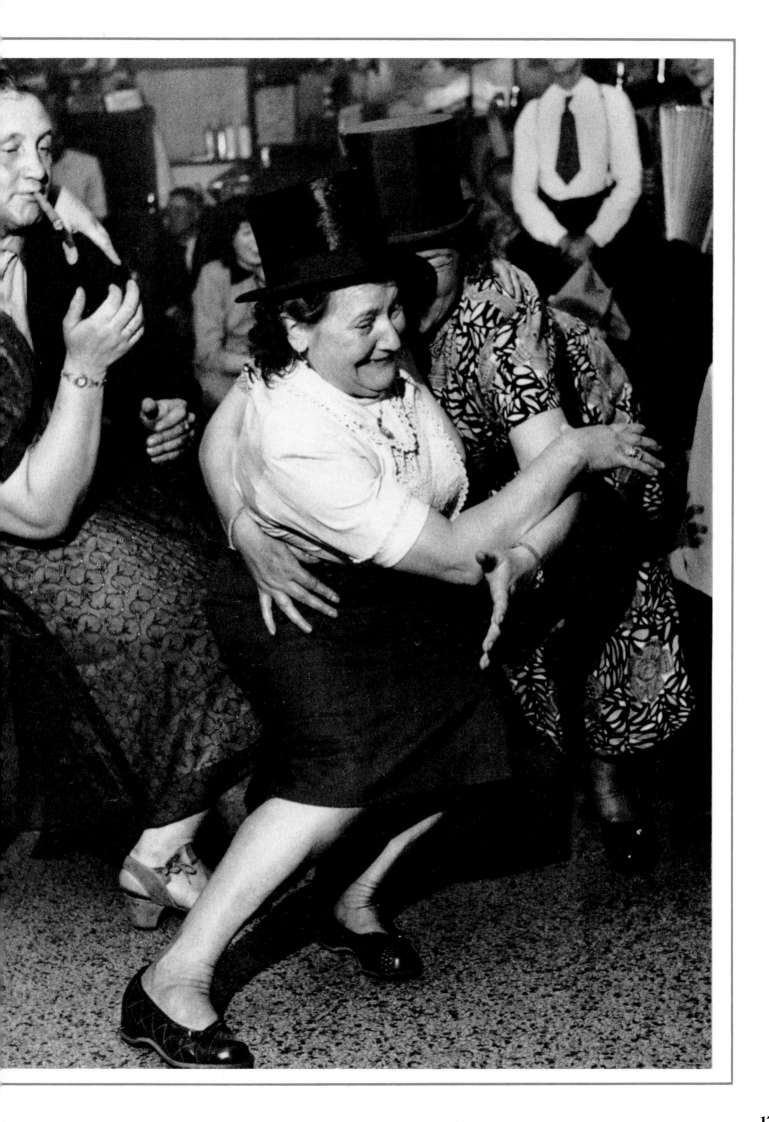

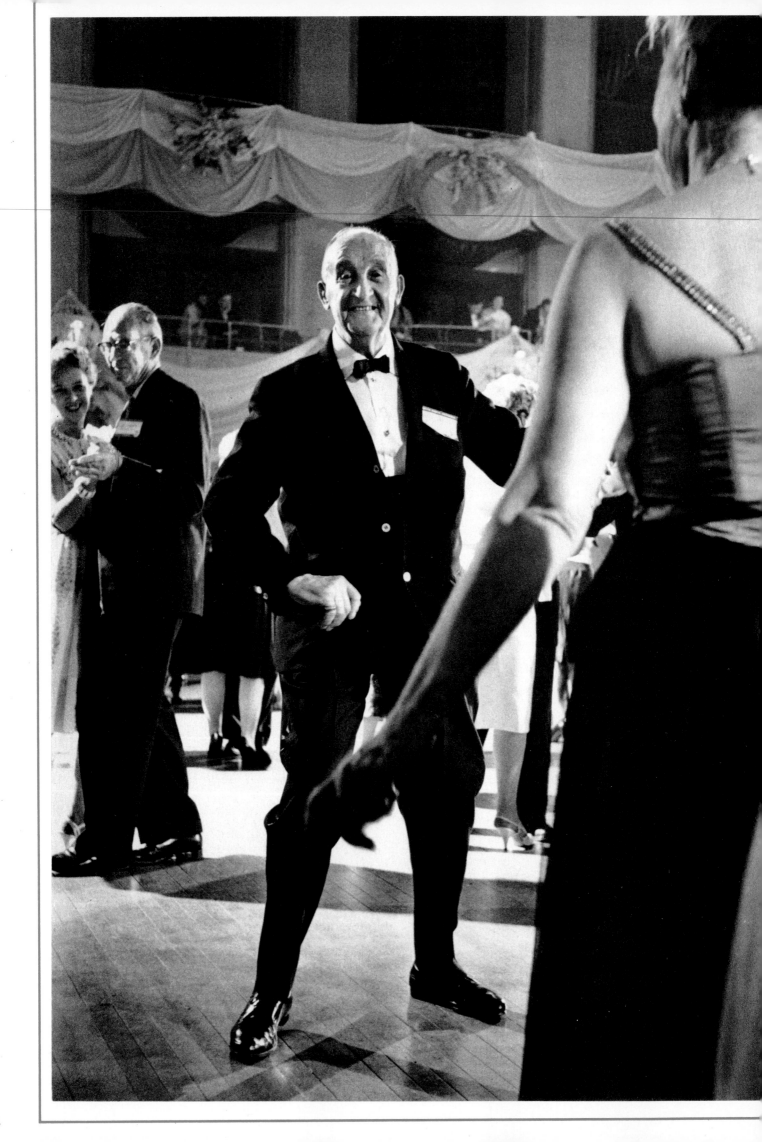

Old show of fancy footwork

At a medical convention ball, 80-year-old Joseph St. Angelo, a Rhode Island general practioner, tries out some sharp new footwork with his wife. ● At a festival of mountain music and dance in Asheville, North Carolina, fiddlin' Bill Hensley and his sister, Sarah Bailey, show the younger dancers what the tradition was like before most of them were born.

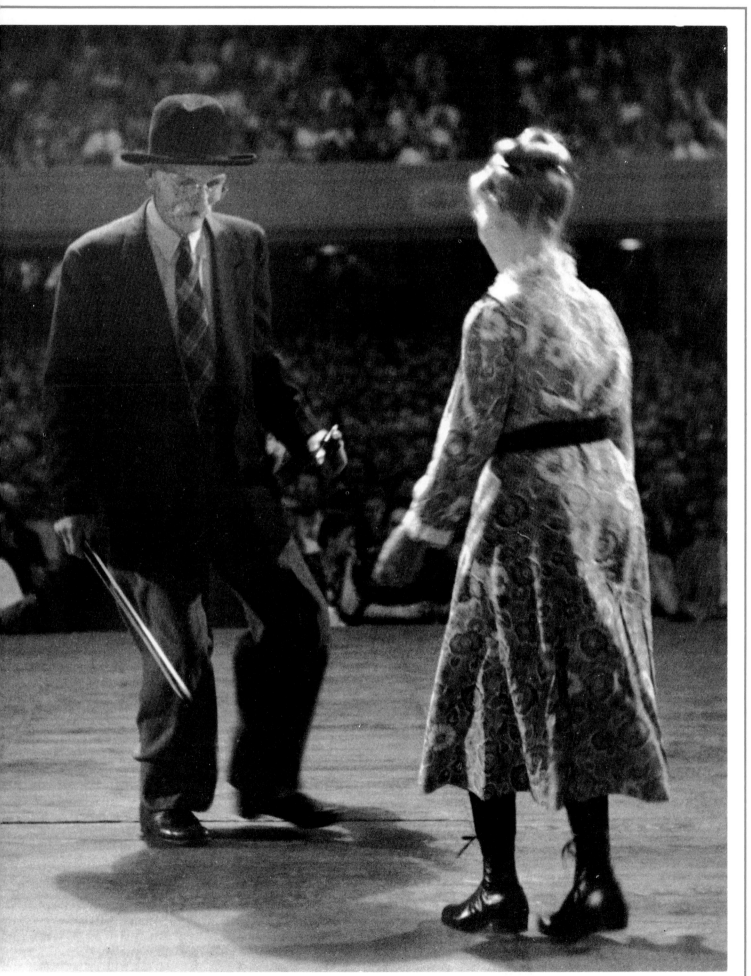

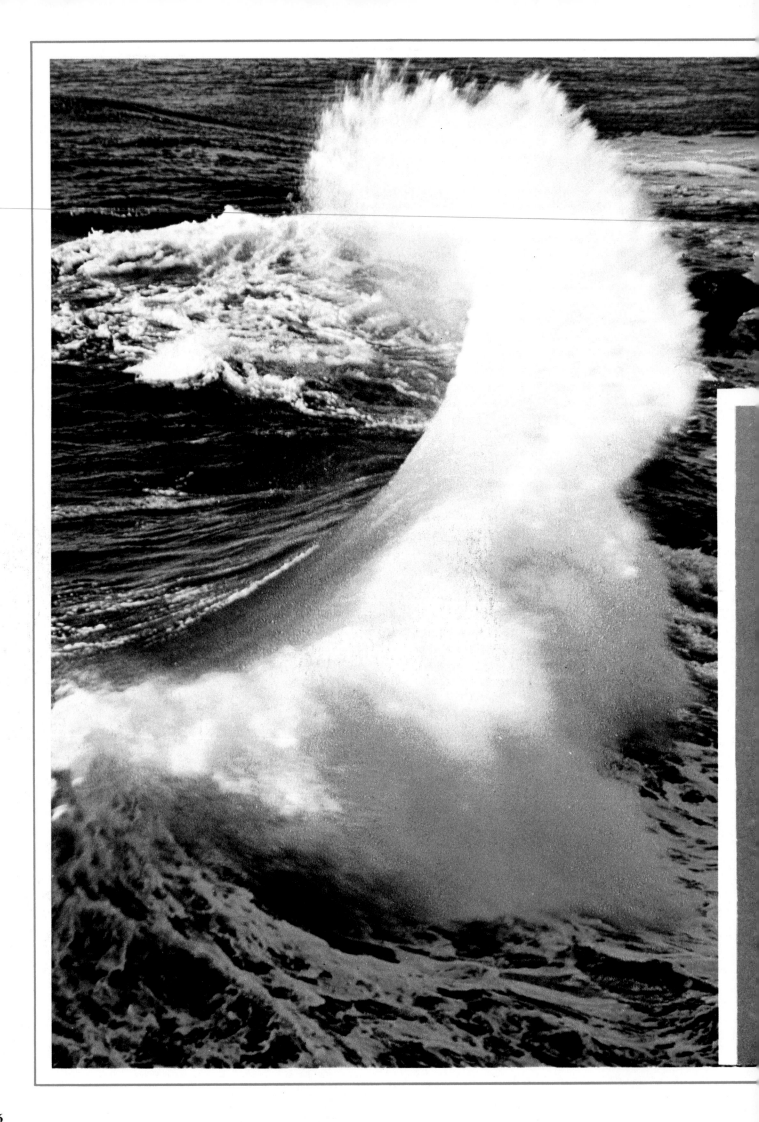

Miracles

Those astounding occurrences that cannot happen—but do.
The impossible suddenly attainable—and the heart soars.
Hope for the hopeless.
Cure for the incurable.
Freedom for the helplessly trapped.

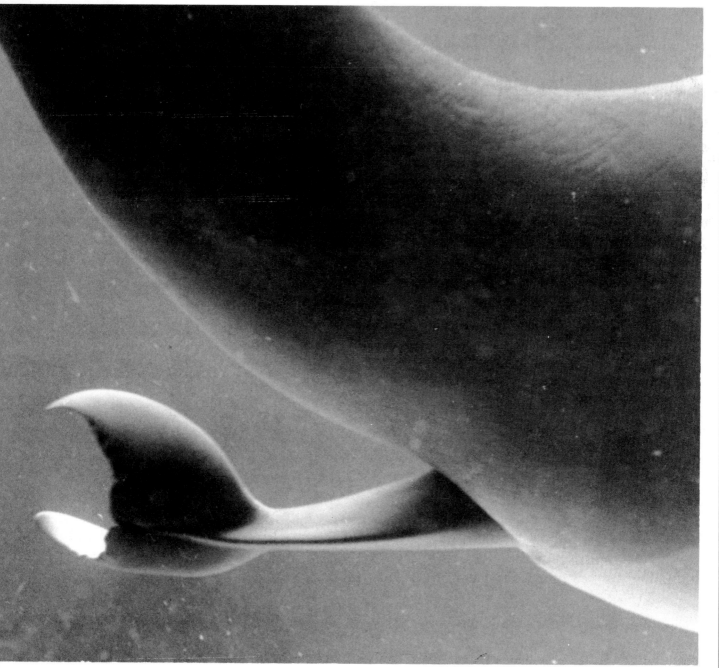

The sea itself is a miracle, promising us the infinite, speaking of majesty, letting us dream. Look! A baby
porpoise is emerging from its mother as delivery begins and another life joins its trillion upon trillion relatives.

177

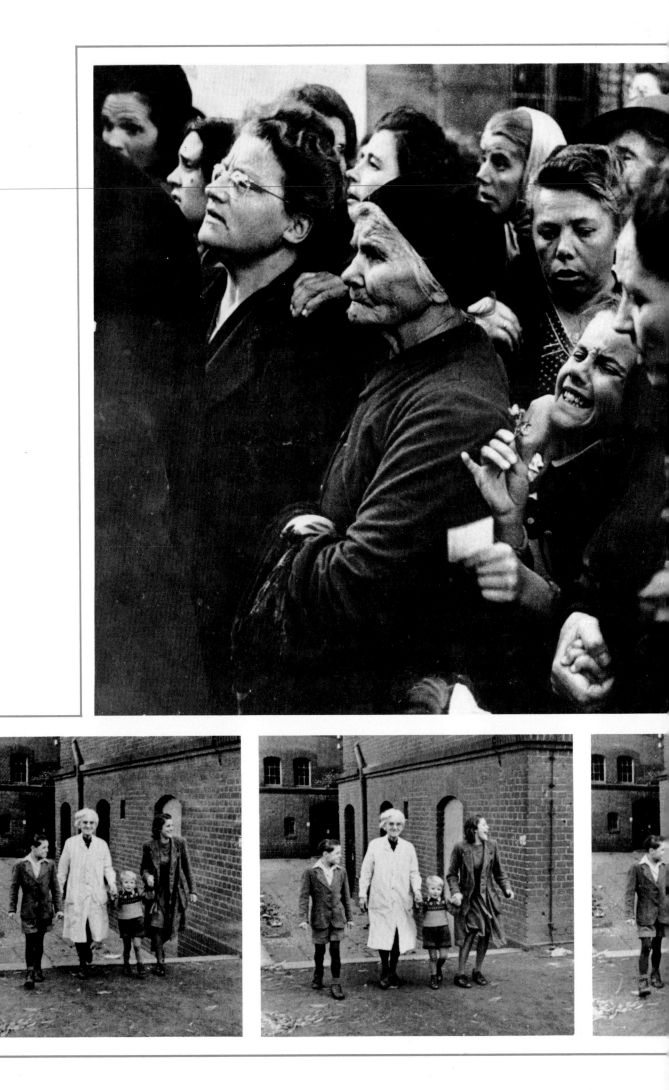

The lost and missing are reunited

See that little girl in the crowd of women.
She has come to the railroad station in Vienna
to try to find her father
who has been a prisoner of war in Russia for four years.
She has been waiting with a snapshot of him in one hand
and a tiny bouquet in the other.
Finally, there he is.
The moment is too much to bear.

Erika Trenkner is one of hundreds of German children who got separated from parents in the chaos of World War II.
Five years after he had last seen her, her father spotted her picture in a "missing children" newsreel.
For each, the feeling as they met, shown in these four pictures, was as if the other had risen from the dead.

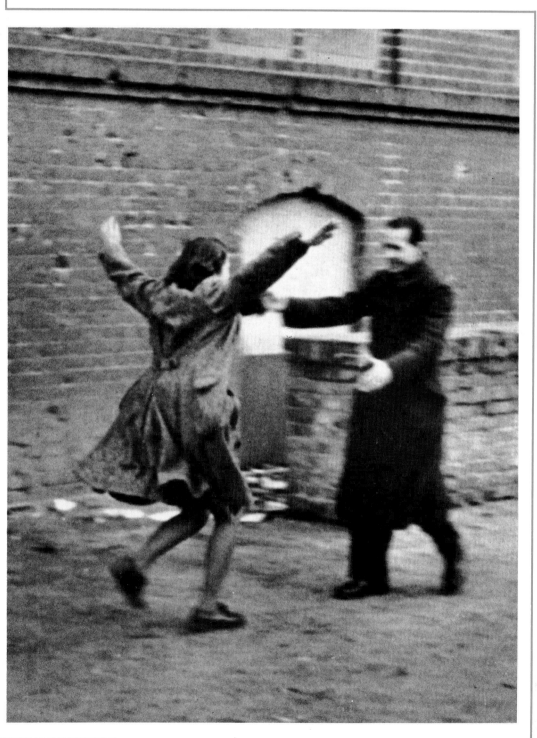

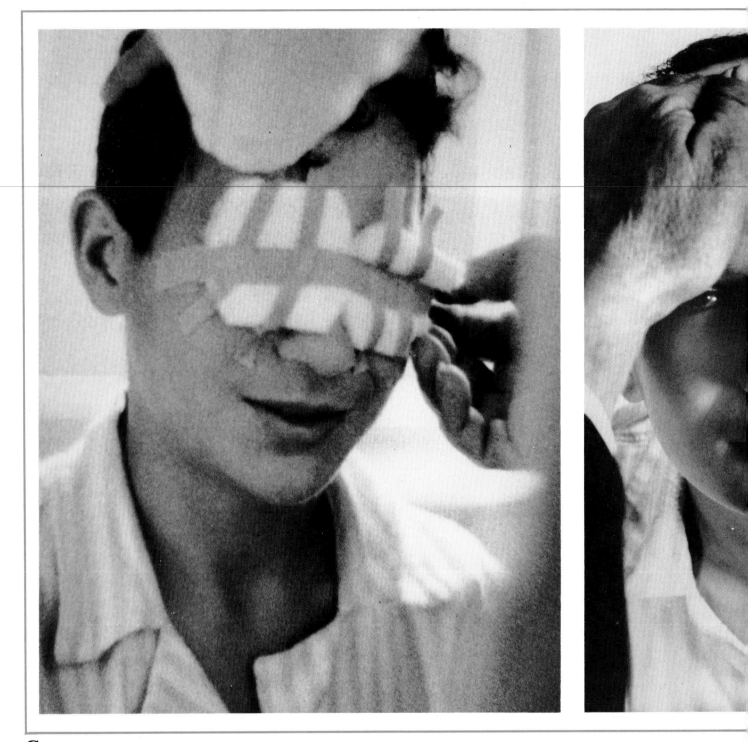

Can you see, my son,
can you really see?

Along with four of his brothers, 13-year-old Carmelo Rotolo
faced a lifetime of blindness from birth.
But remarkable new surgery brought hope.
Nine days after the operation
the bandages on Carmelo's eyes
are finally stripped away
and he gazes at his father for the very first time.
It was the same for all five brothers—
they could see.
With delight and wonder the five little Sicilians
set about exploring a brand-new world.

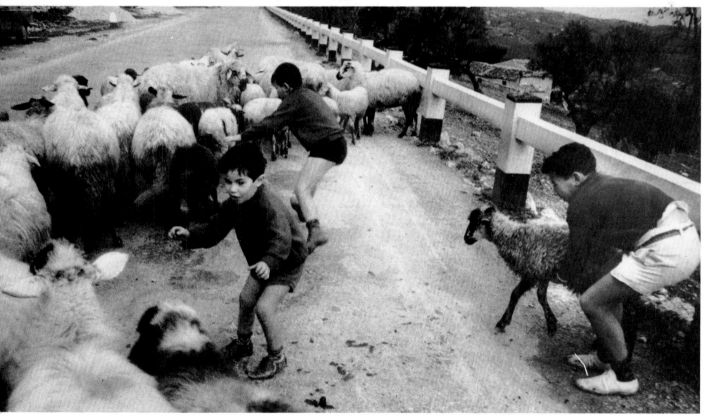

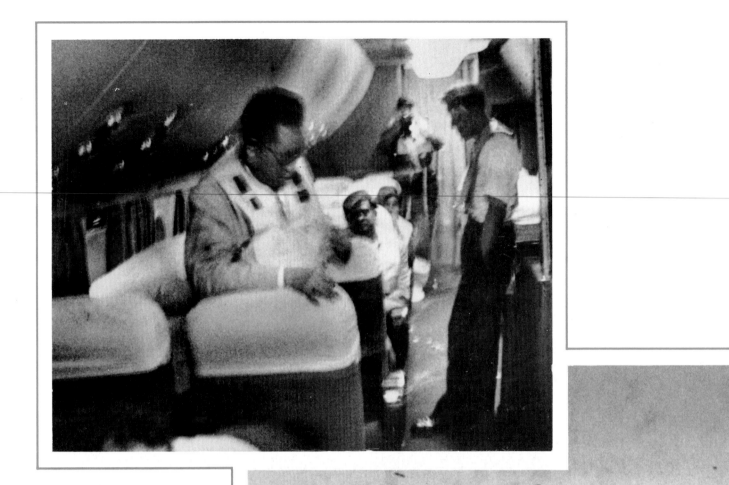

Walking away from a plane crash at sea

In our worst nightmares most of us have found ourselves in the plight of the people here—trapped in an airplane cabin with multiple engine trouble and nothing but ocean below. When this Pan Am Stratocruiser bound for San Francisco from Honolulu was forced to ditch, its tail was severed from the fuselage by the impact and it began to sink immediately. Fortunately, a Coast Guard weather ship was close by and picked up the passengers from life rafts. Finishing their trip by sea, the survivors included Mrs. Ruby Dami, who was swept off her feet by her waiting husband.

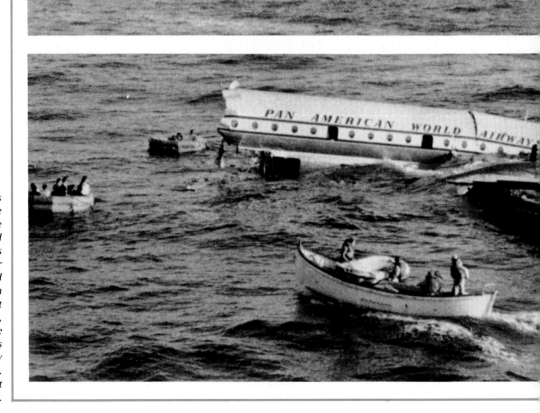

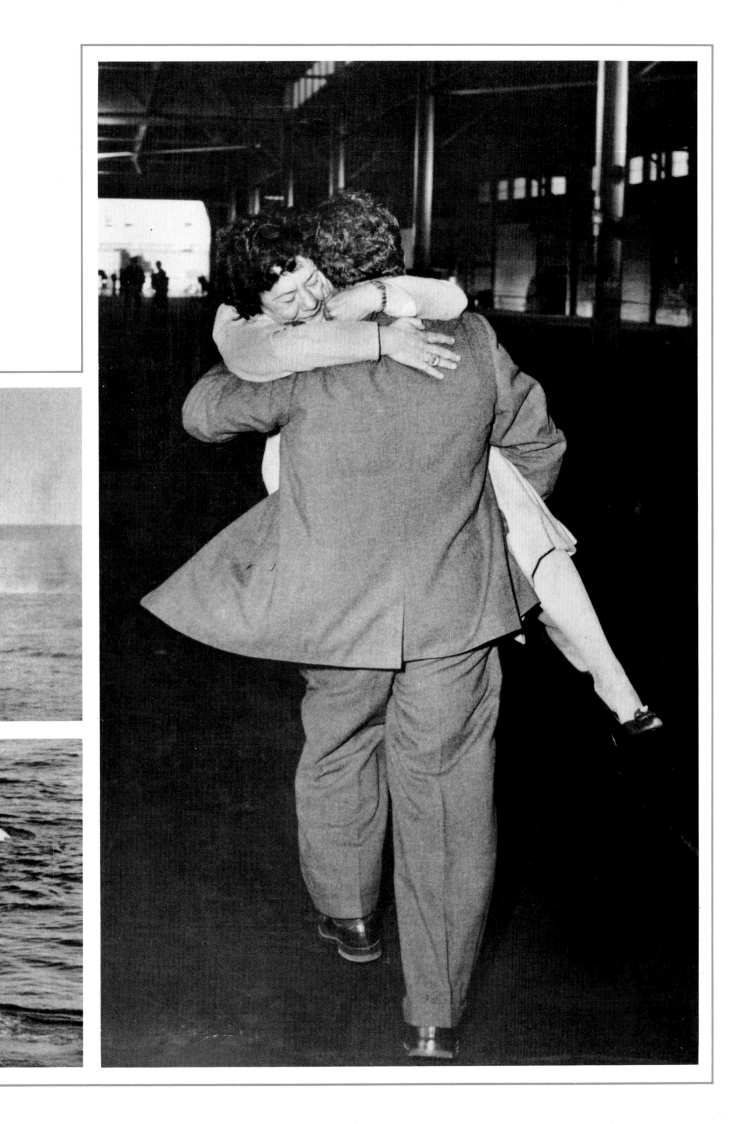

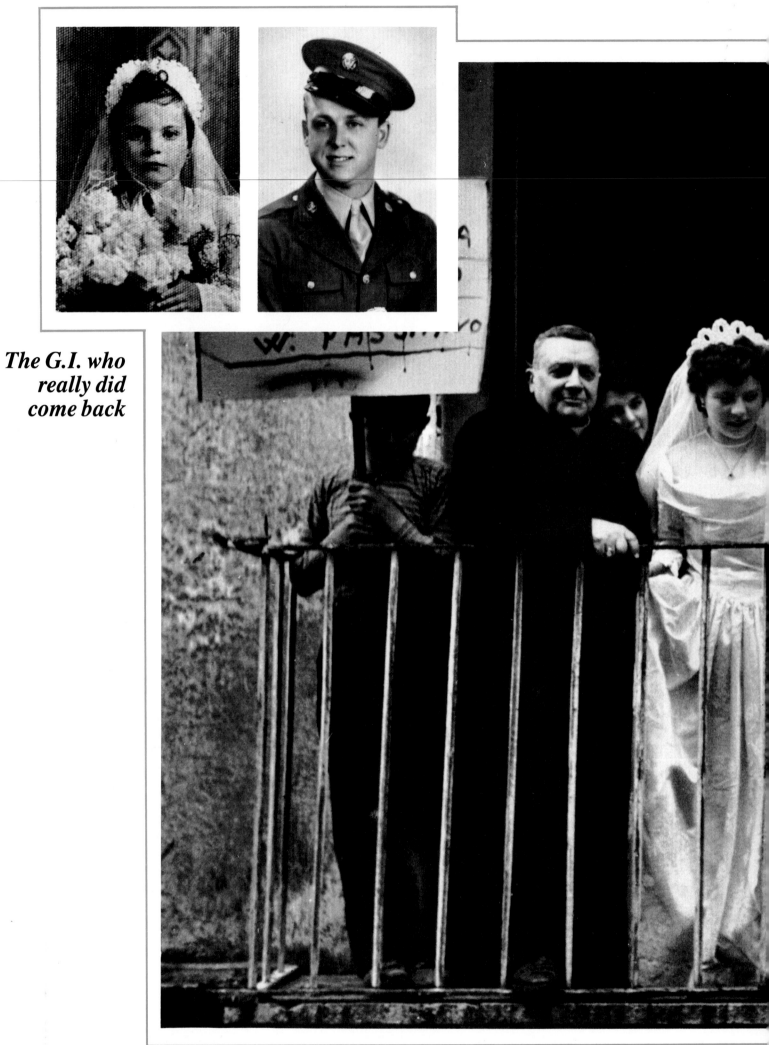

The G.I. who really did come back

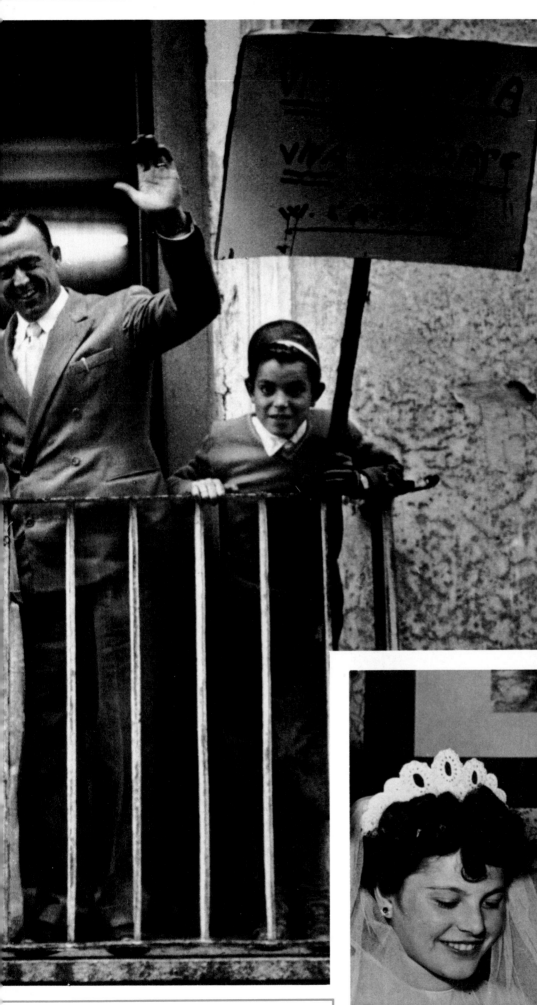

During World War II, in the summer of 1944, a 25-year-old U.S. tank gunner befriended a weeping 10-year-old on the streets of the crumbling old Italian village of Passiano. He visited her home and met her family. Something about her haunted him and when he had to move on, George Fortin told little Nina Farano, "When you grow up, I'll come back and marry you and take you to America." At the end of the war George went back to work in a textile mill in New Bedford, Massachusetts, but he kept in touch with the Farano family and the little daughter with the "dark, lovely eyes" that he remembered from her Communion picture. After wooing the budding beauty by letter, George finally proposed and, now 31, he returned to Passiano and married his Nina, one day before her 17th birthday.

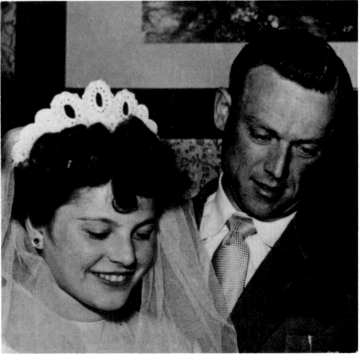

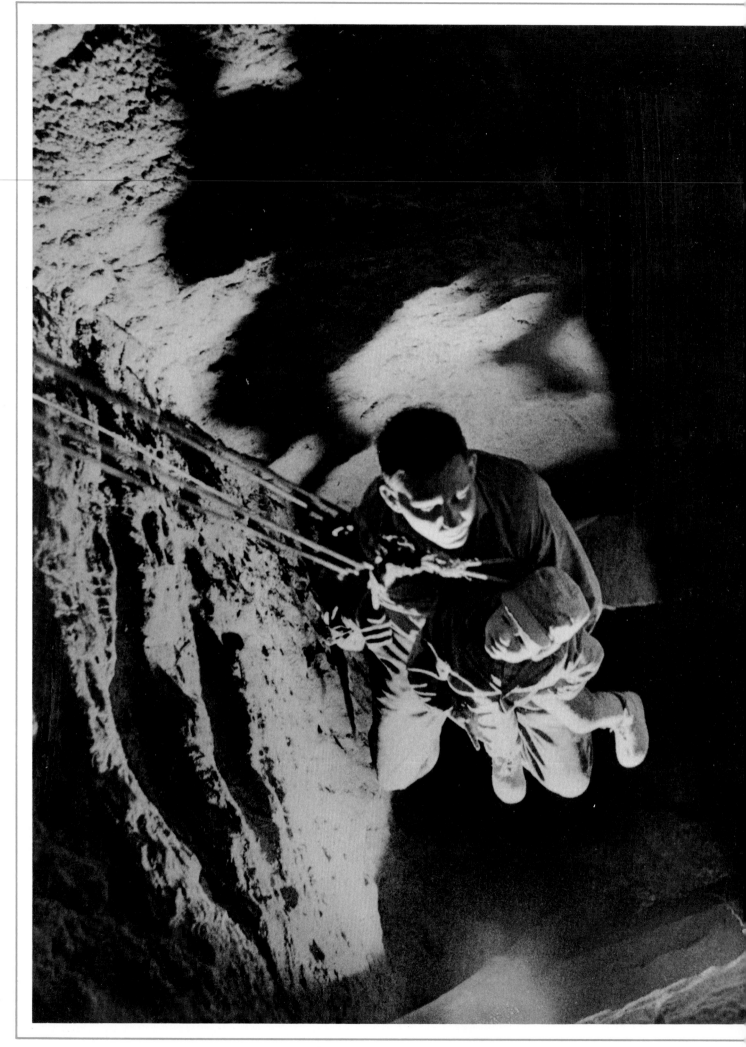

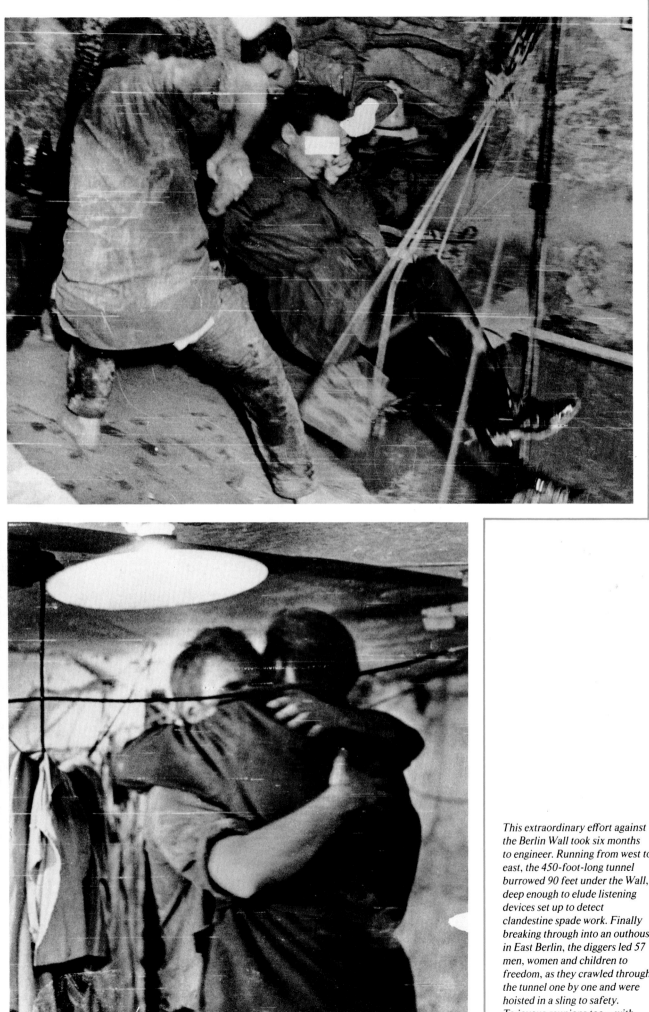

This extraordinary effort against the Berlin Wall took six months to engineer. Running from west to east, the 450-foot-long tunnel burrowed 90 feet under the Wall, deep enough to elude listening devices set up to detect clandestine spade work. Finally breaking through into an outhouse in East Berlin, the diggers led 57 men, women and children to freedom, as they crawled through the tunnel one by one and were hoisted in a sling to safety. To joyous reunions too—with family, friends and the free world.

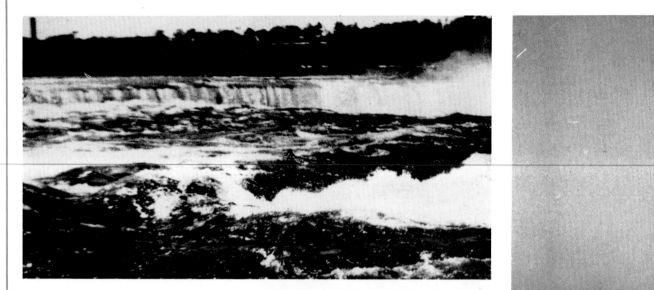

The boy who was swept over Niagara and lived

When his 12-foot outboard was swamped 700 yards above Niagara Falls, Roger Woodward, 7, was thrown into the boiling torrent. Kept afloat by his life jacket, the boy was flung over the lip of the Falls and down the raging, 162-foot precipice. Miraculously unhurt, Roger was rescued by the crew of the tourist boat Maid of the Mist II who spotted his bobbing head, maneuvered to his side, threw him a life ring and hauled him to safety. Except for three stunters in barrels and a rubber ball, no one before had ever survived a trip over the Falls.

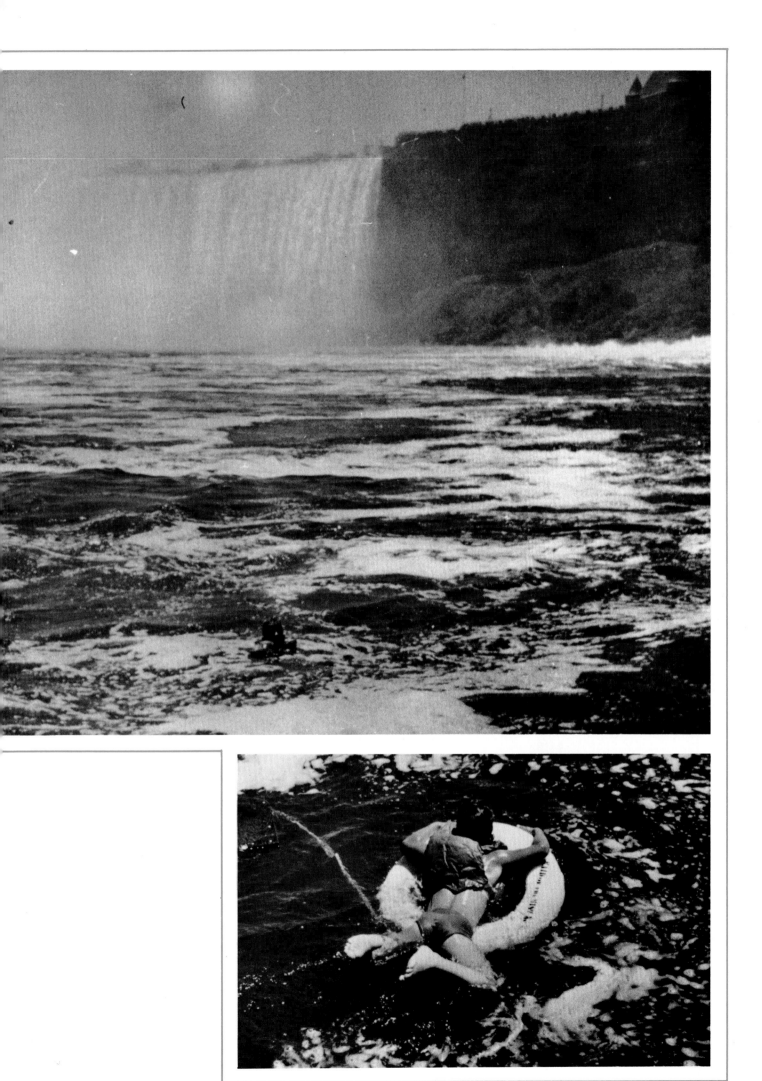

They brought him back from the dead

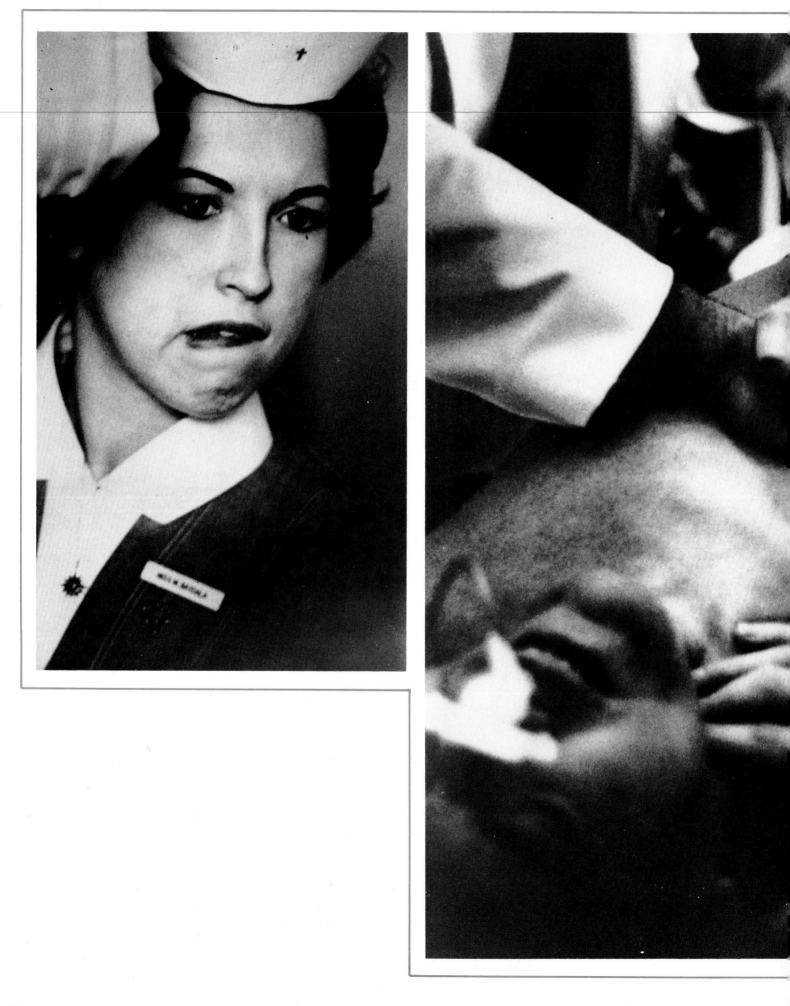

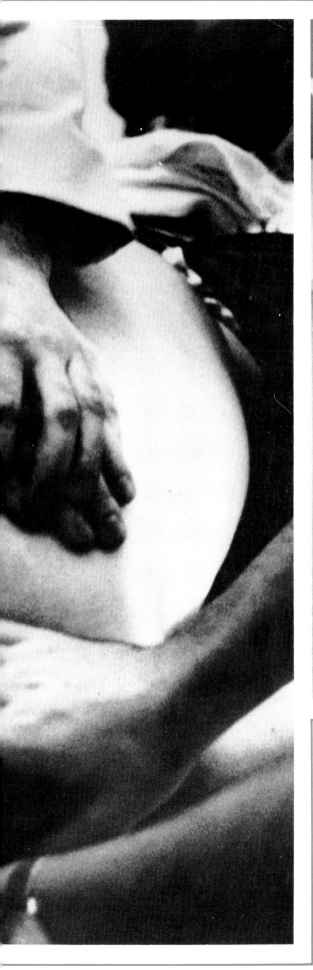

His heart has stopped. Throughout the hospital's corridors
the emergency call Code 99 is sounded. Within moments help
is at hand. The first resident on the scene blows air into
the patient's lungs. The second slaps the heels of his hands
on the man's breastbone and, leaning hard, depresses the
bone and squeezes the heart against the spine until the blood
inside it spurts into the arteries. This rough heart massage
breaks ribs, but it keeps the patient's brain alive for
precious minutes while the doctors diagnose what went
wrong. It is decided to shock the heart back into action.
Mary Jo Baydala, a student nurse, bites her lip as electrodes
are placed on the patient's chest. The doctor massaging
the heart steps back. A 550-volt jolt of electricity
courses through the patient, and his body arches up. The
massage begins again. Life flickers back. Mary Jo can
smile. The heart is beginning to beat on its own.

In Kenya an impossible dream has come true

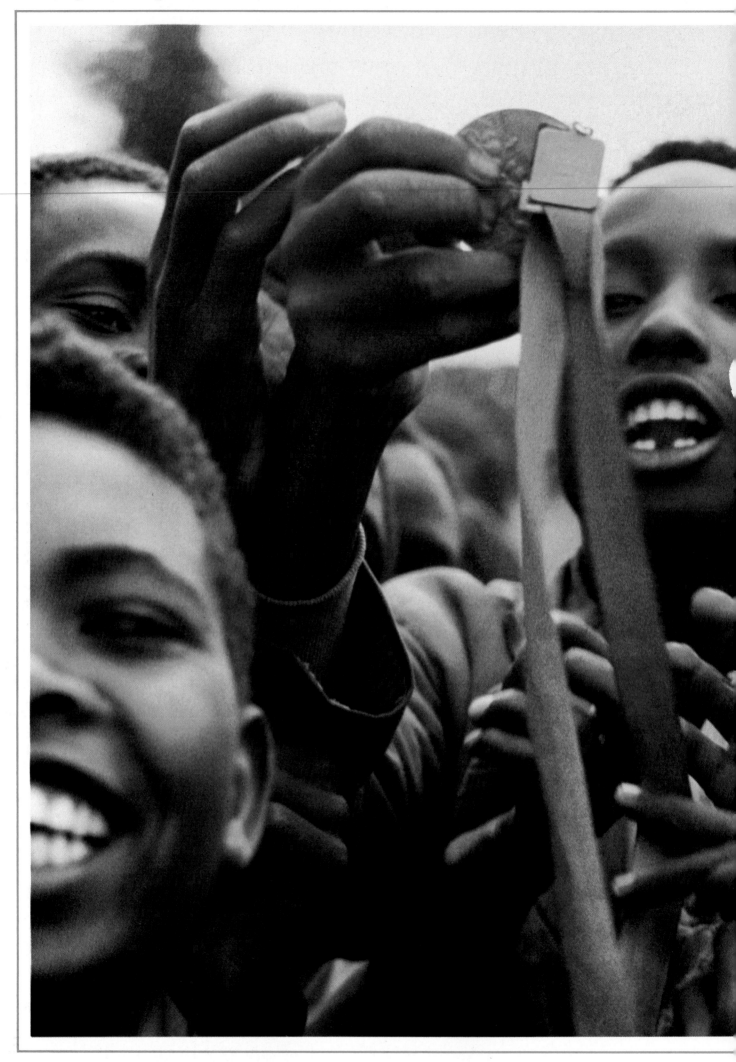

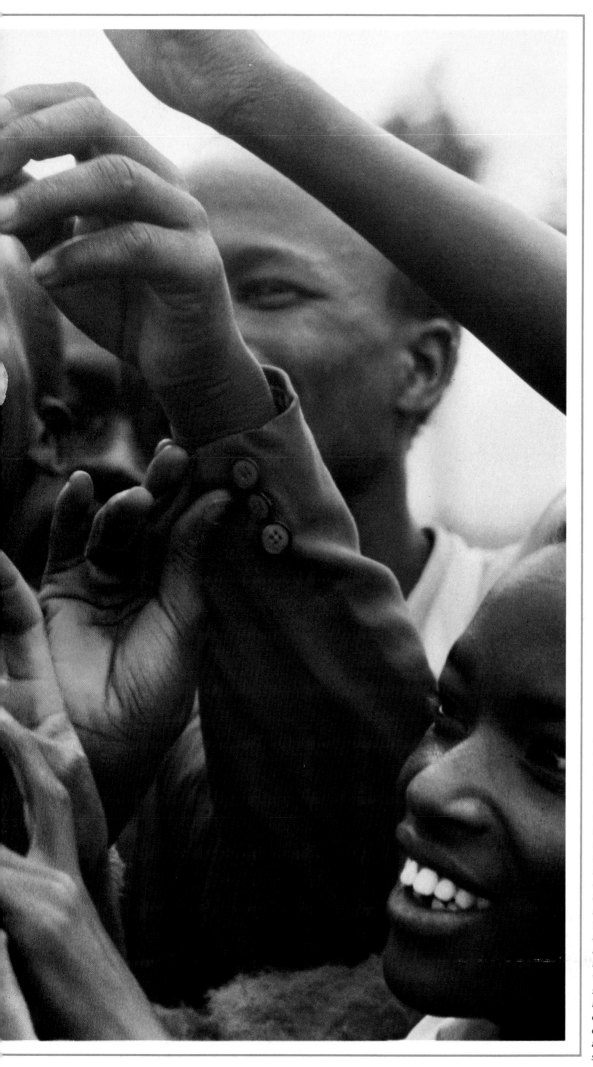

Just home from Mexico are the most amazing athletes of the 1968 Games: the 15-man Kenyan track and field team, which astonished the world by winning eight Olympic medals—three of them gold. The national display of emotion recalls the Olympic homecomings of ancient Greece, when laurel-wreathed victors were escorted through gates specially cut into city walls. The gold medal of Olympic steeplechase victor Amos Biwott is passed around with pride and wonder among the wide-eyed boys in the tiny village of Biribiriet, where Biwott grew up. Like something enchanted, it is handled and caressed, this chunk of gold that stands for the dreams of this new generation and is also certain proof that sometimes dreams do come true.

Generations

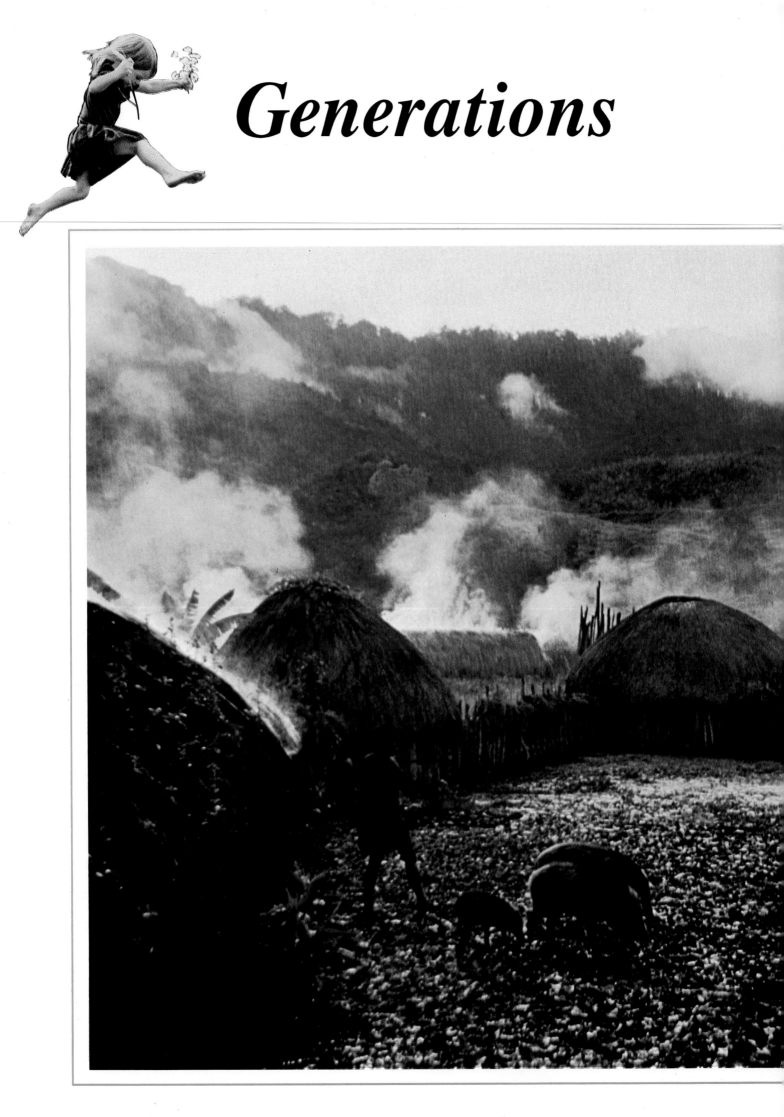

Those legacies of other times and distant places.
Those eternal shapes and shadows that are ever born afresh.
Those habits of the old, those instincts of the young.
Those iridescent lives and the wisdom they leave behind.
Those givens, good and bad, that never seem to change.
Those rituals by which we live.

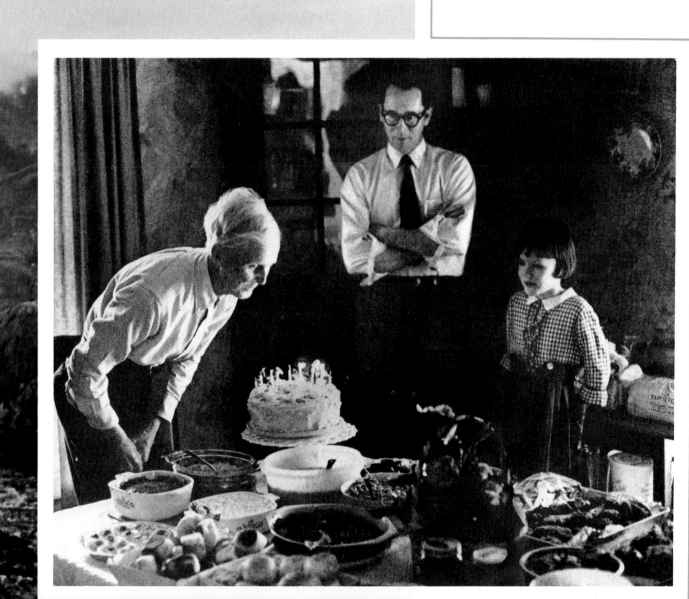

High in the central ranges of New Guinea, breakfast smoke hovers over a village of a Stone Age people. ● *In more up-to-date surroundings a grandfather makes a wish on his 93rd birthday while younger eyes look on.*

The simple art of sharing

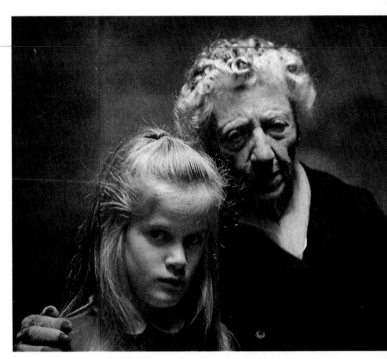

Martha Hessenberger, 78, imparts the flavor of her Berlin childhood to her granddaughter Melissa Gribbon, 8. ● An abiding strength radiates from this couple. ● Off to the circus together, each a link in a family chain. ● Hendrikus Zandbergen quit the advertising business and now he and his family live off the land. ● The nearest town is 400 miles away, the closest neighbor, 120. But the Mahood family glories in sticking together smack in the middle of the central deserts of Australia's outback.

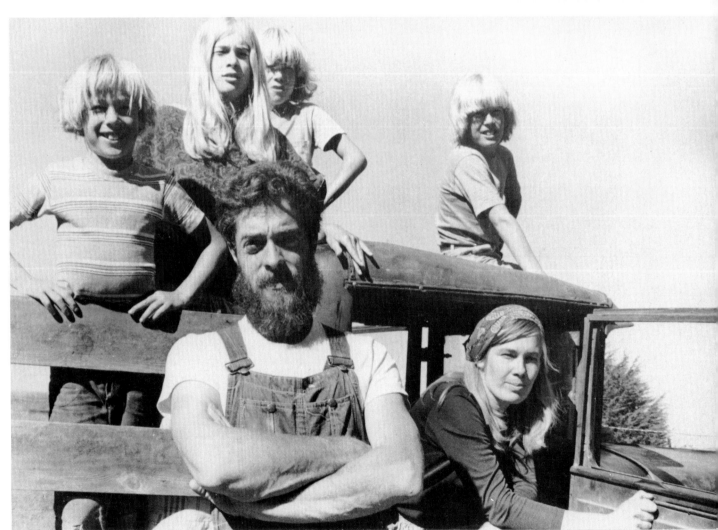

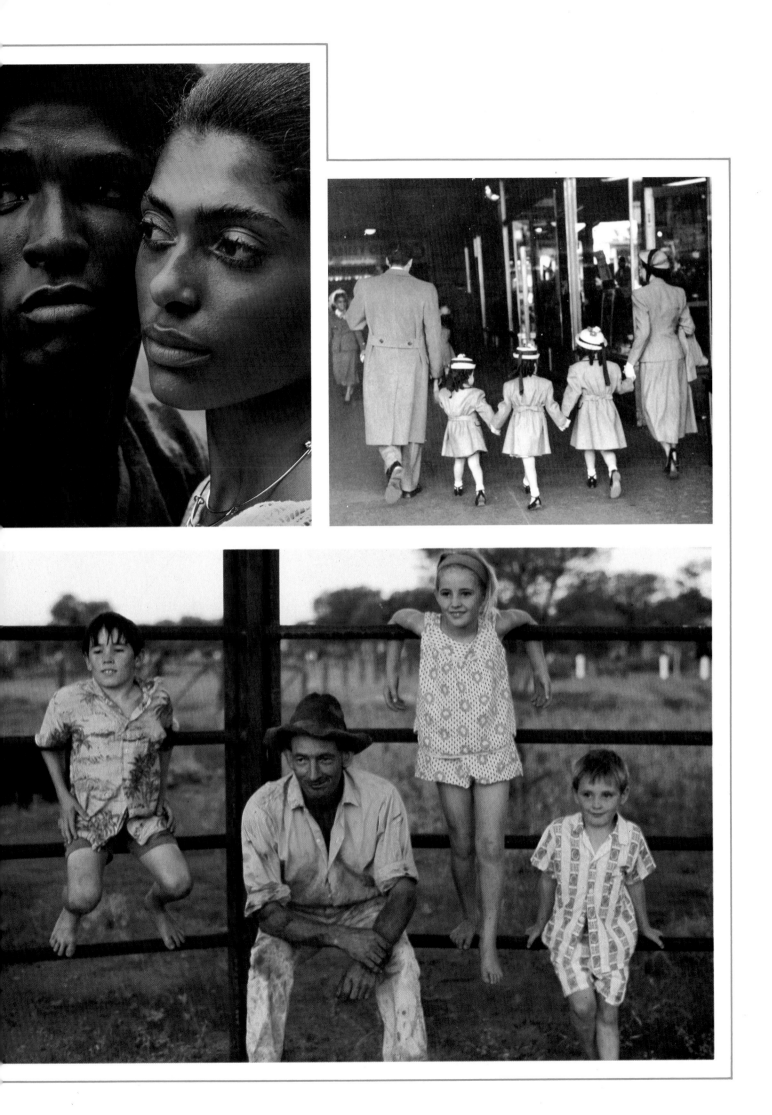

"And then she said . . ."

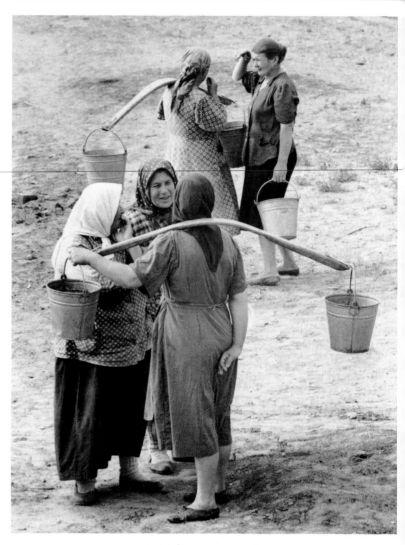

How the news gets around
is much the same in a Russian
village near the Caspian Sea,
or Union Street in a North Dakota
town or wherever two or three
are gathered together
to passionately trade fact,
opinion and hearsay.

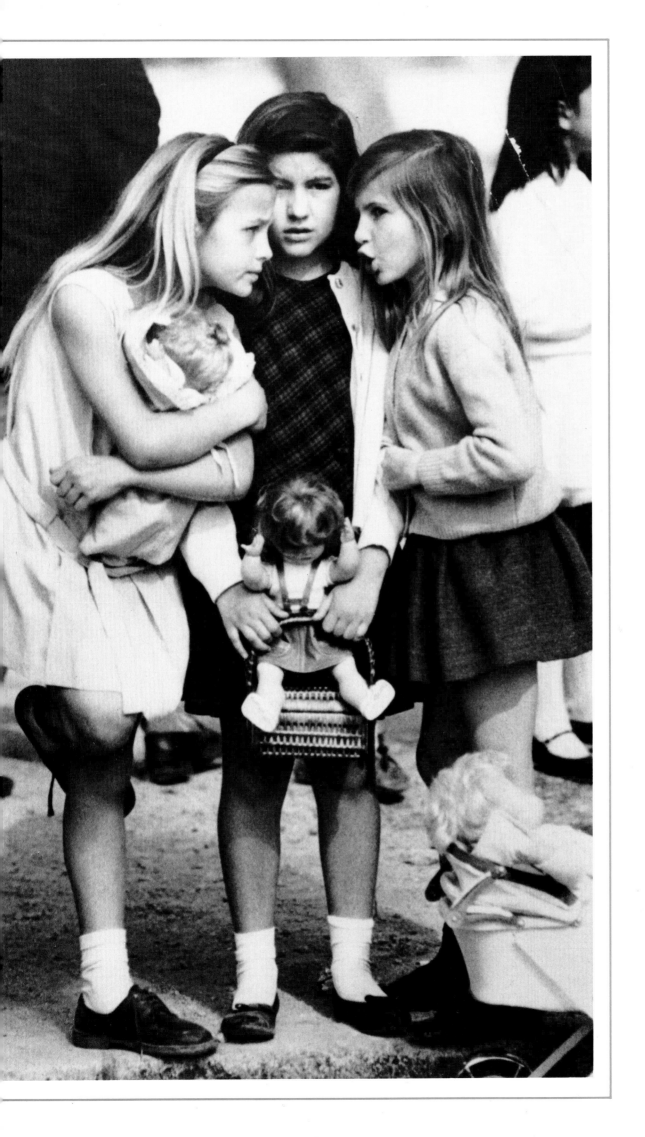

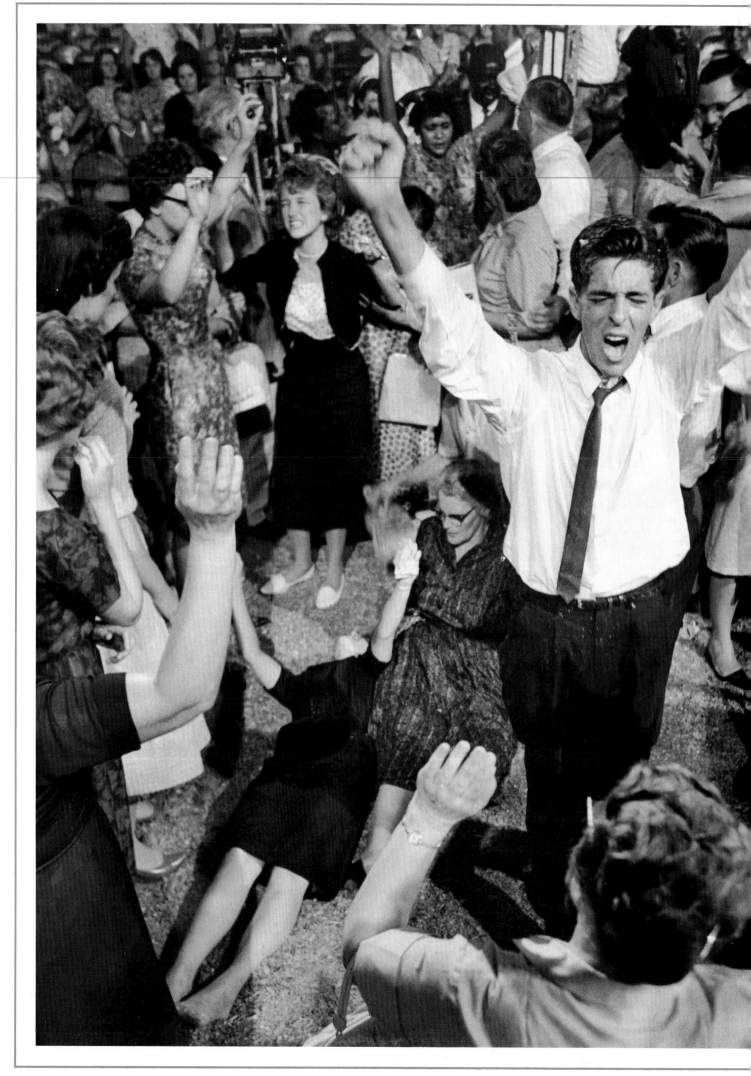

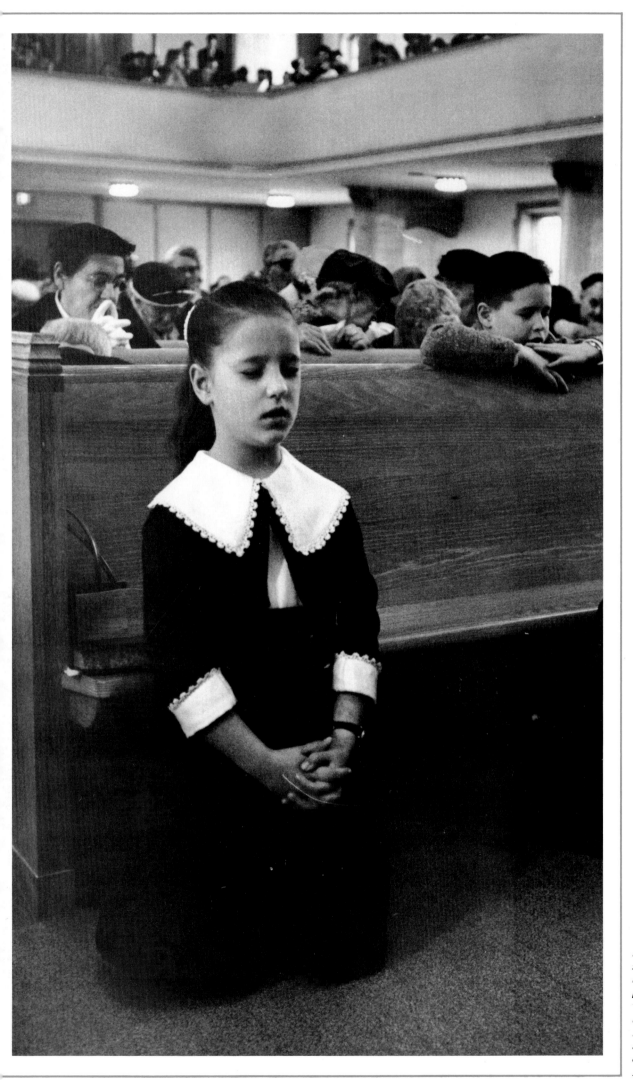

In the throes of spiritual
seizure brought on by
the preaching of a Pentacostal
practitioner, the faithful
writhe and shout as
they demonstrate their
faith. ● A more sedate
approach to God is
offered by Seventh-Day
Adventist Debbie McBurnie.

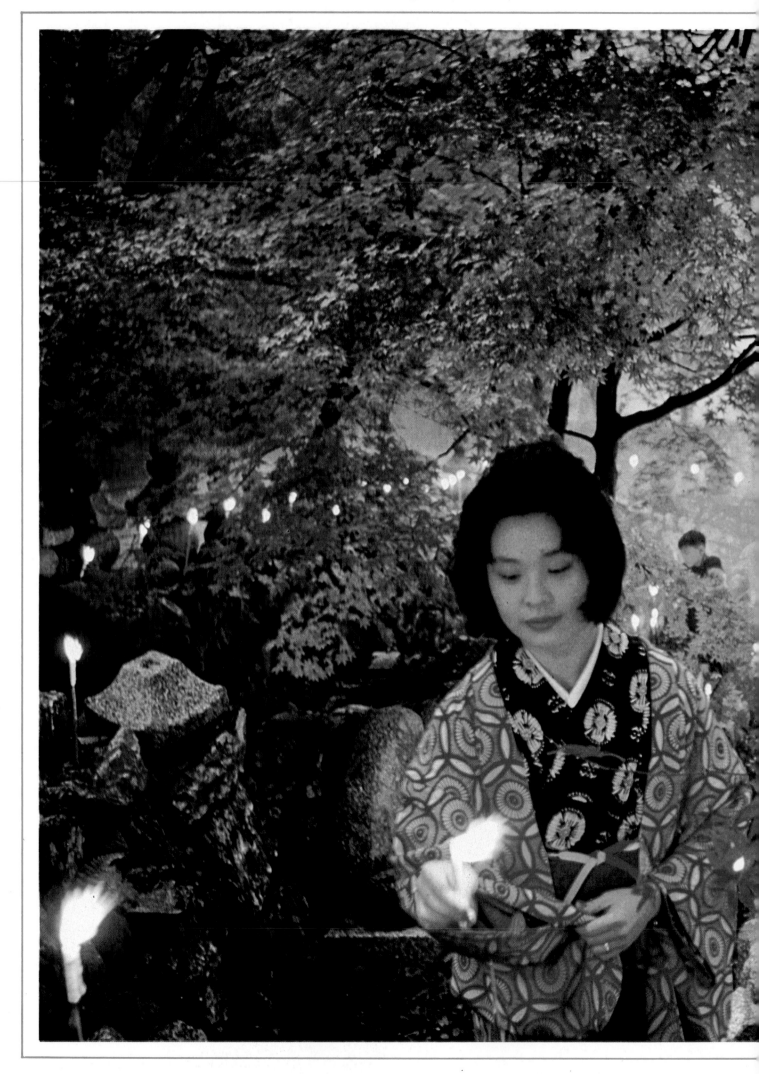

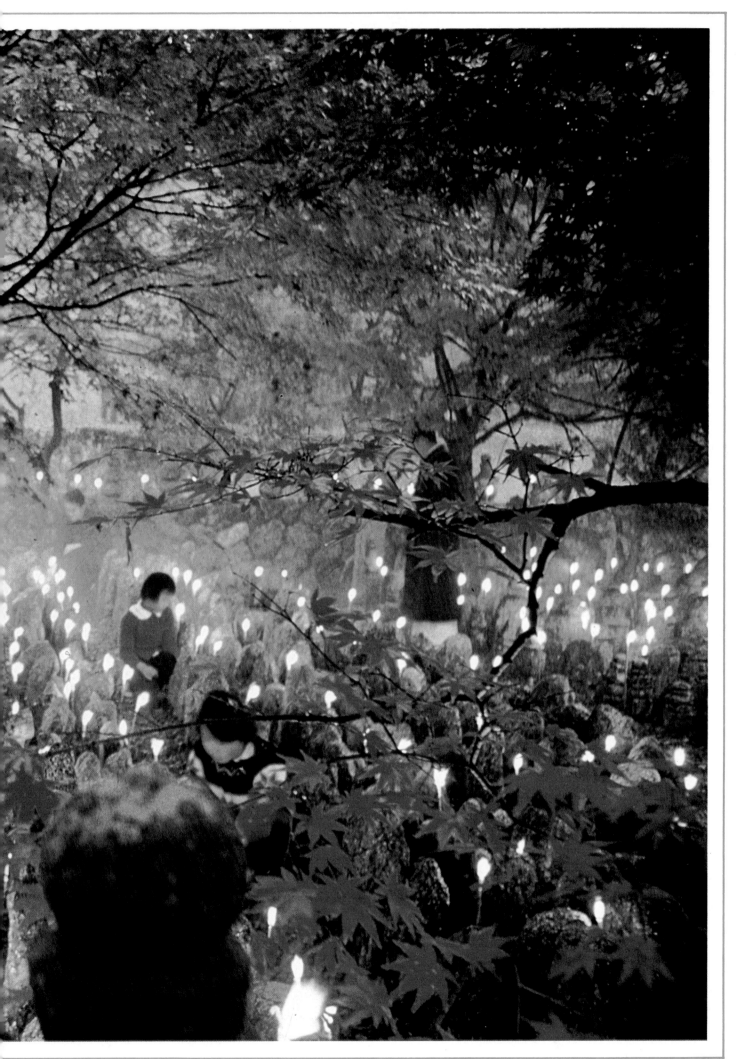

*In an ancient Buddhist graveyard near Kyoto, a young woman is comforted
by the beauty of a candlelighting ceremony to honor the dead.*

Performing for others stretches souls and spreads the spirit

At a California dance festival, inhibitions disappear with the impetus of achievement. • Kiss Me Kate is performed in ringing Elizabethan style by Salt Lake City youngsters. Playing the lead, 12-year-old Eleanor Bliss flees shrewishly. • In a church basement retired grocer John Heblich makes age seem unimportant to a troop of Boy Scouts he entertains with an Indian dance.

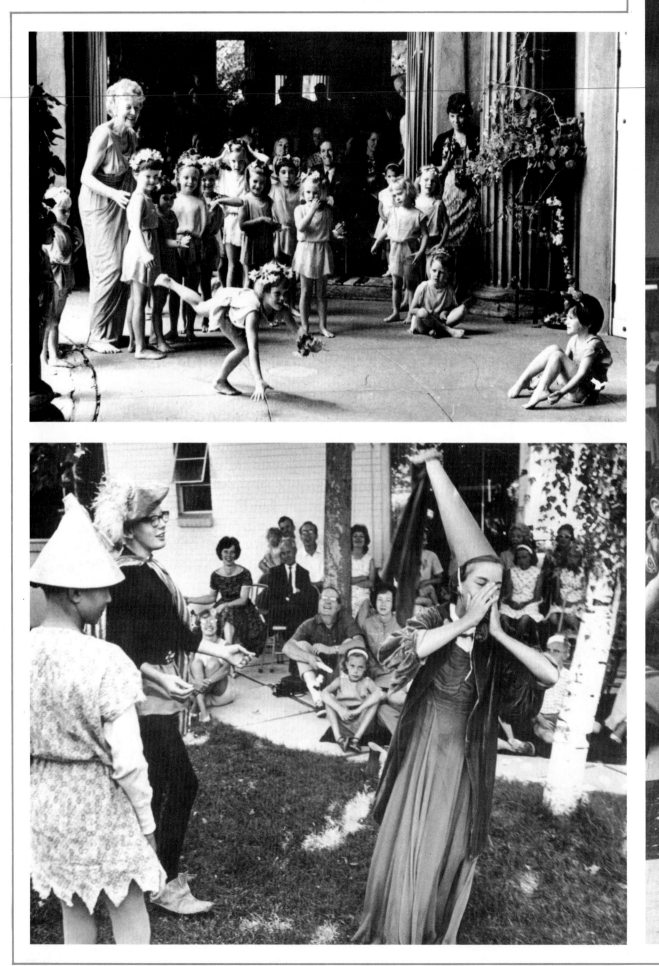

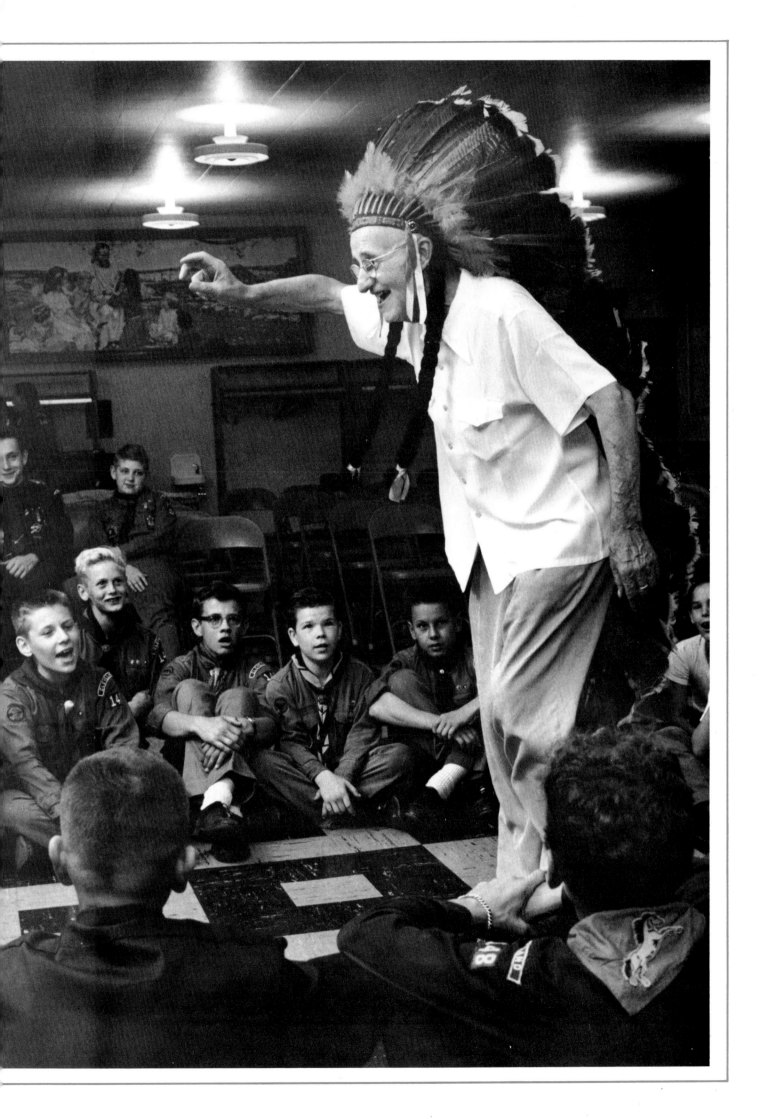

Recording milestones as well as how things used to be

On the country's 200th birthday, a man on a New York City rooftop positions his wife and a flag for a snapshot that will reflect his pride in both. ● On Della and Silas Underwood's 60th wedding anniversary, their grandchildren are recorded outside the church as the celebration for the West Virginia farm couple gets under way. ● Trying to hearken back to the old days and avoid the depressing realities of bombed-out cities after World War II, a Polish photographer poses his pleased subject in front of a portable sylvan backdrop.

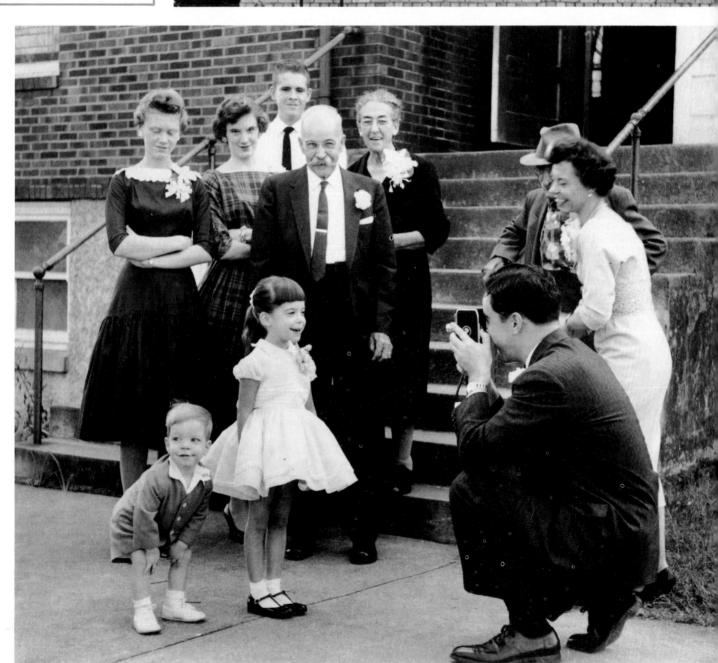

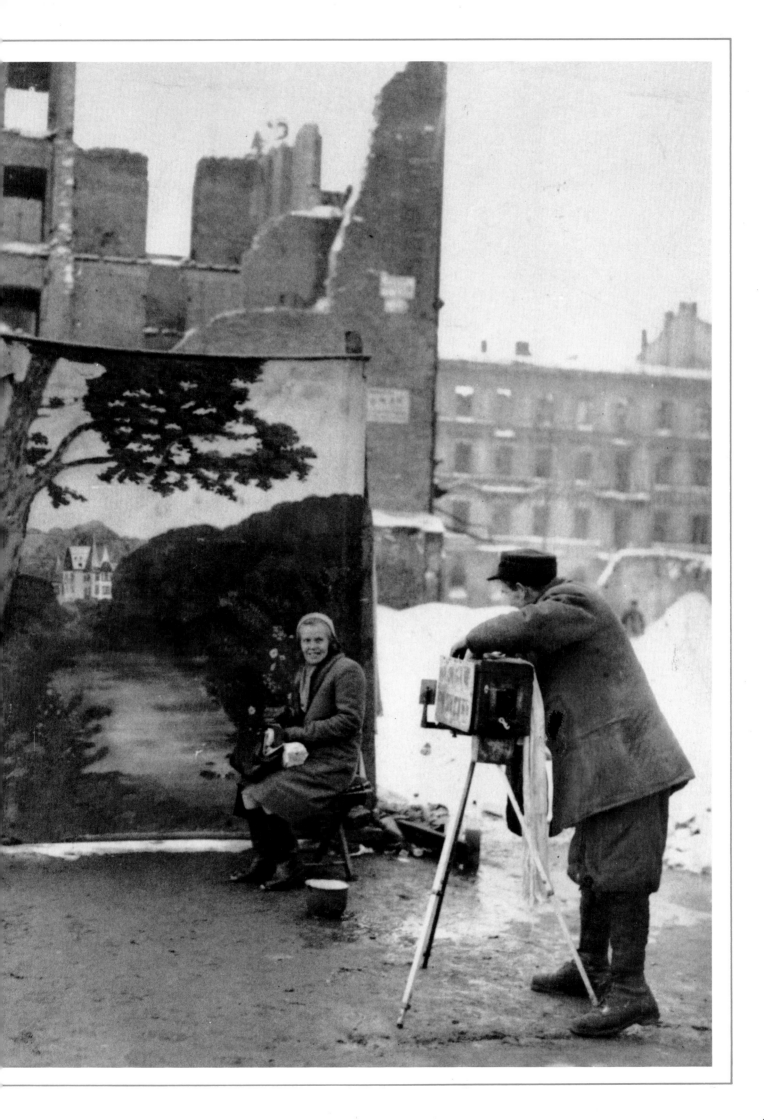

*The hazards of
a young woman
traveling alone
never seem to
change*

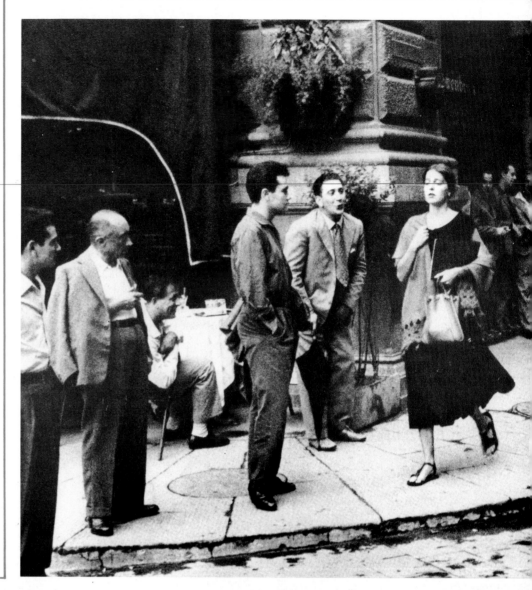

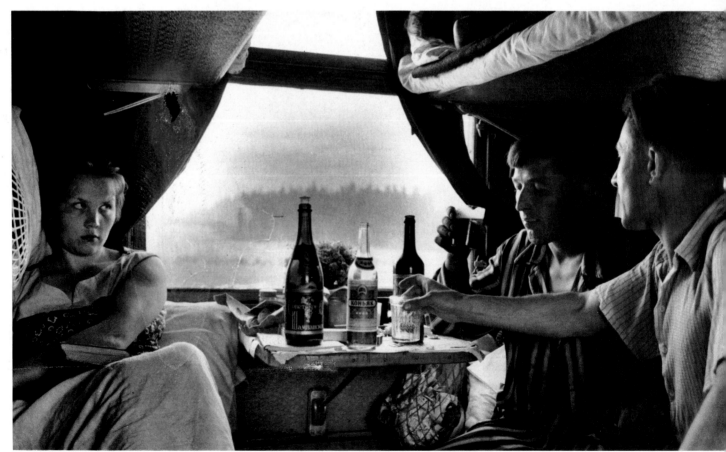

American artist Jinx Allen is ogled in Florence
by an enclosure of leering men. ● On a trans-
Siberian sleeper, a young girl shoots a
distrustful glance at the convivial strangers who
have been assigned to share her compartment.
● Getting the once-over from a park bench.

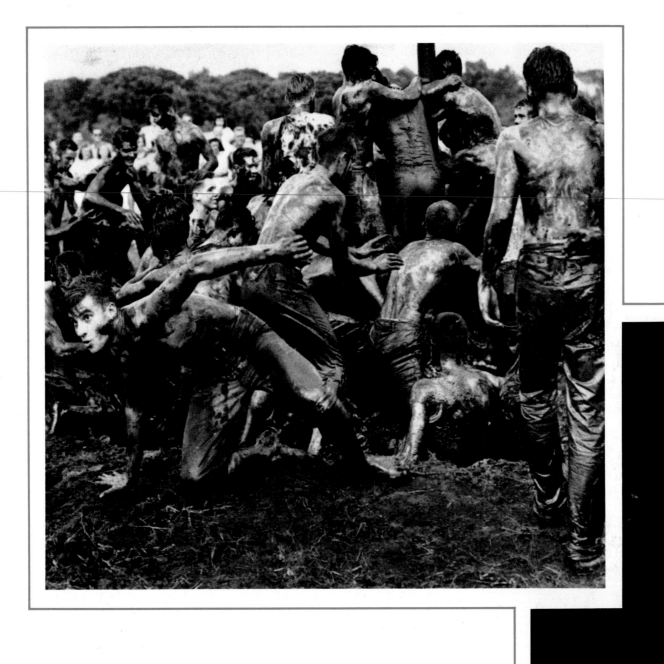

Messy ways to prove their manhood

At Beloit College in Wisconsin, if the freshmen can fight their way through defending sophomores, wade a ditch of crankcase oil, climb a 15-foot greased pole and pull down a flag, then they won't have to wear little green hats anymore. ● In a Japanese winter festival near Okayama, thousands of young men wearing loincloths take part in another annual messy exercise. In a darkened temple chamber two batons are thrown into a writhing sea of bodies. The free-for-all may last for hours as contestants struggle in the dark for possession of the batons, which guide the boys by their strong camphor smell. When two battered winners finally crawl from the temple with their prizes, nothing much has been accomplished but at least manhood has been served.

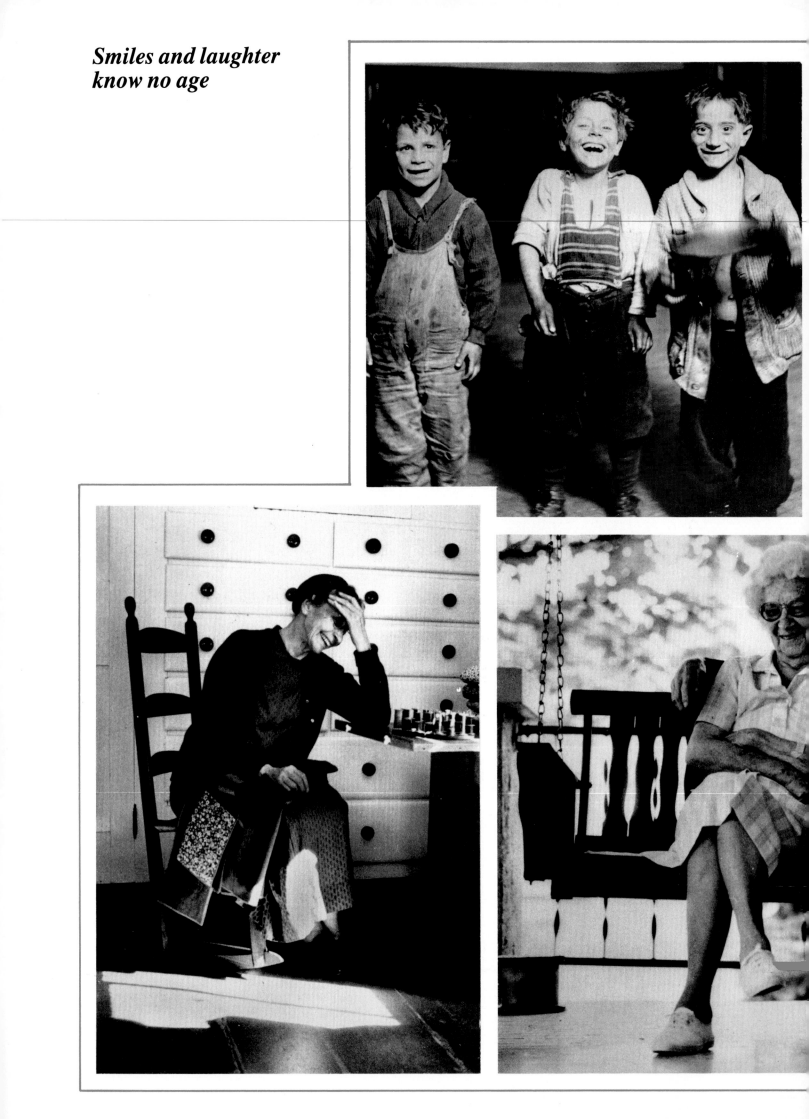

*Smiles and laughter
know no age*

Chicago urchins in the
1920s. ● Father Charles Cranham
at a Notre Dame football
game. ● Michael Francis McElroy
and his grandmother. ● Genevieve
and Vernon Evans on their front
porch in DeSoto, Missouri. ● Sister
Mildred in a Shaker sewing room.

Trusting a granddad and pushing his patience

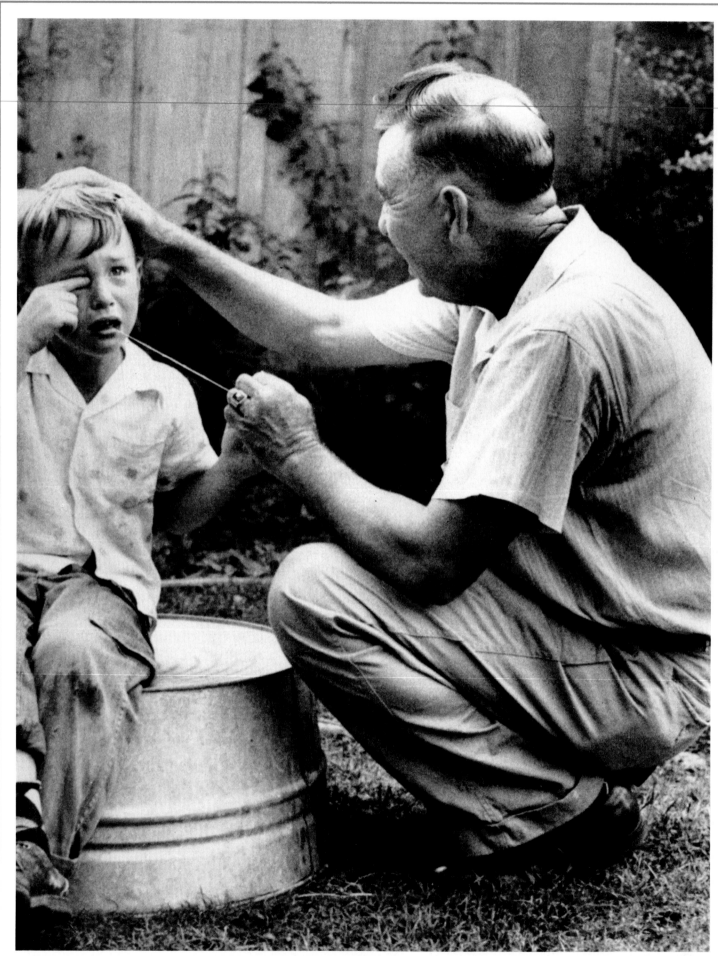

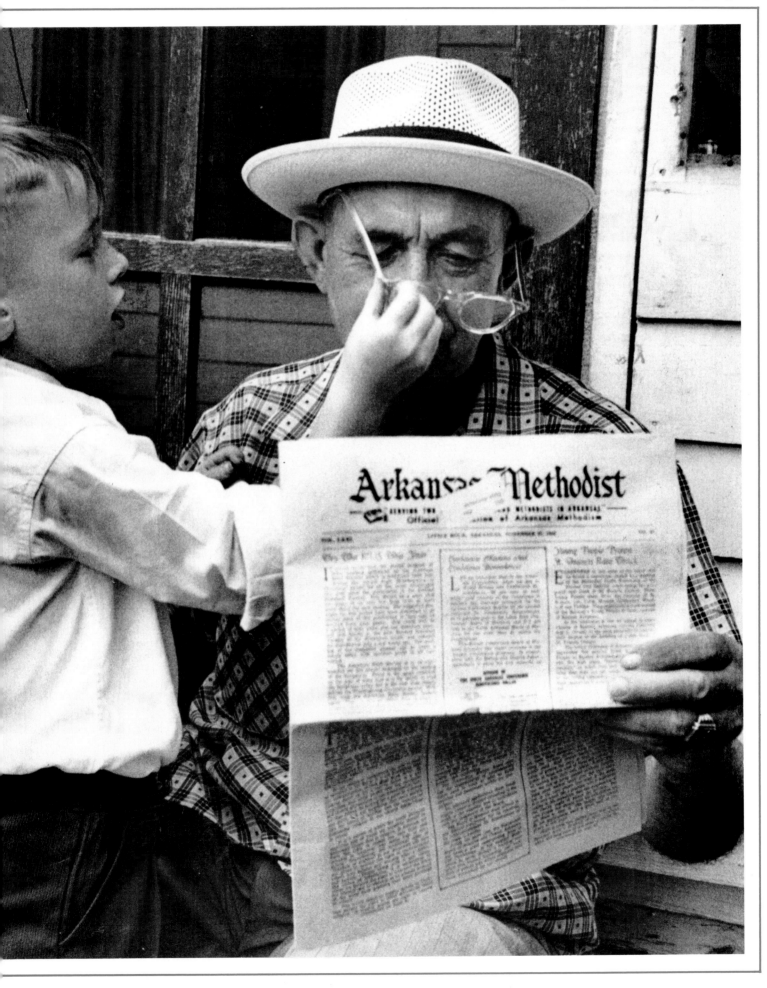

When a wiggly tooth has to come out, it is Granddad who introduces Billy Connors to the subtleties of the string technique. ● *Using his own artistry, Billy tries to get his grandpa's attention by dislodging his glasses.*

Old-fashioned advice for a younger generation

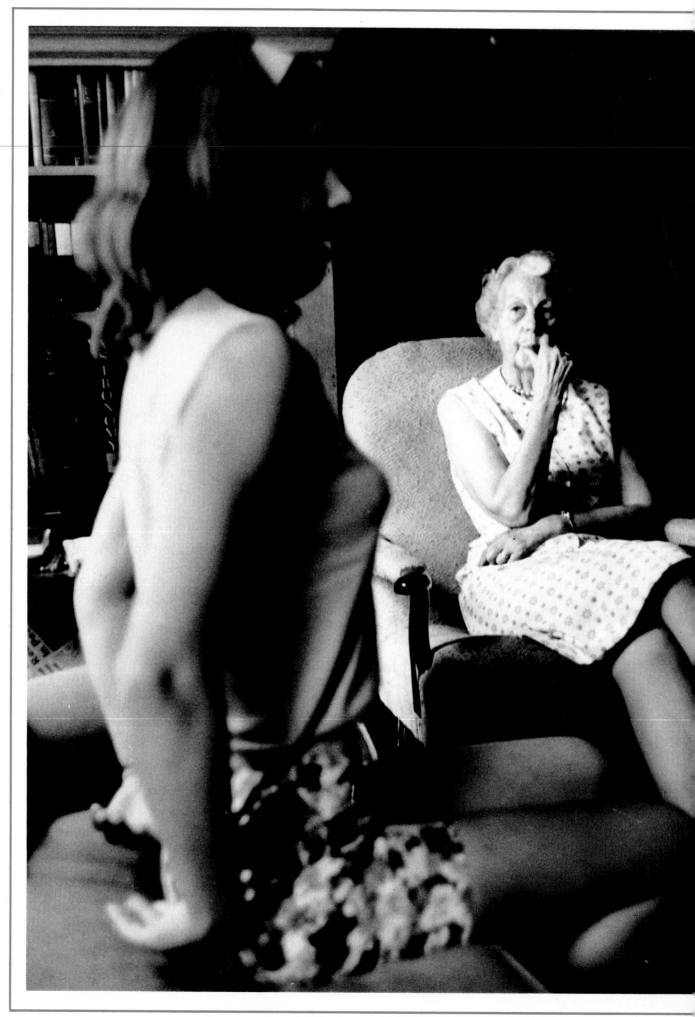

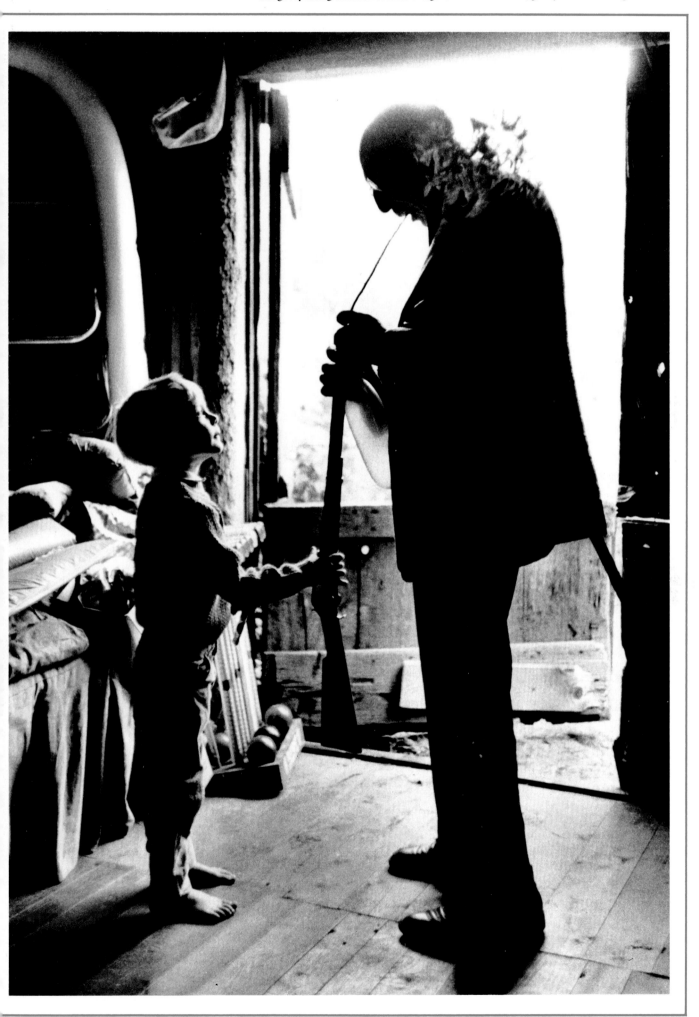

A senior diplomat disapproves of the skimpiness of her granddaughter's new bathing suit. Julia Smith has always tried to convey a sense of permanence, of belonging, to her large family. ● Her husband, Levi Smith, loads a popgun with a willow frond for his youngest grandson. He sees things repeating themselves from one generation to the next, gently teaches courage and caution.

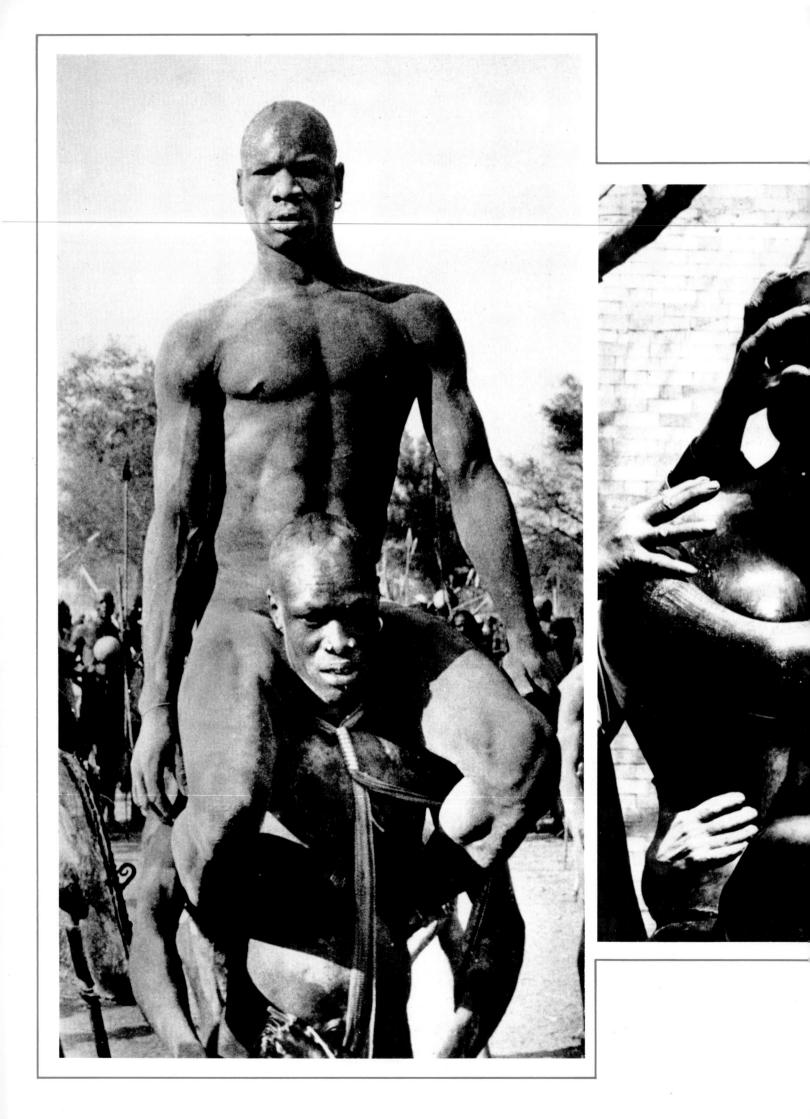

The beauty of the human body, real and imagined

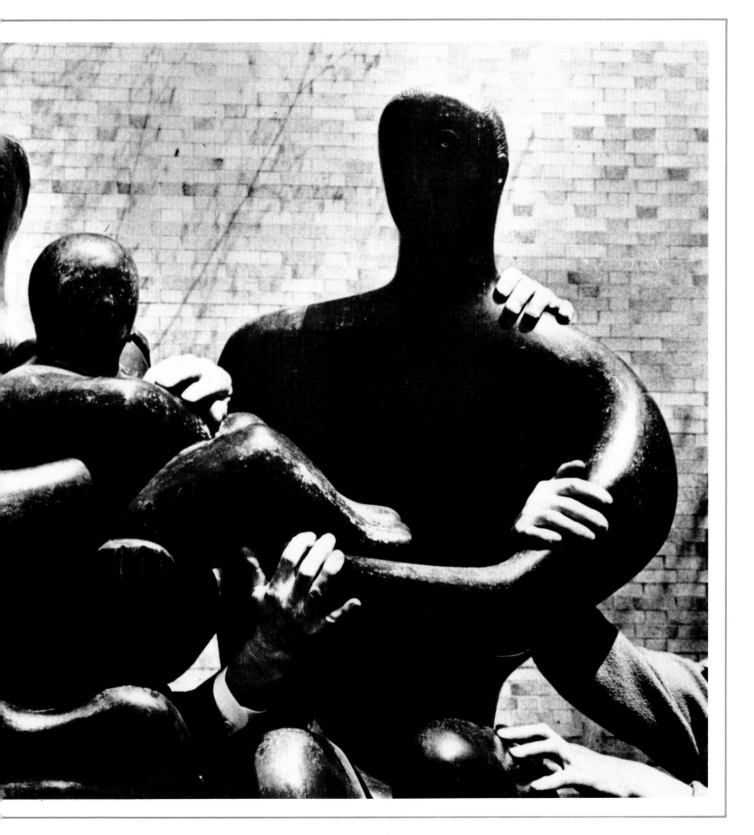

This towering African is paraded piggyback around his village upon the shoulders of the
man he has just vanquished in a ferocious, naked wrestling match for which the Sudan's Nuba are
famous. ● Blind people who do sculpture of their own handle the stoic bronze figures of
Henry Moore's Family Group and visualize its grace and meaning through their educated fingers.

Life's shapes and shadows are repeated

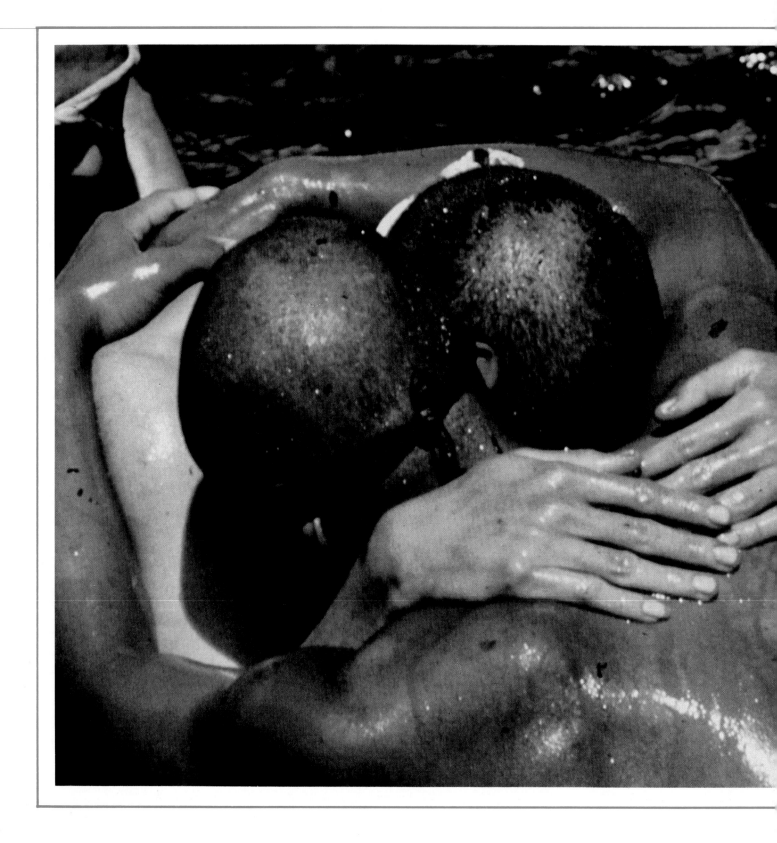

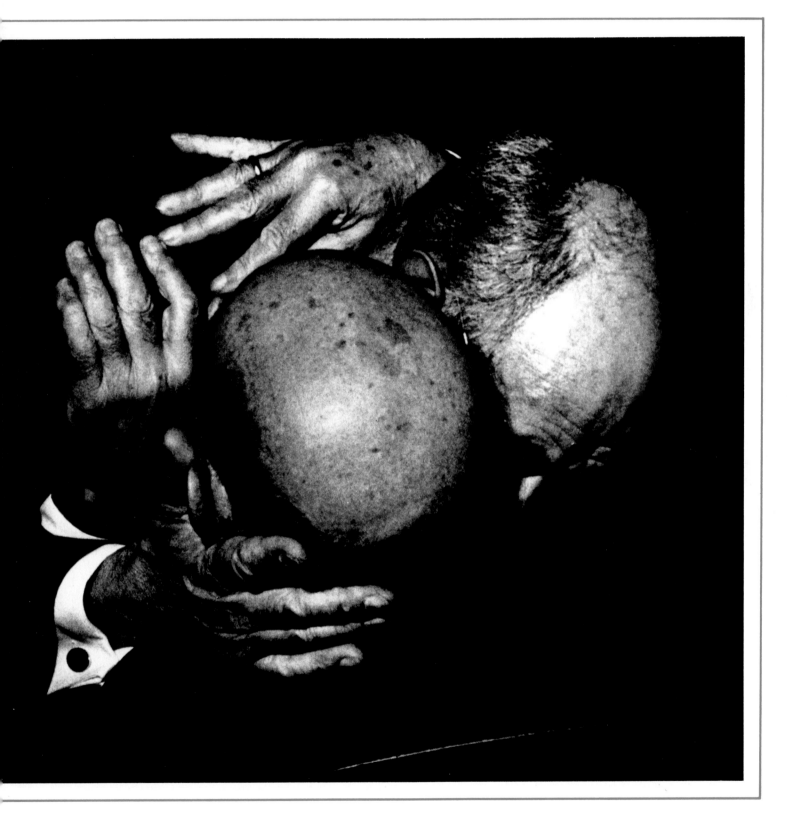

In a freshman rite, two university students go head to head in West Java. ● *After playing*
a Schubert sonata, Rudolf Serkin is embraced by his old colleague Pablo Casals.

Reverence for love,
belief in life

Seven months pregnant,
Margareta Falk and
her husband Willie
feel the outline
of their first child.

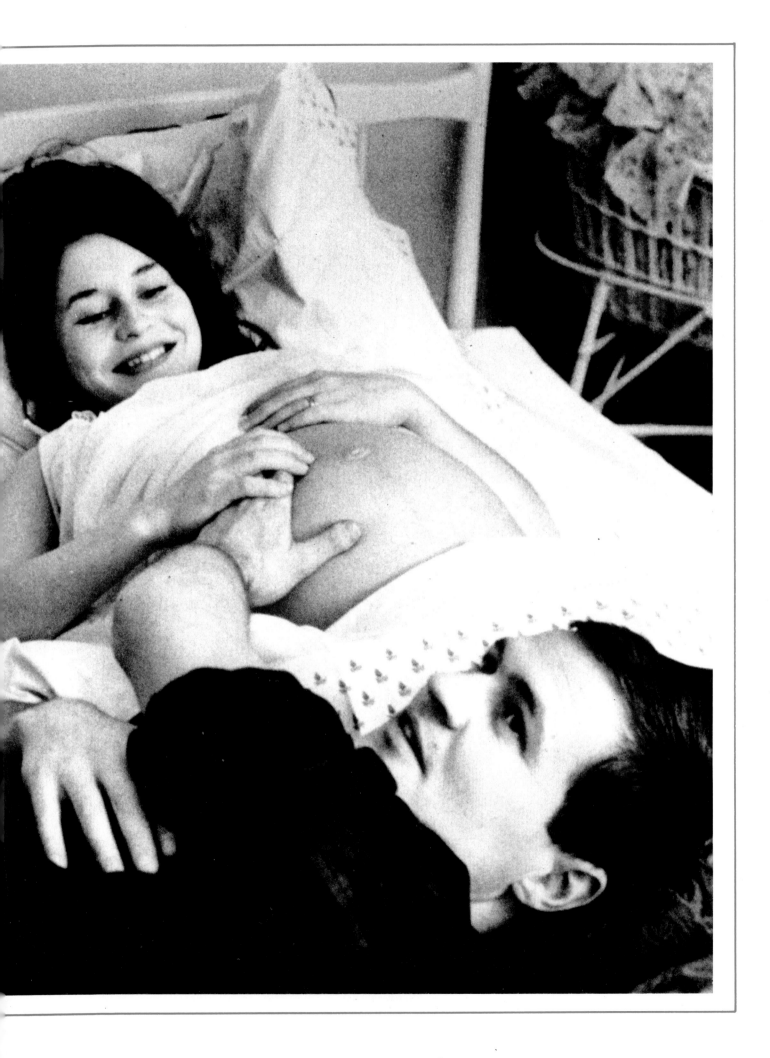

Credits

Photographers' credits are listed page by page and separated left to right by semicolons, from top to bottom by dashes.

All photographs and art work are protected by copyright, except those credited to agencies of the U.S. Government. The Time Inc. Magazine Company owns the copyright to all images credited to LIFE.

Cover: William A. Campbell. **Endpapers:** Leon Kuzmanoff. **3:** George Silk, LIFE. **5:** William A. Campbell. **6:** NASA. **7:** Helen Stitzer. **8:** Charles E. Rotkin. **10:** Georgia Brauer. **12:** Kent H. Barton. **13:** Joanne Leonard—K. Matsuzaki, courtesy Nikkor Camera Club—Gertrude Kaesebier, George Eastman House. **14:** Stefano Robino. **16:** Mario Saponaro. **18:** No credit. **20:** Grey Villet. **22:** Alfred Eisenstaedt, LIFE. **23:** William A. Campbell—Gordon Parks Jr. **24:** Alfred Eisenstaedt, LIFE. **25:** George Krause. **26:** Ken Heyman. **27:** Helen Levitt. **28:** A. Y. Owen—(c) Ruth Orkin. **29:** Carroll Seghers II—Esther Bubley. **30:** George Silk, LIFE. **31:** William A. Campbell. **32:** Leonard McCombe, LIFE. **33:** Lisa Larsen. **34:** Esther Bubley. **36:** Leonard McCombe. **37:** Carl Mydans, LIFE (all). **38:** Allan Grant; Burk Uzzle; Suzanne Szasz. **40:** Enzo Sellerio. **42:** John Dominis, LIFE. **43:** Roger Mayne. **44:** A. Y. Owen. **45:** Leonard McCombe. **46:** Grey Villet; Allan Grant. **47:** Gordon Parks. **48:** Anthony Mauer. **50:** William A. Campbell—Wayne Miller, Magnum. **51:** John Dominis, LIFE. **52:** George Silk, LIFE. **54:** Carl Iwasaki; Frank Scherschel, LIFE—Esther Bubley. **55:** Frank Scherschel, LIFE—Joe Scherschel, LIFE. **56:** Carl Iwasaki. **57:** Yale Joel, LIFE. **58:** Grey Villet; Robert W. Kelley, LIFE. **59:** Robert W. Kelley, LIFE. **60:** Burk Uzzle (all). **61:** Nina Leen. **62:** Vivian Holmgren—Esther Bubley. **63:** Michael Mauney. **64:** Burk Uzzle. **66:** Lynn Pelham. **67:** Lisa Larsen—Paul Schutzer, LIFE. **68:** Brian Brake, Photo Researchers. **70:** Tim Kantor—Leon Kuzmanoff. **71:** Jim Richardson, Black Star—Bill Ray. **72:** Ralph Crane; Peter Stackpole, LIFE—Nina Leen. **73:** Nina Leen. **74:** Michael Rougier, LIFE. **76:** William A. Campbell—Robert W. Kelley, LIFE. **78:** Steven C. Wilson. **80:** Gregory Heisler. **82:** Stan Wayman, LIFE. **84:** Robert Halmi. **86:** Tony Ruta—George Silk, LIFE. **88:** Charles Trainor, Miami Daily News. **89:** Tom Dunn, Jerry Irwin—John Dominis, LIFE. **90:** Michael Salas. **91:** Leonard McCombe, LIFE. **92:** Carl Mydans, LIFE. **94-95:** Robert W. Kelley, LIFE—George Silk, LIFE. **96:** William A. Campbell—Harald Sund. **97:** Michael Rougier, LIFE. **98:** Jim Richardson, Black Star. **99:** Wayne Miller, Magnum. **100:** Leonard McCombe, LIFE. **101:** Don Cravens. **102:** C. William Shrout, LIFE—Peter Stackpole, LIFE; Susan Greenwood. **103:** David Jouris—Leonard McCombe; Peter Stackpole, LIFE. **104:** No credit; Detroit Free Press—Robert Doisneau, Agence Rapho—Robert Doisneau, Agence Rapho; David Scherman, LIFE. **105:** Nina Leen. **106:** Bert Stern. **107:** John Brook. **108:** Toni Frissell, courtesy Frissell Collection, Library of Congress—Carrol Seghers II. **109:** Leonard McCombe, LIFE. **110:** Toni Frissell, courtesy Frissell Collection, Library of Congress (all). **111:** Paul Schutzer, LIFE. **112:** Grey Villett, LIFE. **114:** Jim Richardson, Black Star (all). **115:** Elliot Erwitt, Magnum. **116:** Grey Villet, LIFE. **118:** Don Uhrbrock. **119:** Michael Rougier, LIFE. **120:** Wyn Berry. **121:** A. Y. Owen. **122:** William A. Campbell—Burk Uzzle. **123:** William Garnett. **124:** John Deeks. **126:** Cornell Capa, Magnum—Ralph Morse, LIFE. **127:** George Silk, LIFE. **128:** Henk Jonker—Yale Joel, LIFE. **129:** John Florea, LIFE. **130:** Michael Rougier, LIFE—Alfred Eisenstaedt, LIFE. **131:** John Loengard, LIFE—Ulric Meisel. **132:** Leonard McCombe, LIFE. **133:** Farrell Grehan. **134:** Dmitri Kessell, LIFE. **135:** Leonard McCombe, LIFE. **136:** Rue Drew; Edmund B. Gerard; Wide World. **137:** John Dominis, LIFE. **138:** Tim Kantor. **140:** William A. Campbell—Co Rentmeester. **142:** Esther Bubley. **143:** George Silk, LIFE. **144:** Art Rickerby, LIFE. **146:** Leonard McCombe, LIFE—Yale Joel, LIFE. **147:** Ralph Crane, LIFE. **148:** Tim Kantor. **149:** Bryan Moss, Louisville Courier-Journal. **150:** Paul Schutzer, LIFE. **152:** Ken Whitmore. **153:** Richard Hartt. **154:** Esther Bubley—Joel Gerdts. **155:** Carl Iwasaki. **156:** Ed Clark. **158:** William A. Campbell—Lisa Larsen. **159:** Gjon Mili. **160:** George Skadding, LIFE—Martha Holmes. **161:** Ed Clark, LIFE. **162:** Burk Uzzle; Lisa Larsen; Peter Stackpole, LIFE. **164:** Larry Burrows, LIFE. **166:** Ralph Crane, LIFE. **167:** Dmitri Kessel and Yale Joel, LIFE. **168:** Edmund B. Gerard. **169:** (c) Philippe Halsman. **170:** Yale Joel, LIFE. **171:** Lisa Larsen. **172:** Cornell Capa, LIFE—Stan Wayman, LIFE. **173:** Henk Jonker. **174:** John Loengard, LIFE. **175:** W. Eugene Smith, LIFE. **176:** Ray Atkeson. **177:** Miami Seaquarium. **178:** (c) Ernst Haas—No credit (3). **179:** No credit. **180:** Calogero Cascio, Agence Rapho; Carlo Bavagnoli. **181:** Carlo Bavagnoli. **182-183:** Albert Spear; Lonnie Wilson—William Simpson (2). **184:** No credit—David Lees. **185:** No credit. **186-187:** Michael de Voss, Michael Werner, Rene Reichenbach (all). **188:** Richard L. Burket—A. M. Coomaraswamy. **189:** A. M. Coomaraswamy. **190:** Charles Harbutt (all). **192:** George Silk, LIFE. **194:** William A. Campbell—Michael Rockefeller, Film Study Center, Harvard University. **195:** Leslie Todd. **196:** Max Waldman—Samm Wooley Coombs. **197:** Ken Beckles; (c) Ruth Orkin—George Silk, LIFE. **198:** Howard Sochurek, LIFE—Michael Rougier, LIFE. **199:** Ken Heyman. **200:** Francis Miller, LIFE. **201:** Carl Mydans, LIFE. **202:** Brian Brake, Photo Researchers. **204:** Arthur Gough—Leigh Wiener. **205:** Francis Miller, LIFE. **206:** William Cody—Don Cravens. **207:** Michael Nash, Wide World. **208-209:** (c) Ruth Orkin—John Launois, Black Star; Michael Mauney. **210:** Bob Miller. **211:** Takahiro Ono. **212:** Wallace Kirkland—John Loengard, LIFE; Brian Lanker. **213:** Ralph Crane, LIFE—Robert W. Kellye, LIFE. **214:** Leonard McCombe. **215:** Leonard McCombe. **216:** Grey Villet. **217:** Grey Villet. **218:** George Rodger, Magnum. **219:** Jack Manning. **220:** Co Rentmeester, LIFE. **221:** Gjon Mili. **222:** Lennart Nilsson.